IMAGES
of America

GREER

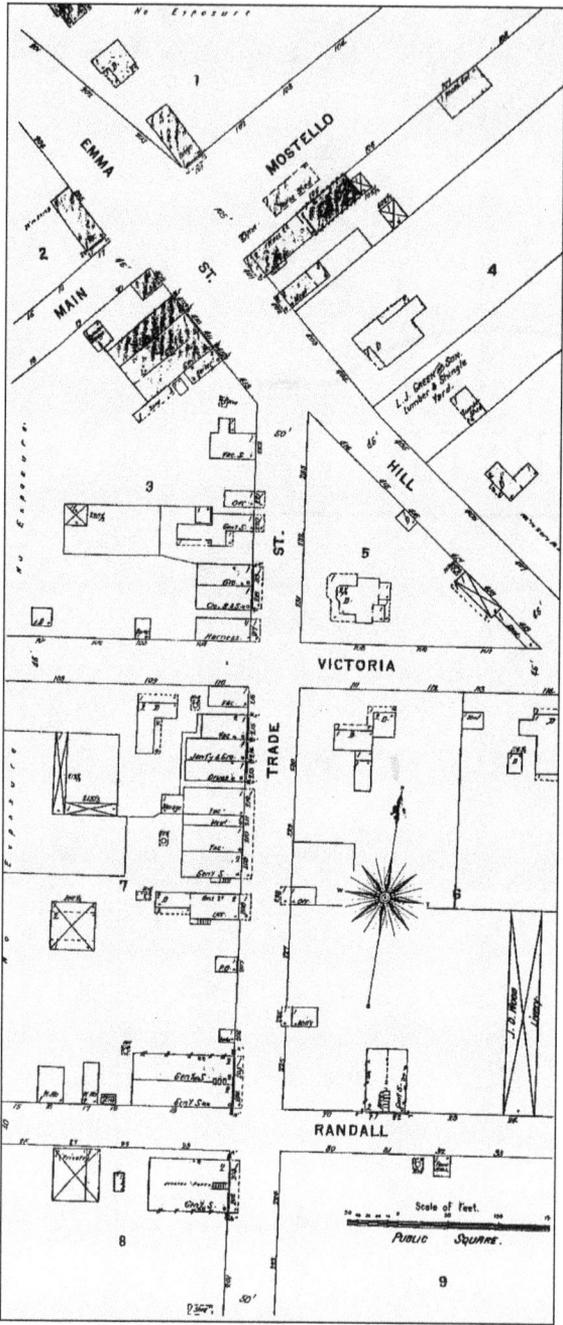

A portion of Greer's downtown is shown in an 1898 Sanborn Map Company map.

Cover Photo: In 1905, A.G. Howell moved his family and country store from Holly Springs to downtown Greer. Pictured in the bowler hat next to the wagon, he operated his store at the corner of Main and Poinsett Streets until his retirement in 1945. The building, which was torn down in the 1970s and is now the parking lot for Greer Florist, also housed the Turner Grocery Store. Note the telephone number on the side of the wagon in this 1913 image. (Courtesy of J.B. Howell, Clinton, MS.)

IMAGES
of America
GREER

Greater Greer Chamber of Commerce

ARCADIA
PUBLISHING

Published by Arcadia Publishing
Charleston, South Carolina

Library of Congress Catalog Card Number: 00-108142

For all general information contact Arcadia Publishing at:
Telephone 843-853-2070
Fax 843-853-0044
E-Mail sales@arcadiapublishing.com
For customer service and orders:
Toll-Free 1-888-313-2665

Visit us on the Internet at www.arcadiapublishing.com

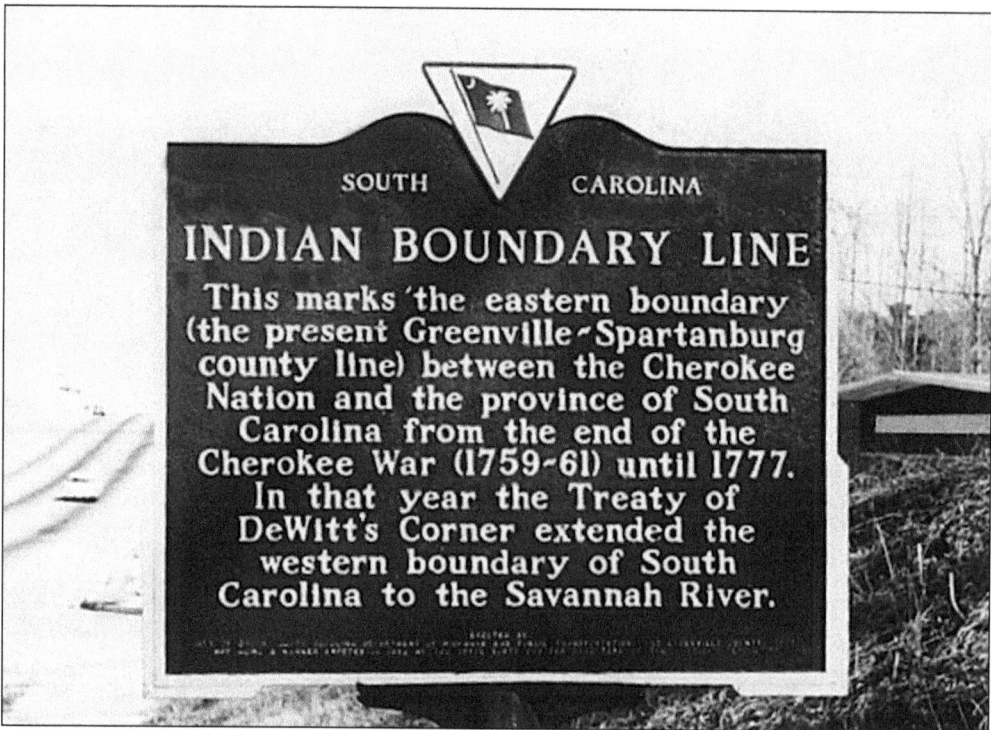

This historic marker on the Greenville-Spartanburg County line commemorates the 1761 treaty with the Cherokee Indians who deeded the Spartanburg County side of the line to the Carolina Colony. The Greenville County lands continued to be Indian territory until 1777. (Courtesy of E. Duke.)

CONTENTS

INTRODUCTION

Long before there was a Greer, South Carolina, the Cherokee Indians hunted, and early settlers began to farm along the abundant rivers and creeks of the area. When the Indian Boundary Line was drawn in 1761 from the block house in Tryon, North Carolina, south toward Greer, the Spartanburg County side of the line was deeded to the South Carolina Province. The closest block house to Greer was Thompson's Fort, which offered safety and trading. In 1777 the Cherokees made treaties to cede the rest of the land to South Carolina. Today Line Street commemorates this early history and serves as a county line.

Short Sketch of the Town of Greers, S. C., 1896 by Miss Anna Greene was the first recorded history of Greer and the basis for most articles about the city. In her history she noted that the name "Greers" was the only one in the nation. Even today the only other Greer with a post office is Greer, Arizona.

The site of Greer was called the old Blakely Place, a 200-acre farm owned by James Manning Greer. The Blakely farm house was the first known house in the history of Greer and sat behind the Greer Drug Company in the vicinity of Victoria Street. According to tradition, Greer traded a few acres to the railroad in exchange for a wagon and team of mules. He then sold the rest of his land to W.T. Shumate, who began selling lots when he realized the potential for a town around the train station. A lot in the planned business district sold for $25 to $75 per acre. Dr. Westmoreland bought his 90 residential acres at $4 an acre.

Since the first post office was in the station, the postmark read "Greer's Depot." On March 25, 1876, with 15 votes the town was incorporated as "Greers." William C. Bailey was elected mayor, and the first councilmen were Dr. H.V. Westmoreland, W.A. Hill, David Cannon, and A.J. Morgan. The "s" disappeared some time in the early part of the century. The town was known as Greer until the 1976 centennial celebration planners discovered that the dropping of the "s" had not been made legal. The state legislature remedied the oversight.

Thus, Greer owed its creation to the Southern Railroad, which was finished in 1873. The first shipment was fertilizer from Greenville. A second railroad, the Piedmont and Northern (P&N), laid tracks through Greer in 1914. With two active train lines, Greer became an attractive site of commerce. Textile mills, such as Victor, Apalache, Franklin, and Greer Mill, were important in the town's development. Agricultural products, especially peaches, were grown and shipped out of state. When the Jones Brothers began to can peaches and tomatoes, the Greer label appeared on grocery shelves across the nation.

In the 1950s, Homelite was one of the early companies to bring a new industry to Greer. A new hospital and high school were built, and Greer began to grow. Downtown Greer thrived with people driving from Greenville and Spartanburg to shop at Miss Elsie Fleming's and Miss Alta Cunningham's fine ladies clothing stores and Smith & James men's shop.

Just as the railroads brought progress to Greer, the Greenville Spartanburg Airport and I-85 have been important to modern development. BMW brought more jobs for the city, and an active program of annexation has doubled its size. Greer prides itself for its friendly, small-town atmosphere and its big-city expectations for growth and progress into the 21st century. Miss Anna was prophetic when she wrote "[Greer's] future is full of hope and promise . . . Guided by the Angel of Progress, and following the polar star of Truth, she hopes to make her future achievements commensurate with the progress of the past."

Joada Hiatt
Branch Manager
Jean M. Smith Library of Greer
Greenville County Library

ACKNOWLEDGMENTS

A project of this magnitude, especially for a relatively small non-profit organization, is one that begins with excitement, enthusiasm, and anticipation. As work begins in earnest it evolves into one of apprehension, uneasiness, and finally, genuine fright. As deadlines approach and the work moves into a frenzied pace for everyone, the panic can be clearly seen and felt. It ends in the reflection and the realization that there are many individuals who made this book possible. The Historic Book Committee and the everyday citizens and friends of Greer are this book's real heroes.

The first to be acknowledged are the individuals who make up the initial committee, led by Joada Hiatt, the head librarian at Greer's Jean M. Smith Library. Joada Hiatt is primarily responsible for the book's success. Harold James (of The James Agency), a member of one of Greer's oldest families and an amateur photographer of some renown, jumped right in from the beginning and also worked tirelessly to get everything ready.

The other committee members need to share in the accolades. Margarett Turner led the way to secure pictures of the African-American community. Don Owens, a retired insurance businessman (of The Owens Agency), is also a Greer native. His knowledge of Greer history and his enthusiasm for anything Greer is readily apparent. Staffing for this committee was Al Tompkins, the Chamber's president.

Early on, we acknowledged that there were many pictures in the community that might not surface because of a fear of damage or being misplaced in the publishing process. To counter that apprehension, the Chamber brought in an electronic scanner and promised instant scanning and instant return of any photos generously loaned. It was fascinating to see some older citizens, without experience in the digital age, to see their photos electronically stored on a computer and then returned to them in a matter of seconds.

These individuals are the real "authors" of this book. These are people who searched scrapbooks, dresser drawers, and family archives for pictures of people, places, buildings, and events. They called parents and grandparents to borrow photos they remembered seeing. One man, originally from Greer and now living in Mississippi, saw the call for photos in the Greer *Citizen*, to which he still subscribes, and sent in one photo by overnight delivery that turned out to be our cover photo. Mr. J.B. Howell, thank you for your dedication.

Below is a list of those individuals who contributed pictures to this project. Greer's Pictorial History Book Committee, the Greater Greer Chamber of Commerce and, indeed, the entire Greer community are indebted to their generosity and willingness to share personal property and remembrances with the rest of this community. Thank you all very much.

Terry Atkinson
Joe Bearden
George Beason
Bus Belue
Norma Clement Bruce
Phil Clark
Kathy Danesi
David Duncan
Evelyn George
First Baptist Church, Greer, SC
Greater Greer Chamber of Commerce
GSP Airport Commission

Joada Hiatt
J.B. Howell
Rob Hughes
Harold James
Jeff and Nelle Howell
Joe Knighton
Jo Ann Greene McAbee
Thomas McAbee
Arthur McCarroll
Francis Merritt
Sylvia B. Pitts
Marlea B. Rhem

Walter Rogers
Moise D. Smith
Jean M. Smith Library
Senator J. Vern Smith
Marsha Strong
Karolyn Taylor
George Tillotson
Margarett Turner

University of South Carolina
Mary Alice Waddell
Dr. Theron Walker
Sarah Watson
Myra Weatherly
Don Whitmire
Ann Dillard Withrow

Disclaimer: Every effort has been made to insure accurate information, particularly of people' s names. Unfortunately, many photographs were provided without names, or names were written on the reverse side in light pencil, many, many years ago. Some of those were of poor penmanship and/or have faded with time. We apologize if you, a family member, or friend are pictured but not identified.

Alvin A. Tompkins, CCE
President
Greater Greer Chamber of Commerce

Indications point to an interest in the publication of a second volume of *Greer*. Many photographs were not submitted for this current publication and therefore could not be included. Individuals wishing to share historic photographs in future editions of *Greer* should contact the Greer Chamber of Commerce at (864) 877-3131 and leave their names, addresses, and phone numbers. Calls will be confirmed and contributors will be contacted about their photographs at the appropriate time. Thank you.

One

Doing Business in Greer

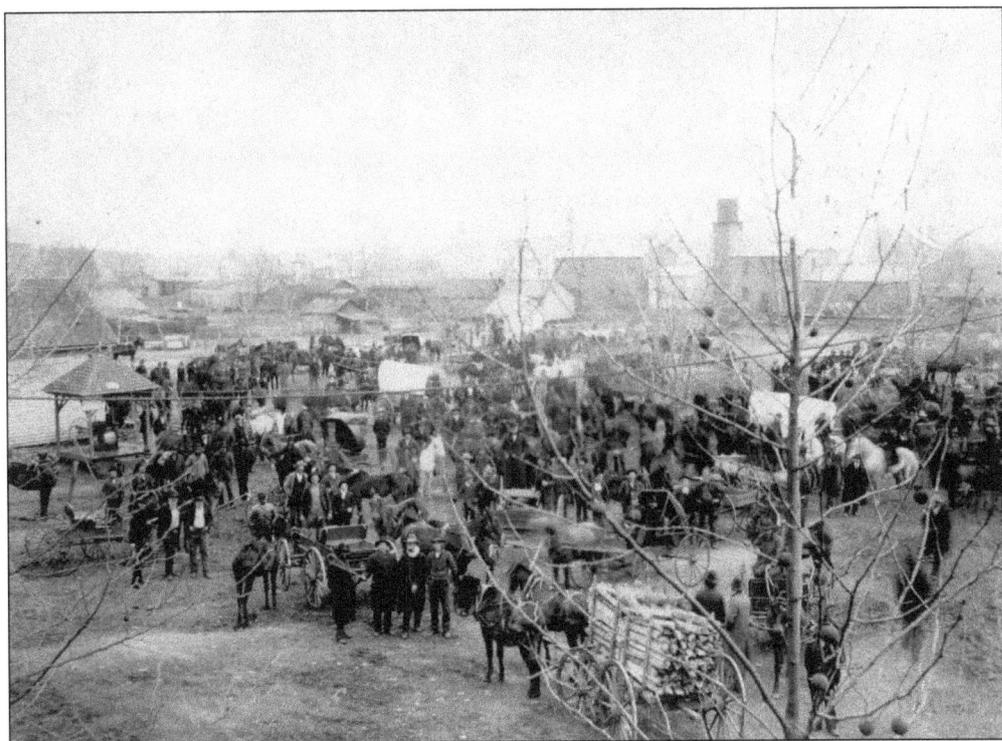

This photo shows the big field in downtown Greer before the P&N Railway was constructed. The square covered an area from Randall Street to the Southern Railroad and from Depot Street to Trade Street. Farmers and merchants mingled to do business. (Courtesy of the estate of Robert S. Hughes.)

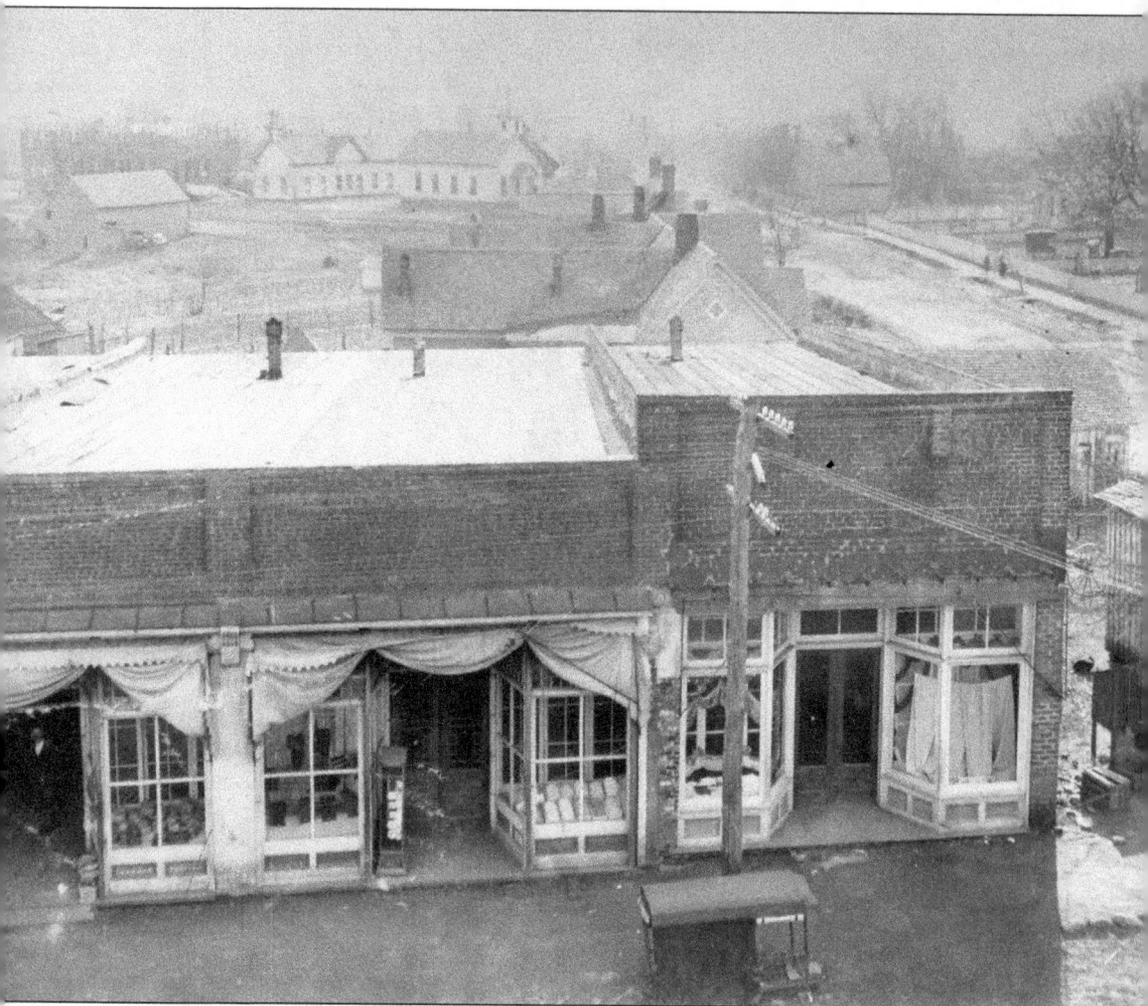

The thriving Greer business district began at the corner of South Main (visible on the right) and Trade (now the 100 block of East Poinsett). In the background is the First Presbyterian Church and Central School under construction around 1904 or 1905. (Courtesy of Jean M. Smith Library.)

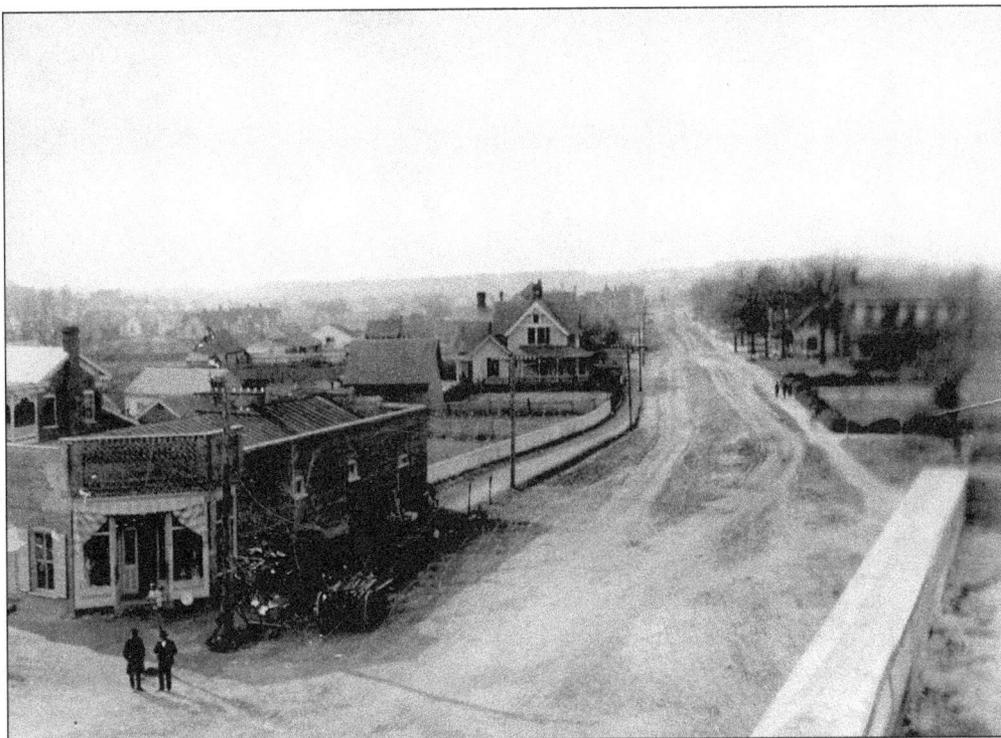

This 1905 photo taken from the top of the building at the corner of Main and Poinsett (later known as the T.E. Jones Furniture Store) looks west on Emma Street. W.M. Ballenger Store is on the left. (Courtesy of the estate of Robert S. Hughes.)

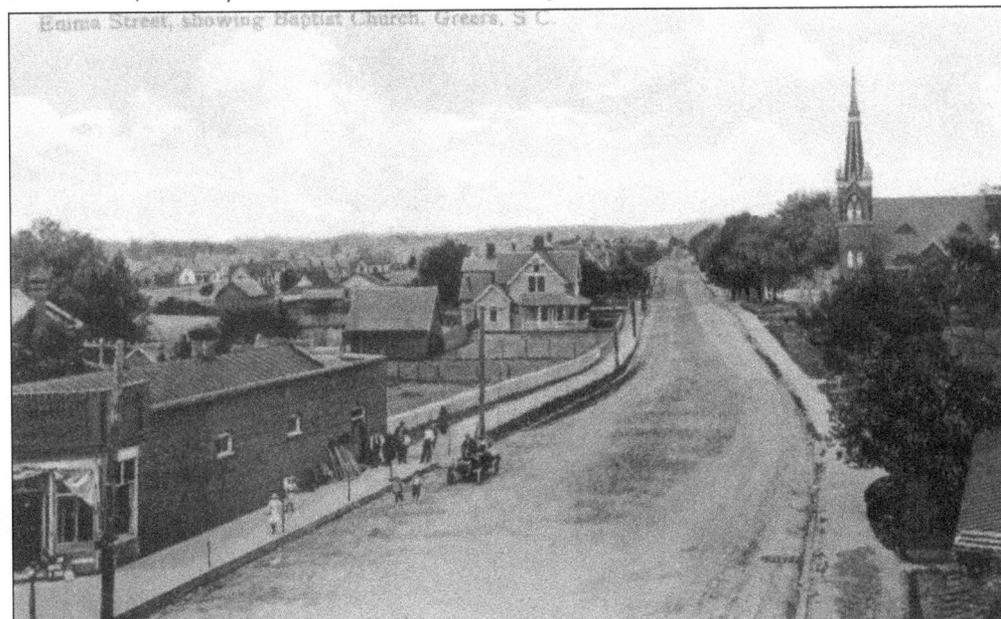

Today Emma Street is known as West Poinsett. The spire of the First Baptist Church is on the right as one looks up the street from Main. Once the road left the city, it was known as the State Highway. (Courtesy of First Baptist Church, Greer, SC.)

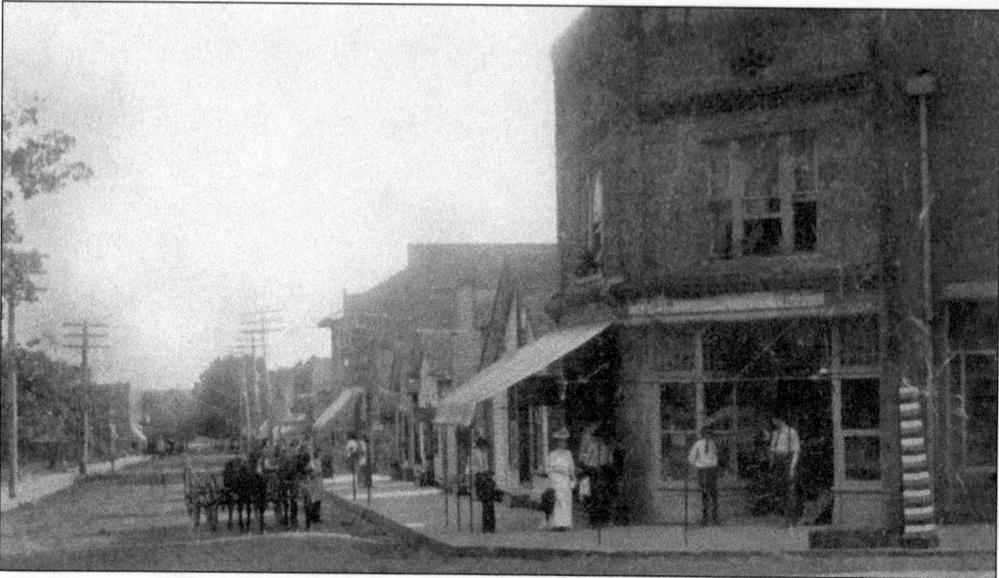

This 1909 street scene shows Carl Ponder's General Merchandise Store on the corner of Trade Street. (Courtesy of Jean M. Smith Library.)

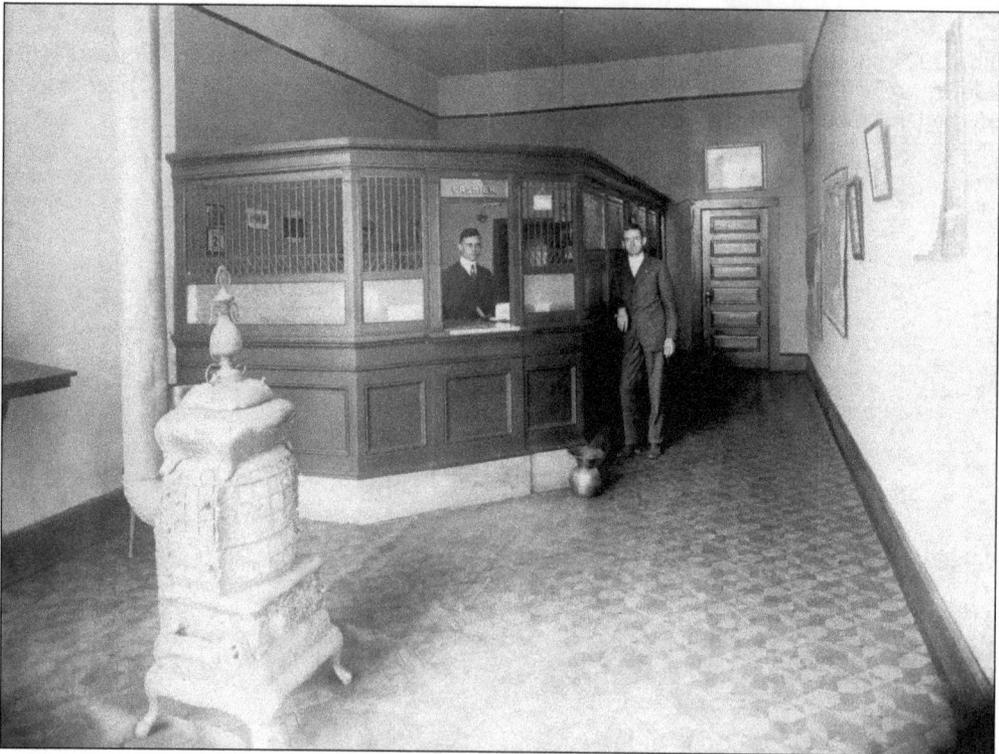

Clarence Stokes (left) and Robert Homer Bearden Jr. pose inside the First National Bank of Greer, *c.* 1920. This building was on the righthand corner of Trade and Randall, across from the depot. (Courtesy of Joe Bearden.)

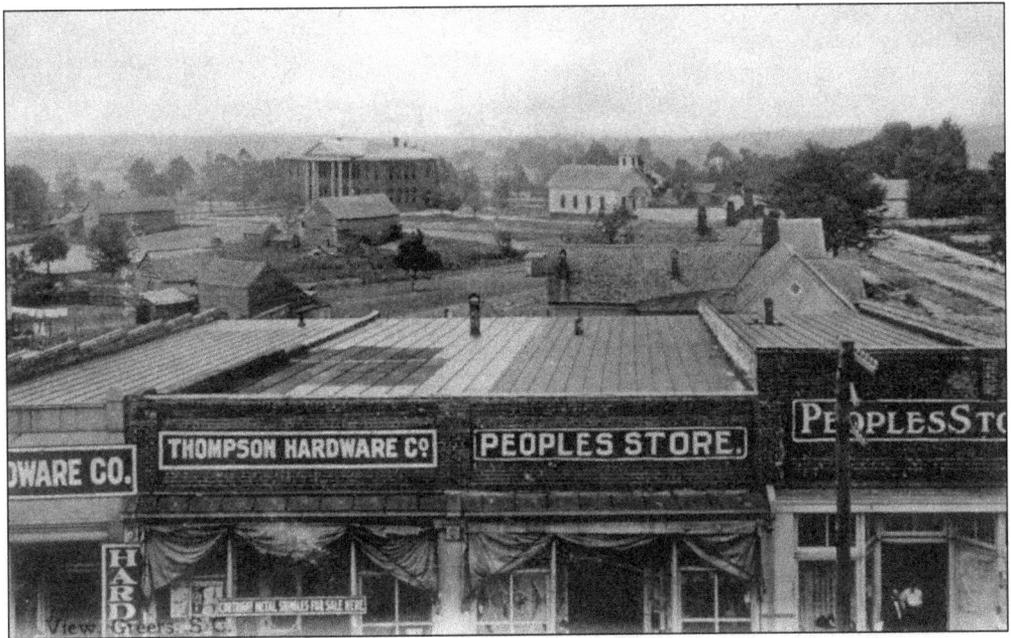

This 1905 Trade Street Scene (100 block of East Poinsett) shows the new Central School in the background beside the Presbyterian church, then called the Mt. Tabor Presbyterian Church. (Courtesy of George Tillotson.)

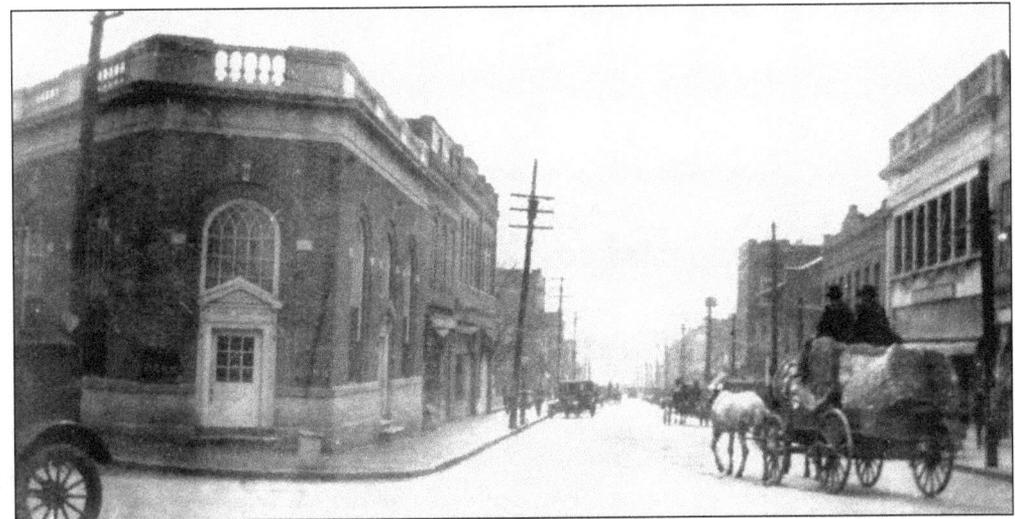

Both cars and horse-drawn wagons shared Trade Street in the early days. On the left was the Planters Savings Bank, which opened in 1921 in an unusual building designed by Beacham and LeGrand at the corner of Trade and Hill Street (East Poinsett). (Courtesy of Jean M. Smith Library.)

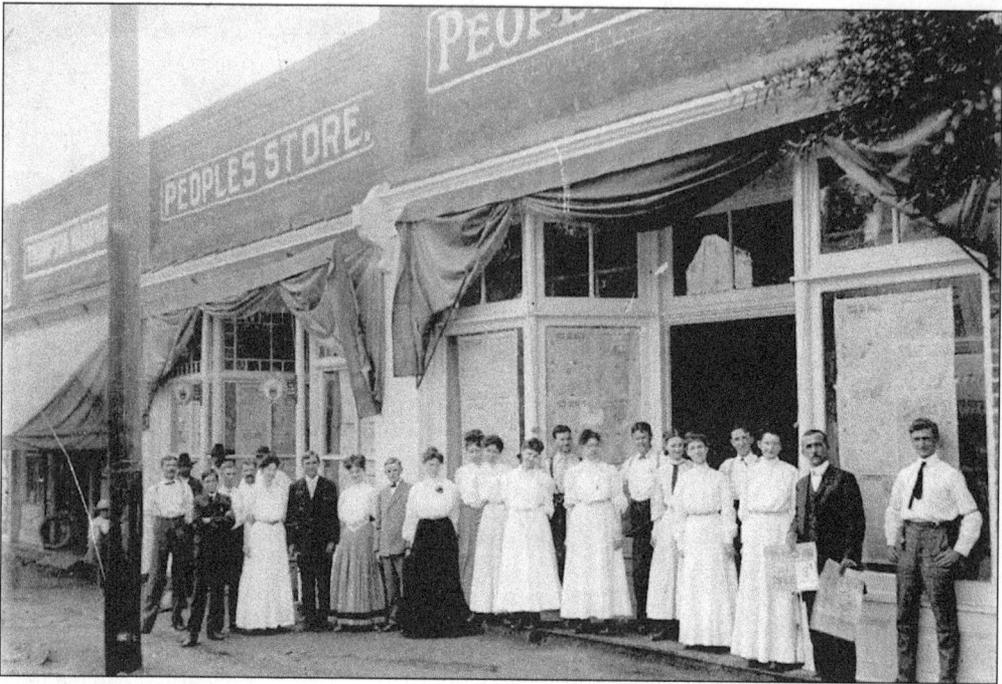

Seen here is the staff of the Peoples Store on Trade Street. (Courtesy of the estate of Robert S. Hughes.)

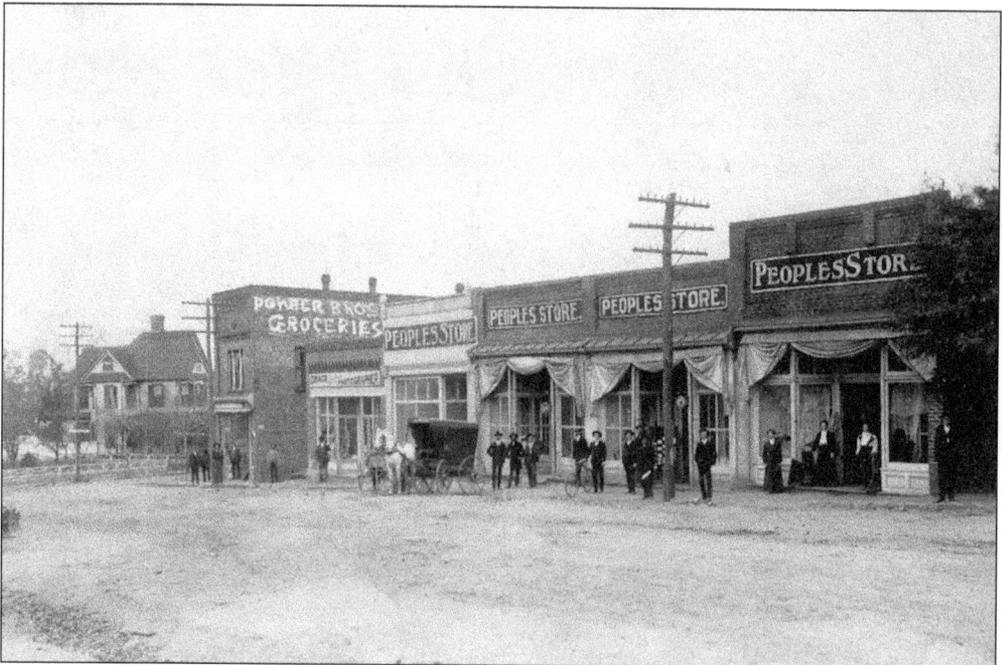

A 1904 picture shows Peoples Store, C.W. Drace Studio, and Ponders Bros. Store with Dr. R.L. Marchant' s home at far left between Hill Street and Trade. R.M Hughes was the manager of the Peoples Store. (Courtesy of the estate of Robert S. Hughes.)

This early Trade Street scene (now East Poinsett) shows where C.W. Drace, a well-known area photographer, had his studio next to Thompson's Hardware. The left side of Trade had not been built in this 1908 scene, but Dr. Marchant's house can be seen in the upper left. (Courtesy of Joe Bearden.)

A progressive small town, Greer had paved streets early on. The 1927 *Greer Community Annual* boasted of 16 miles of paved sidewalks, some of which are seen in this Trade Street scene. (Courtesy of Joe Bearden.)

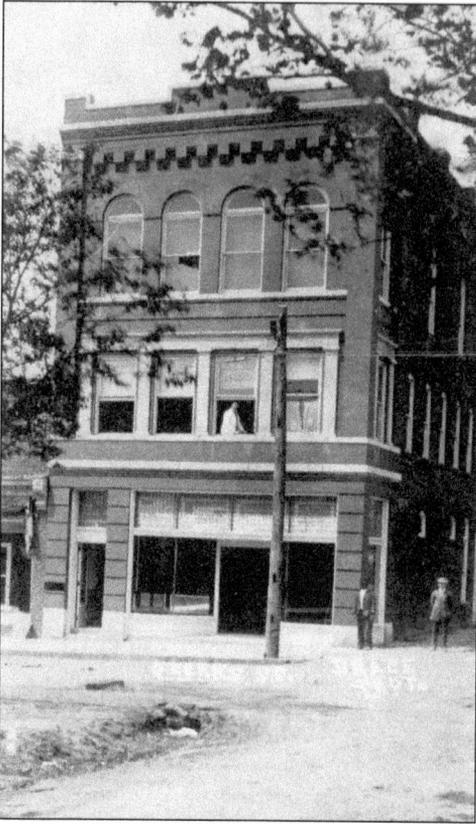

Dr. Drummond filled teeth in his second-floor office above the Greer Drug Company, which was known to later generations as the Rexall Drug Store. Note Dr. Drummond in the window as he looked down on a dirt Trade Street. (Courtesy of Jean M. Smith Library.)

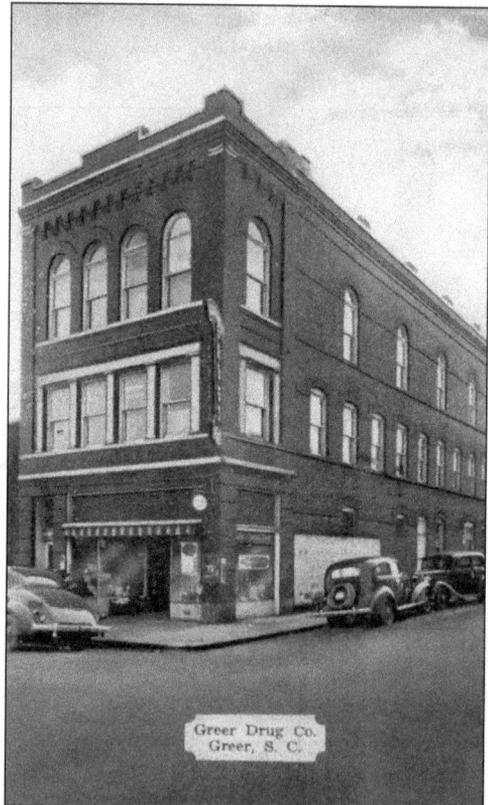

Dr. Robert Lee Marchant filled prescriptions at the Greer Drug Company. In 1910, Dr. Marchant contracted with J.C. Cunningham to construct this building, designed by architect Thomas Keating. (Courtesy of Jean M. Smith Library.)

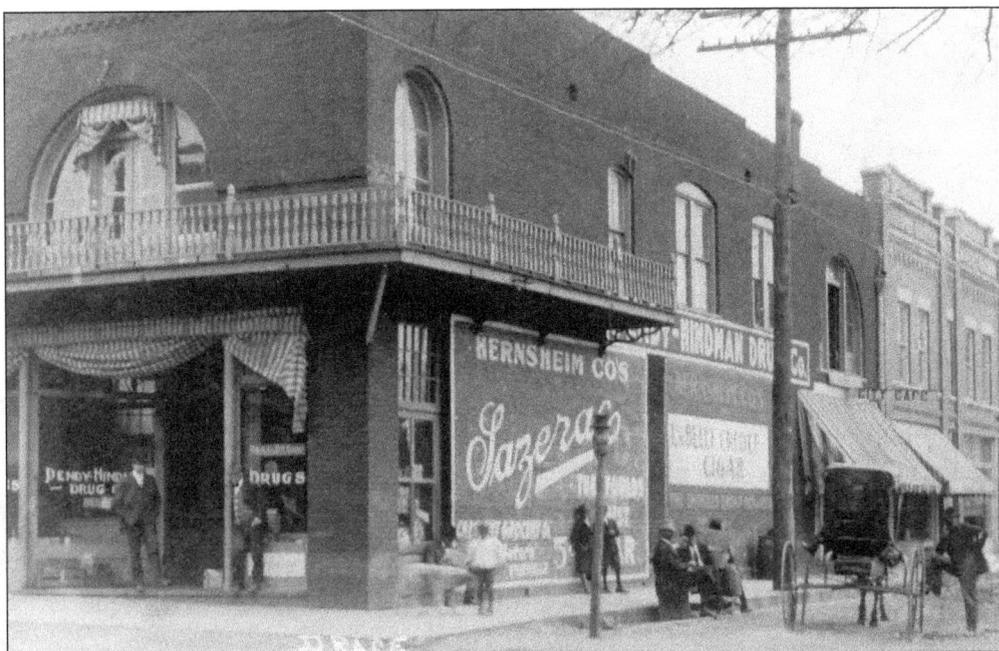

The Dendy Hindman Drug Store was located on the corner of Trade and Randall Streets where the current Citizens Building and Loan office is located. (Courtesy of Joe Bearden.)

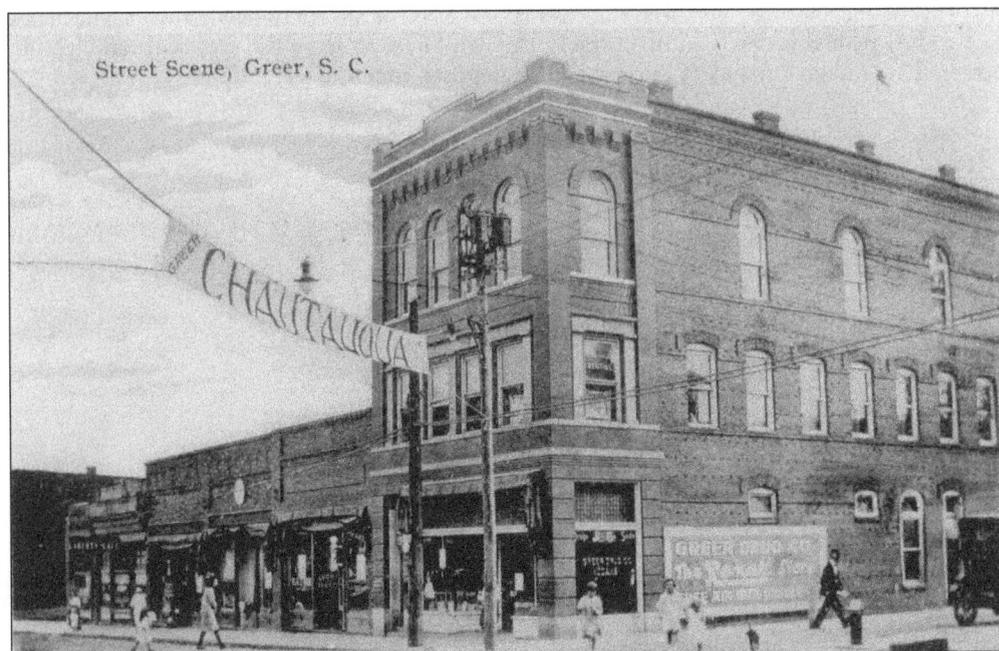

Downtown Greer was a popular gathering place in the early days when the Chautauqua traveling series brought culture to town in the form of lectures and musical programs. The banner is strung across Trade Street near the Greer Drug Company, which was a Rexall Store. (Courtesy of First Baptist Church, Greer, SC.)

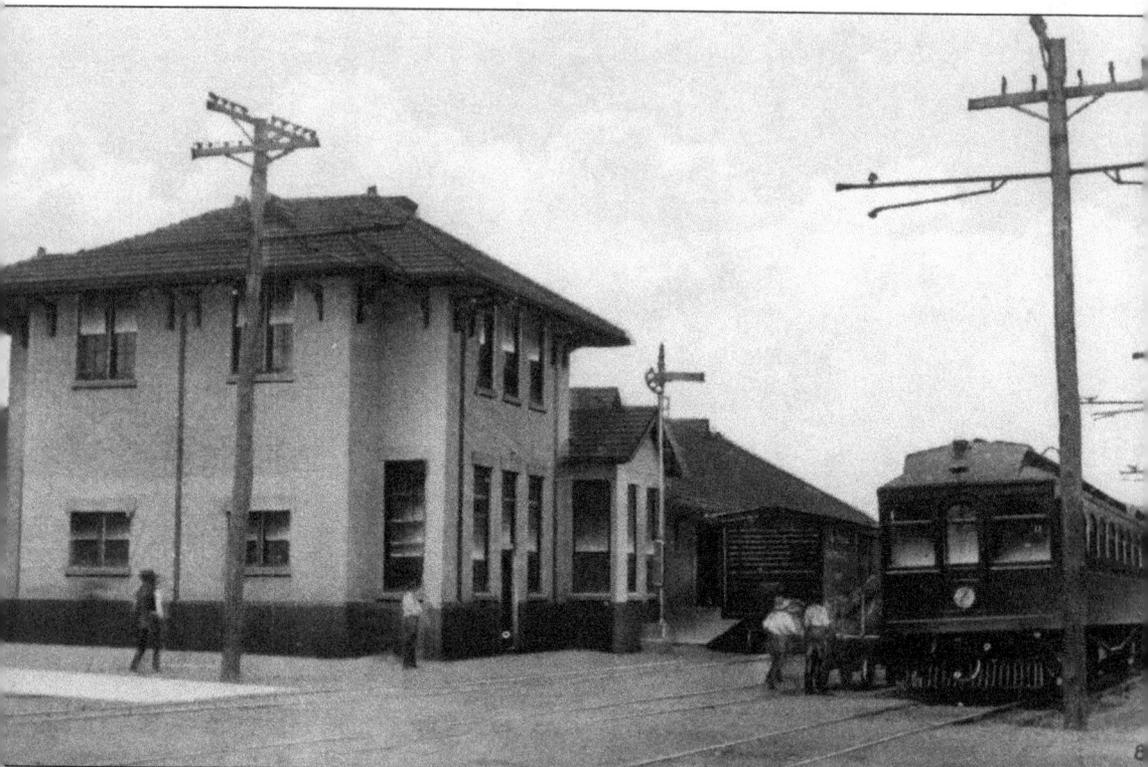

In 1914 the Piedmont & Northern Railroad (the P & N, or affectionately known as the "Poor & Needy") built this depot and laid tracks through Greer to serve the area with an electric-powered interurban railroad. (Courtesy of First Baptist Church, Greer, SC.)

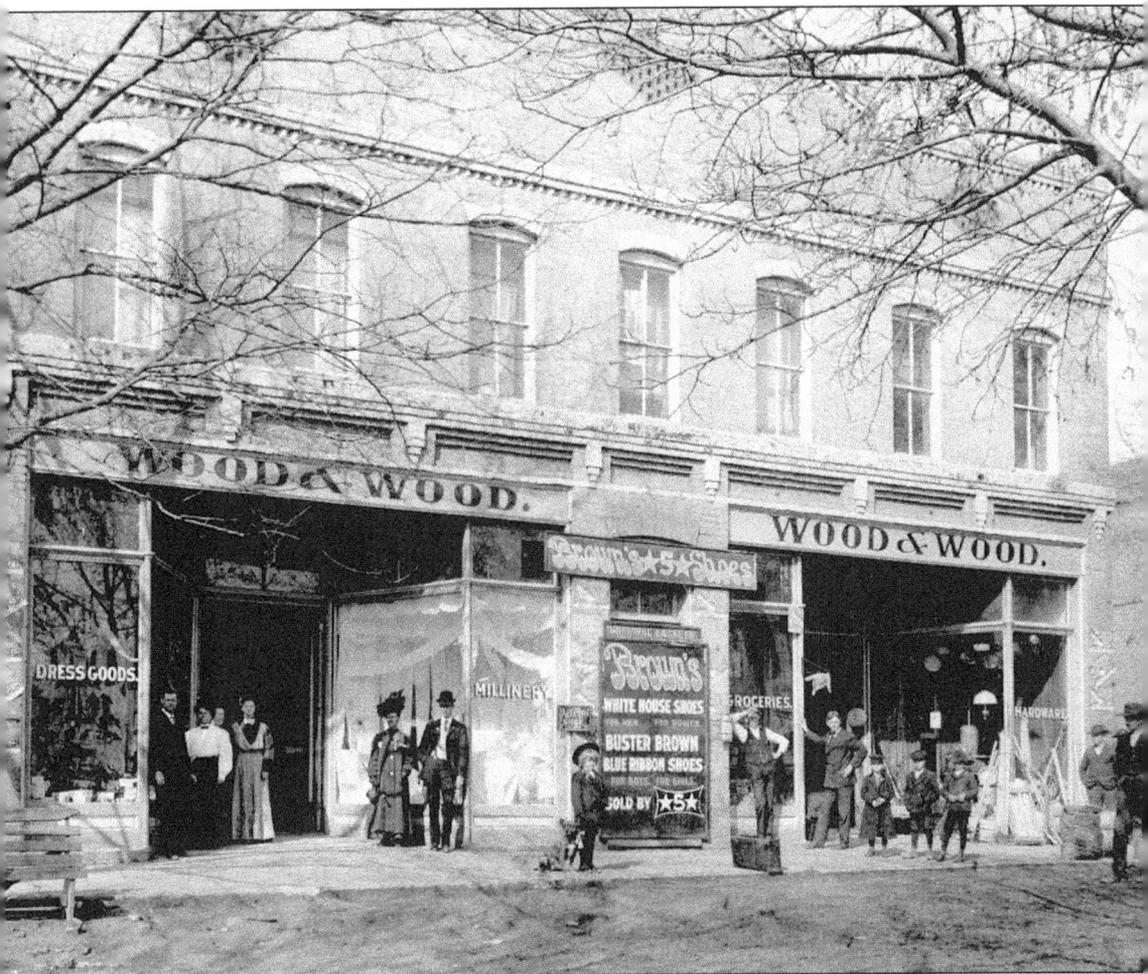

Cousins John D. Wood and J.T. Wood opened this mercantile store facing Randall Street (in the vicinity of where Citizens Building and Loan now sits), sold caskets, and conducted funerals. J.T. took the mercantile and John took the funeral business. Note in the center of this photo either an actor or mannequin depicting Buster Brown and his dog, Tige (they lived in a shoe). (Courtesy of Mrs. Lois Wood.)

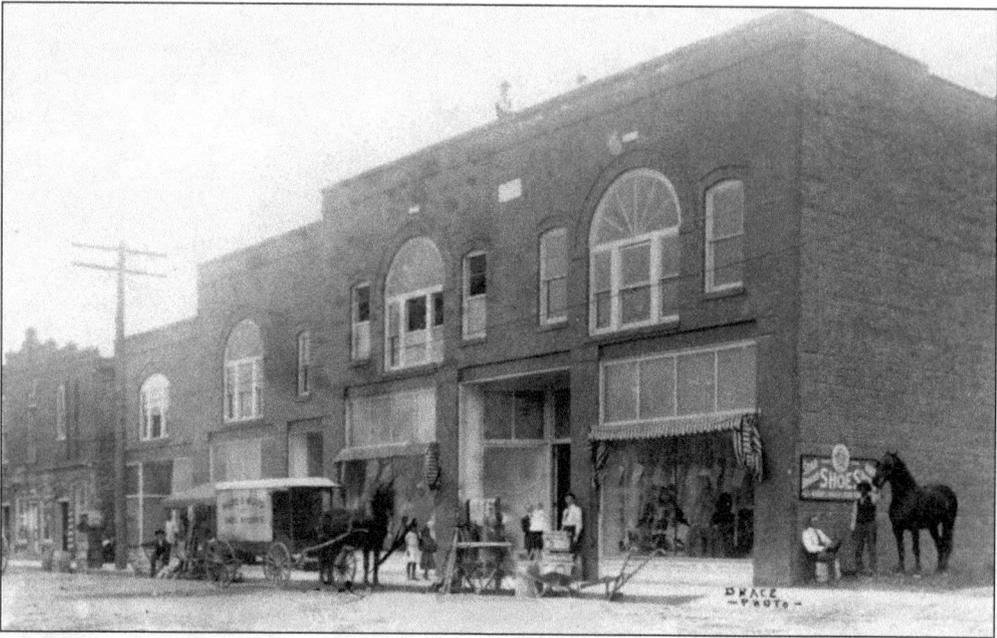

This Randall Street scene at the turn of the century shows buildings that no longer exist. The Citizen Building and Loan building now sits on this site. (Courtesy of South Caroliniana Library, University of South Carolina, Columbia.)

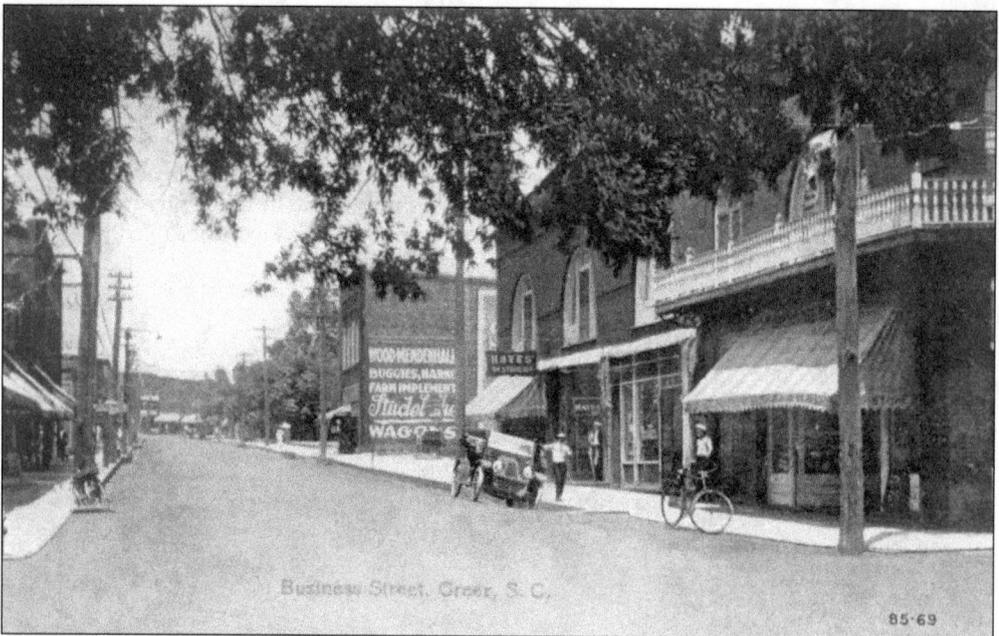

This view was taken looking up Trade Street from Randall toward Wood-Mendenhall Hardware. (Courtesy of the Greer Chamber of Commerce.)

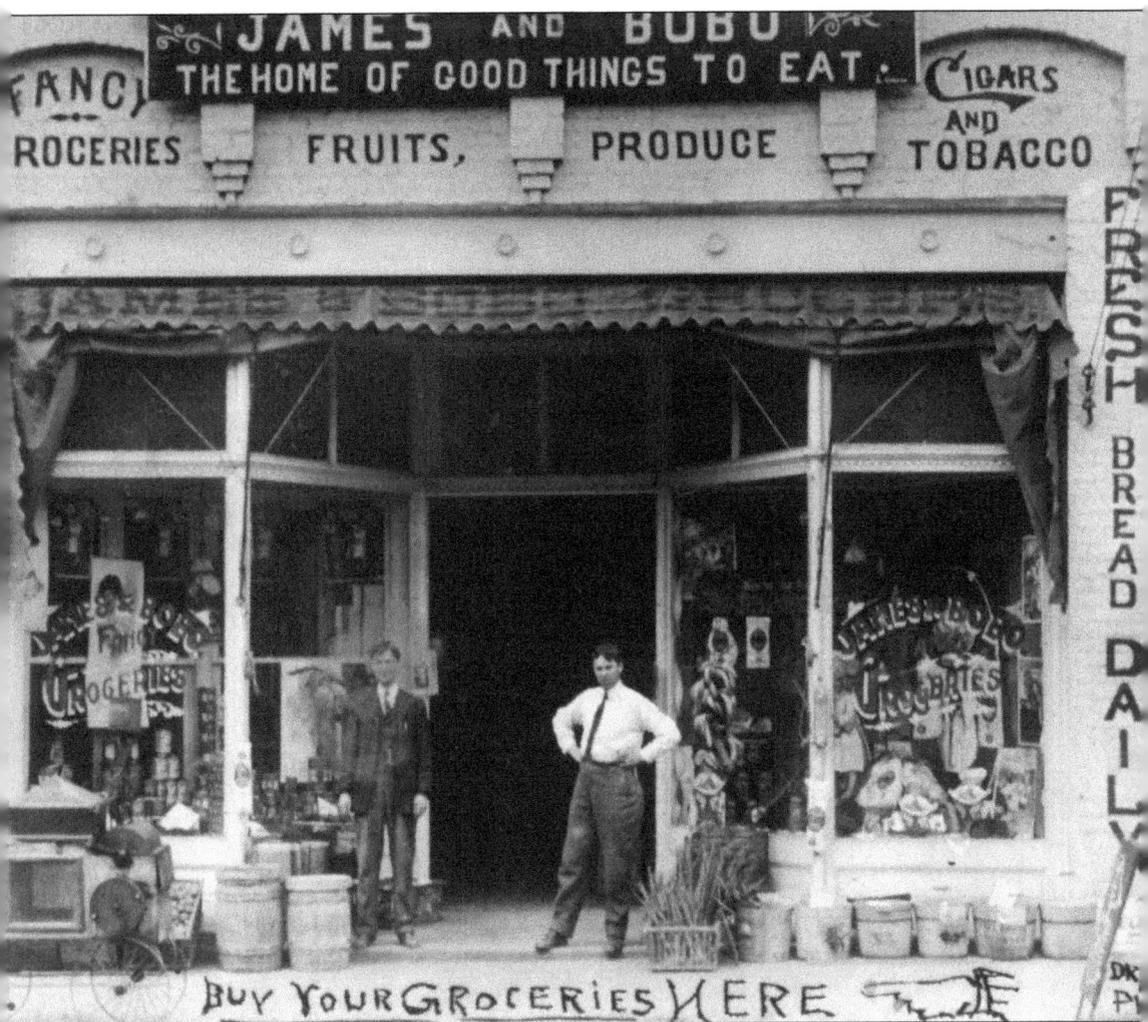

The James and Bobo Grocers, shown here *c.* 1912, was on the west side of Trade Street. In the left foreground is the peanut roaster. Pictured on the left is Walter Ennis James and on the right, his partner Bobo. (Courtesy of Jeff and Nelle Howell.)

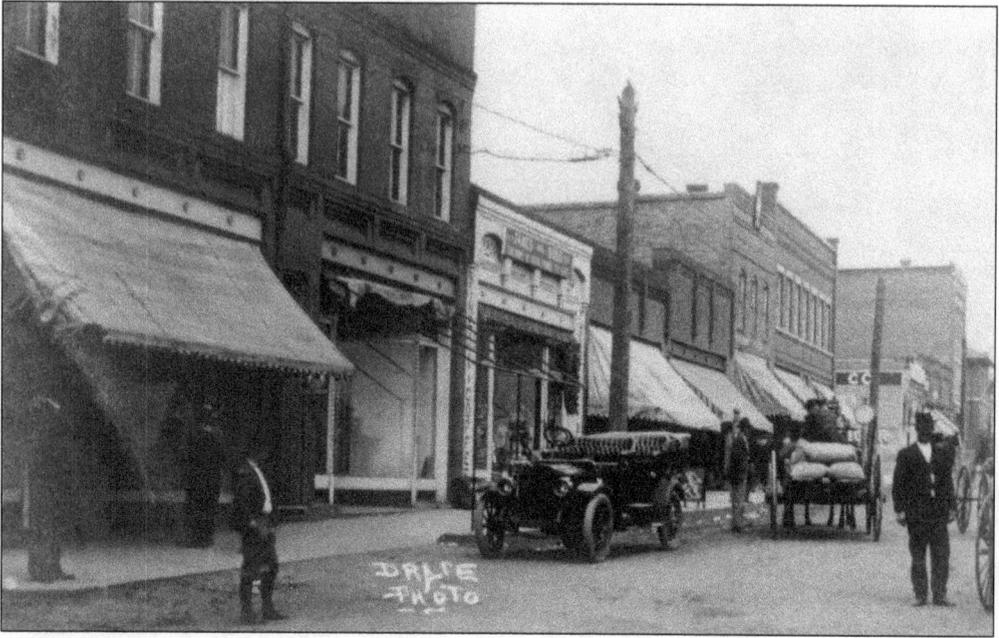

Another image shows the James and Bobo grocery store located on Trade Street. (Courtesy of Jeff and Nelle Howell.)

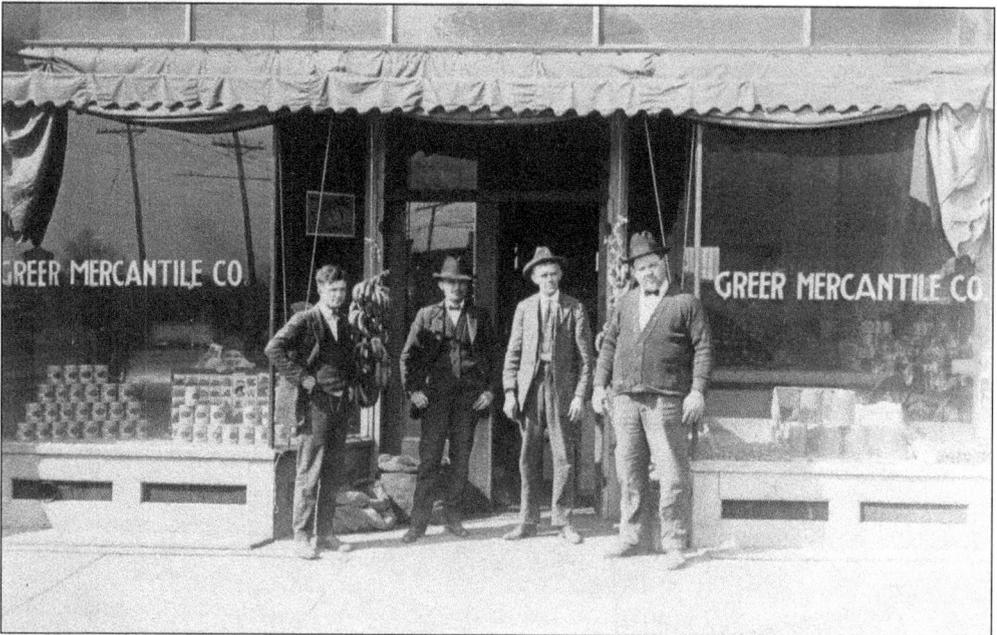

Greer Mercantile was located at 308 Trade Street, the present site of Price's Feed and Seed. Seen in this 1912 photo are Denny Tillotson (left) and Norm Collins (right). (Courtesy of George Tillotson.)

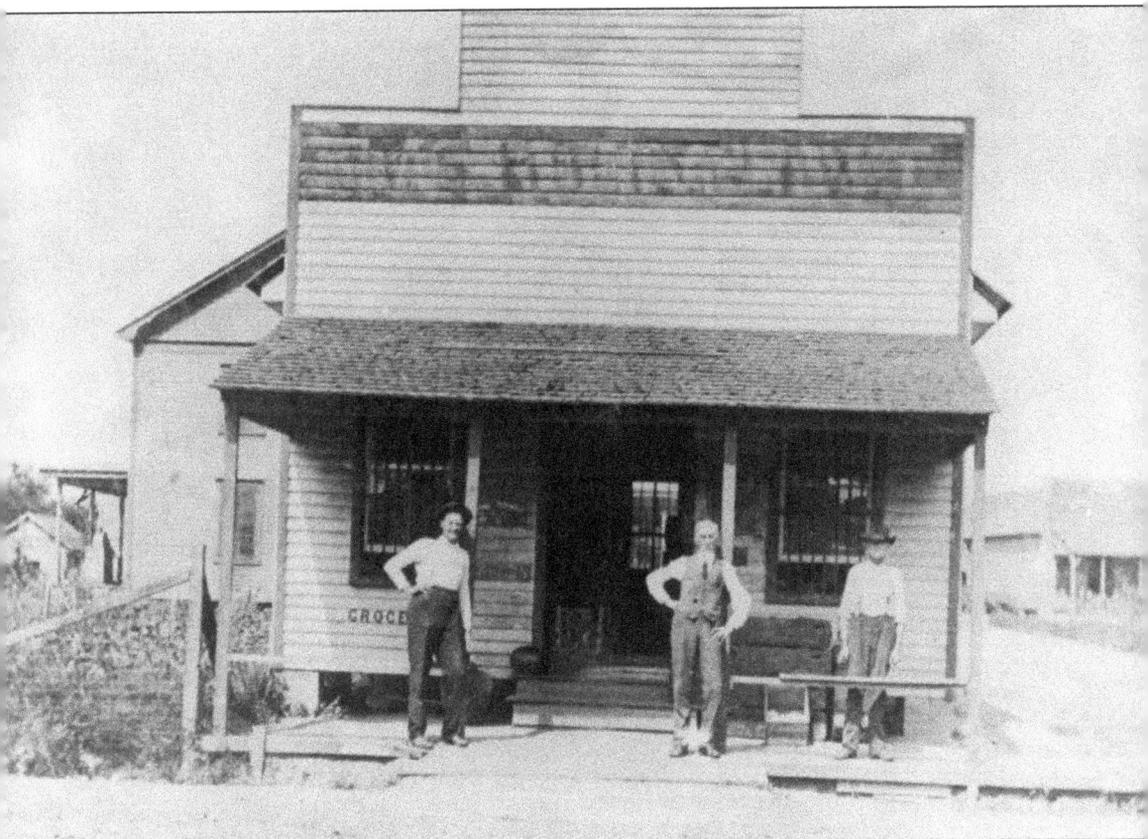

The store of George Andrew Flack (center) was located on Marchant Street and his house is to left in the picture. He loved to play checkers so much that customers would come in, shop, add up their own bills, and leave the money. George would hardly look up from the checker board. (Courtesy of Don Whitmire)

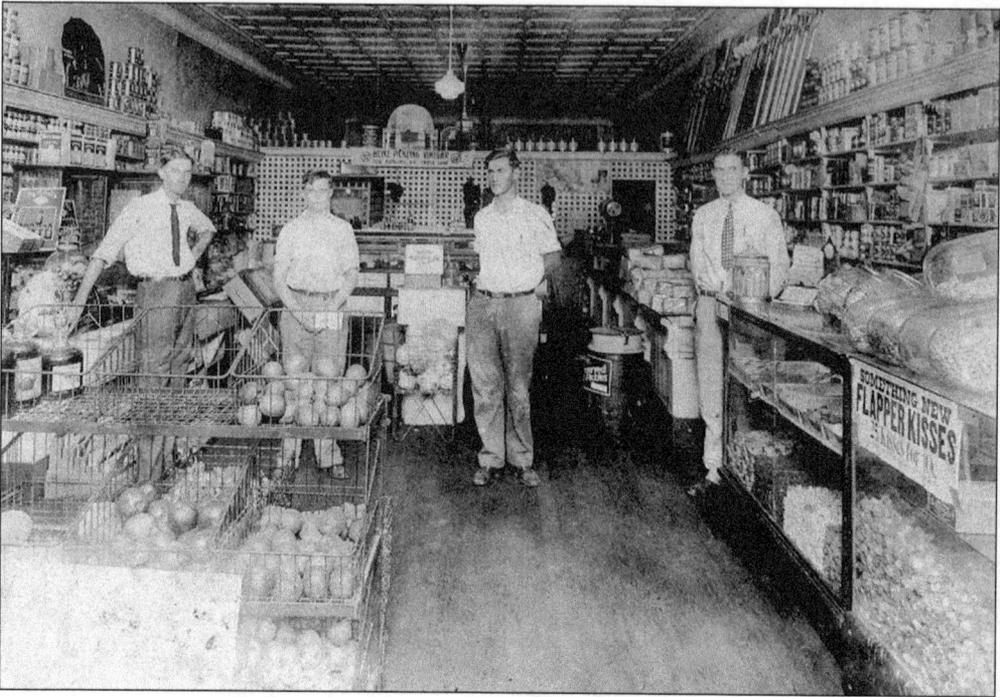

A damaged photo shows the Clement Bros. Grocery Store in 1926. Pictured, from left to right, are Terrill Smith, Gordon Smith, Calhoun Clement, and Jones Clement. (Courtesy of Norma Clement Bruce.)

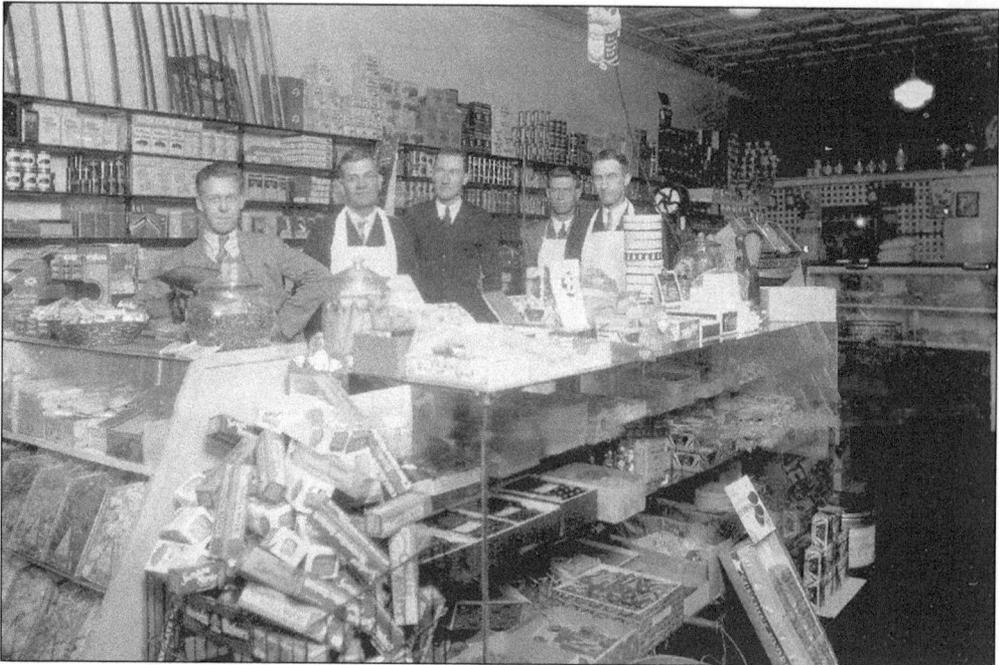

Pictured inside the Clement Bros. Grocery Store in 1930, from left to right, are Terrill Smith, Ed Boswell, R.J. Clement, M.E. Clement, and Jerrel Smith. (Courtesy of Norma Clement Bruce.)

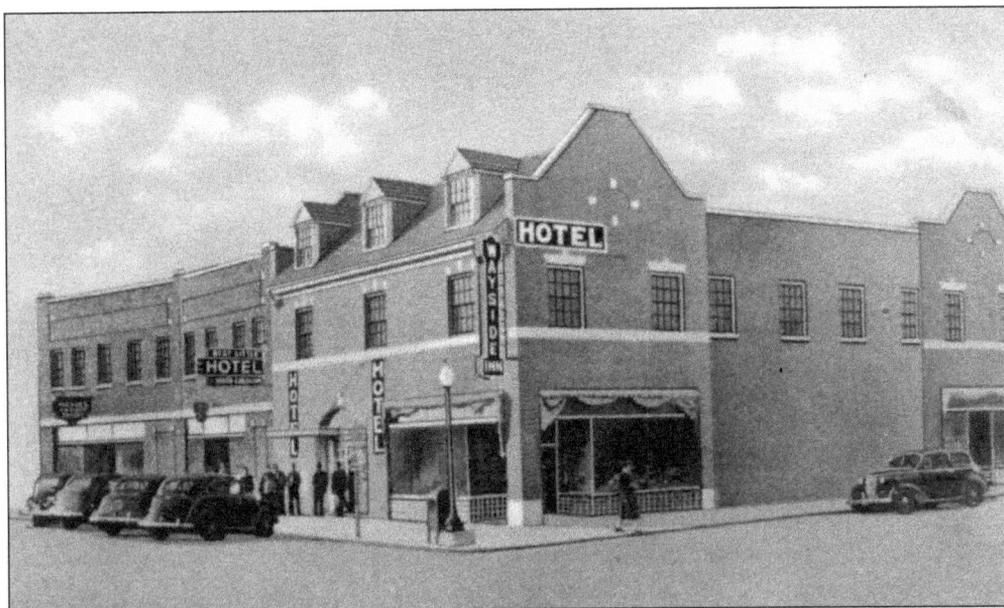

Wayside Inn, located on the corner of North Main and West Poinsett Streets where BB&T Bank now sits, advertised itself as "The Best Little Hotel in South Carolina" during its 1930s and 1940s heyday. (Courtesy of Thomas McAbee.)

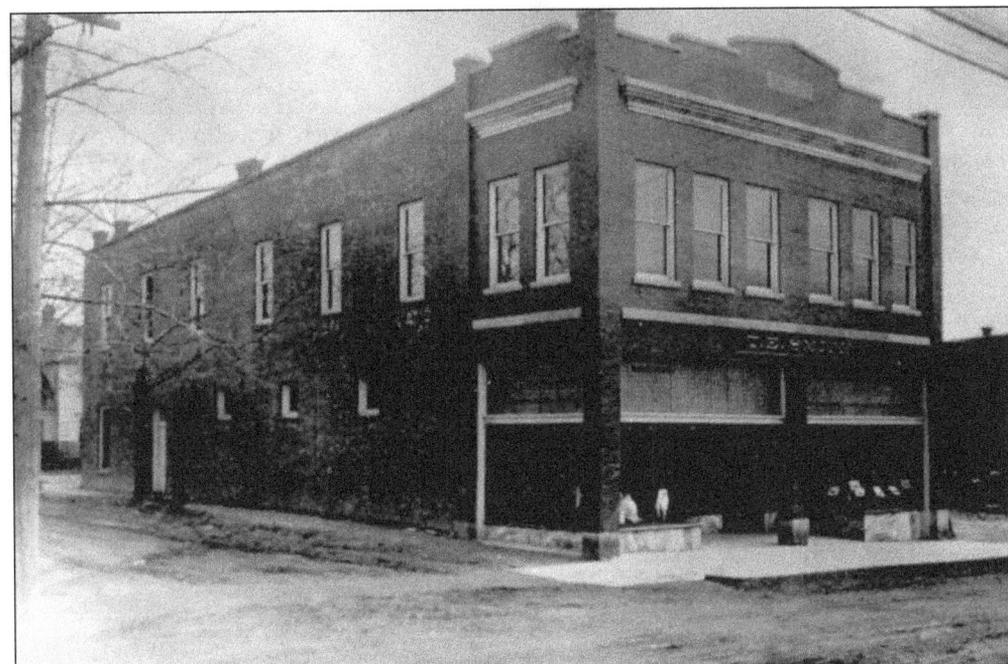

The T.E. Smith Building, known to many Greer citizens as the Leader Building, now houses Stewart's Furniture Outlet on the corner of Trade and Victoria Streets. (Courtesy of Norma Clement Bruce.)

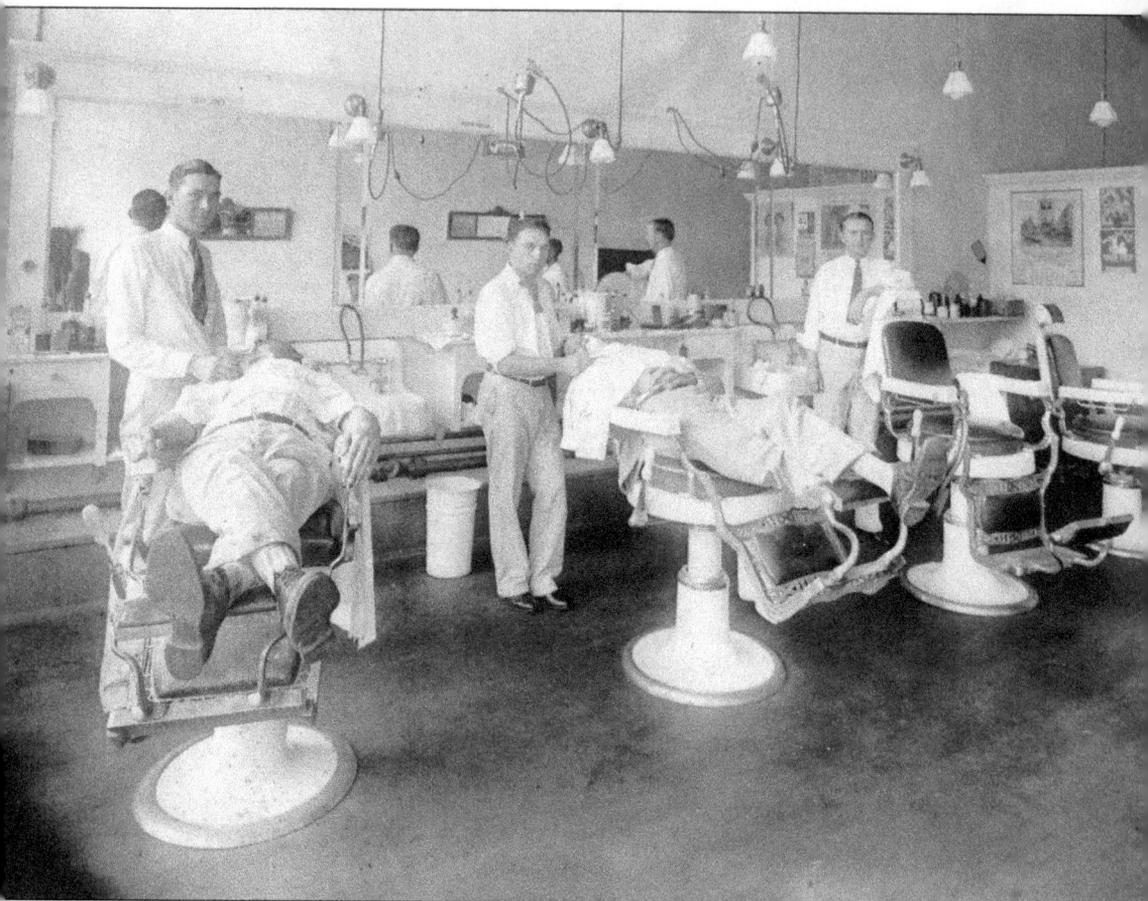

This photo from the Palace Barber Shop included Marvin "Preach" Vaughn (middle barber). The young man at far right is J. Van. (Courtesy of Margarett Turner.)

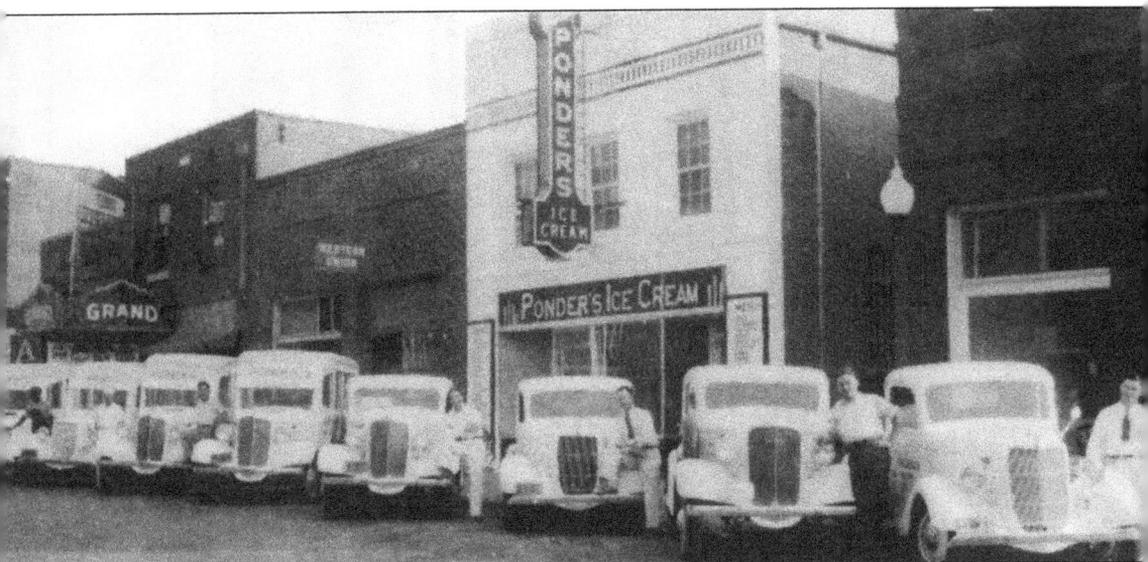

C.M. Ponder organized Ponder's Ice Cream Company in 1905. It was a very popular spot, especially after a movie at the Grand Theatre up the street. This picture was taken prior to 1937. (Courtesy of Thomas McAbee.)

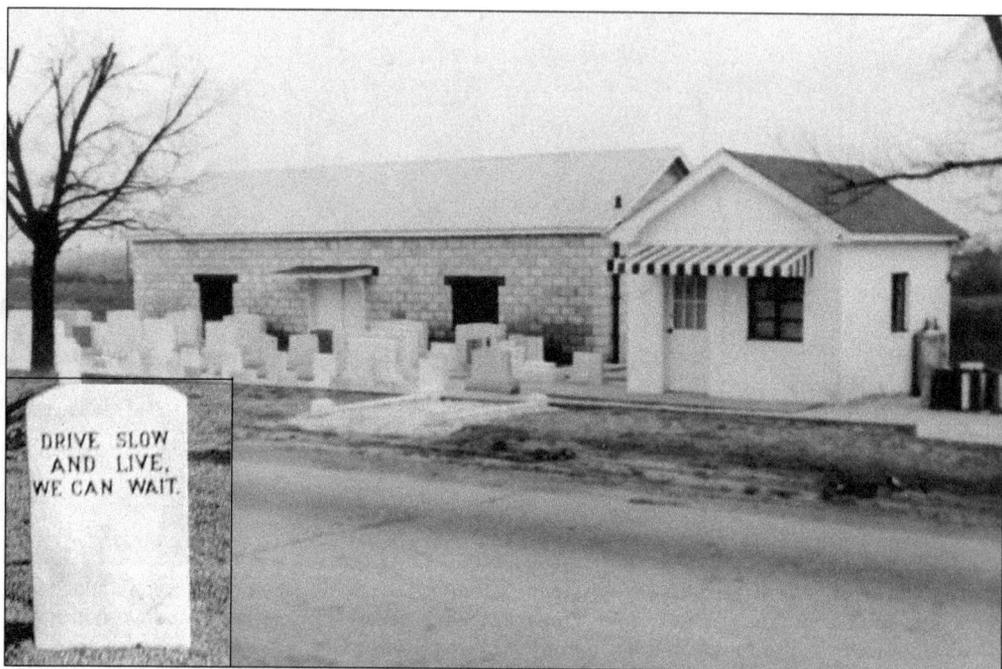

DeYoung Marble and Granite Works was located on West Poinsett Street where First Federal Bank now stands. The firm's sign was more famous than the company. Pictured here it reads, "Drive Slow and Live, We Can Wait." (Courtesy of Marla Rhem.)

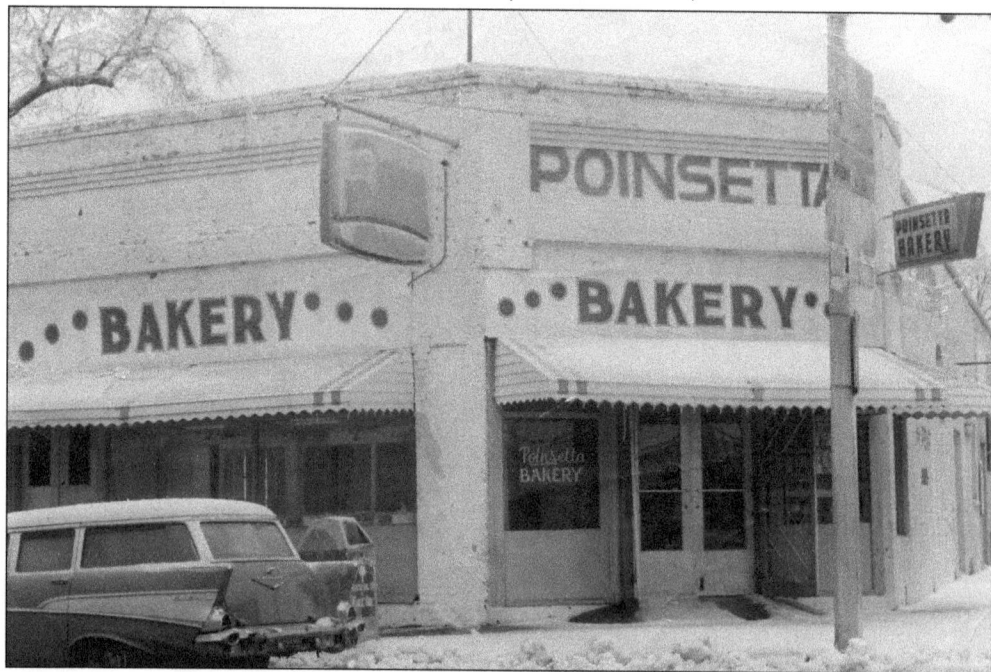

The first home of Poinsetta Bakery was located on the corner of West Poinsett and Main Streets where the parking lot of the current police station sits. From there, Poinsetta Bakery moved (c. 1960) to O'Neal Road and then to its current location at 1207 West Poinsett Street. (Courtesy of Jerry Atkinson.)

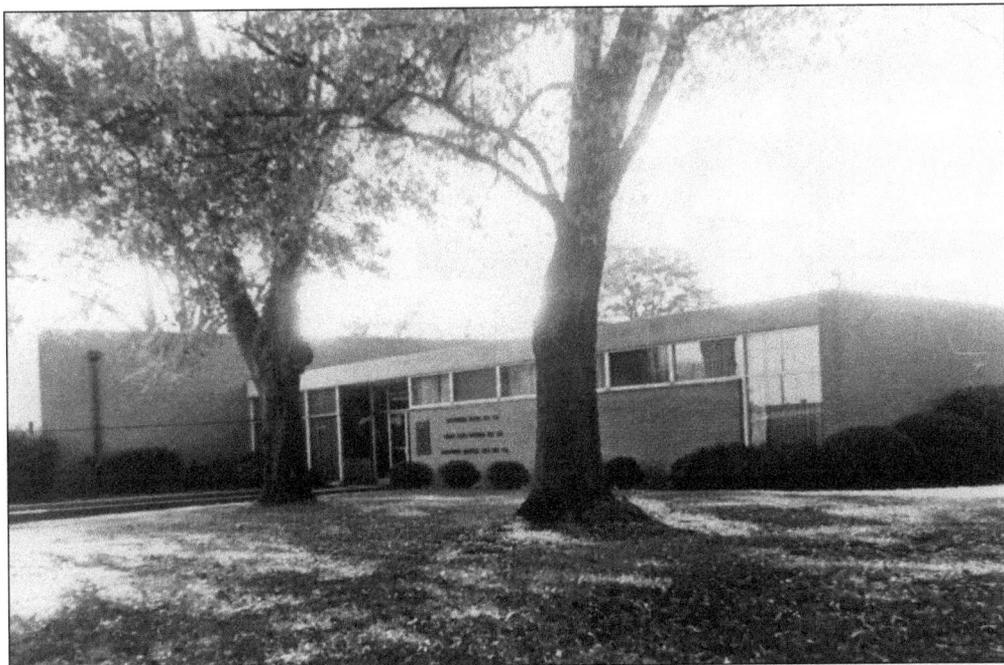

Southern Home Insurance, shown in 1950, was first called Dixie Fire and Casualty and was founded by John Ratterree. It was later purchased by State Auto. (Courtesy of State Auto Insurance Companies.)

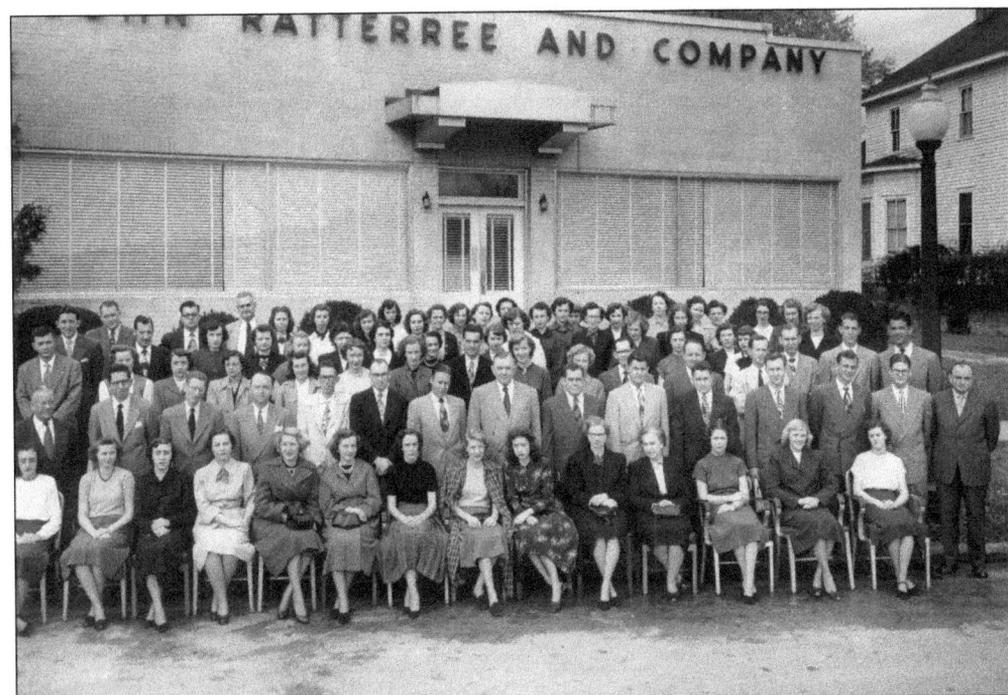

Pictured are employees of John Ratterree and Company, which became State Auto Insurance Companies. (Courtesy of State Auto Insurance Companies.)

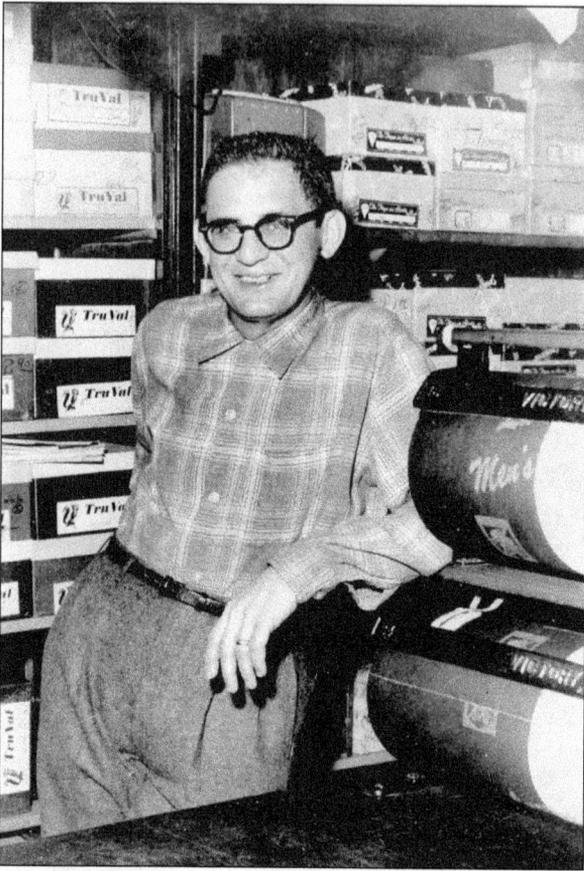

Ralph Lurey is pictured in his men's shop at 214 Trade Street about 1952. (Courtesy of Marsha Strong.)

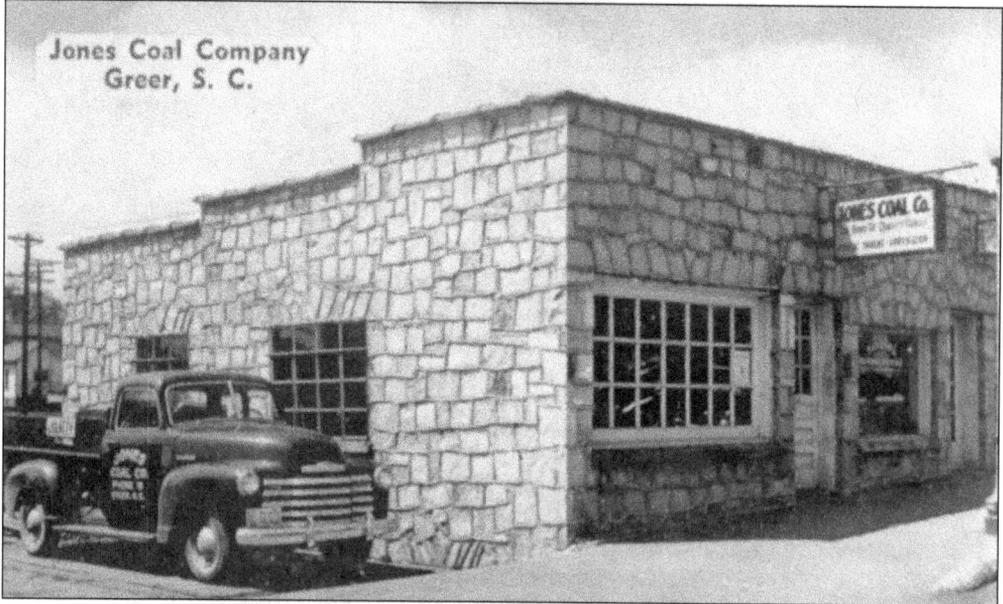

Jones Coal Company was located on Trade Street, just over the railroad tracks. (Courtesy of Thomas McAbee.)

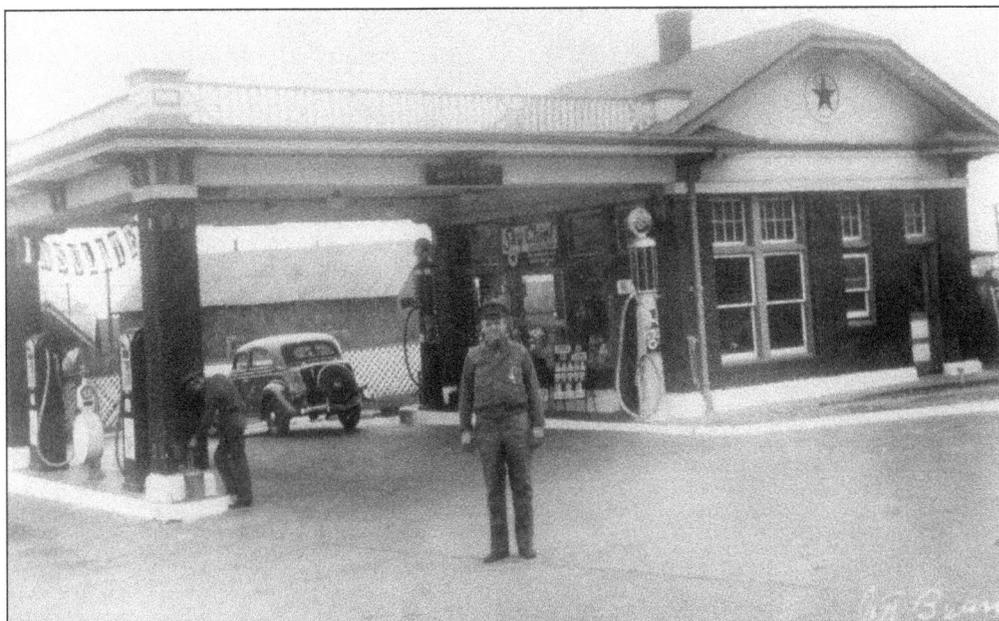

Howell's Sky Chief Service Station was located at 200 East Poinsett Street. Much altered, it is now used as a beauty shop. (Courtesy of Jerry Atkinson.)

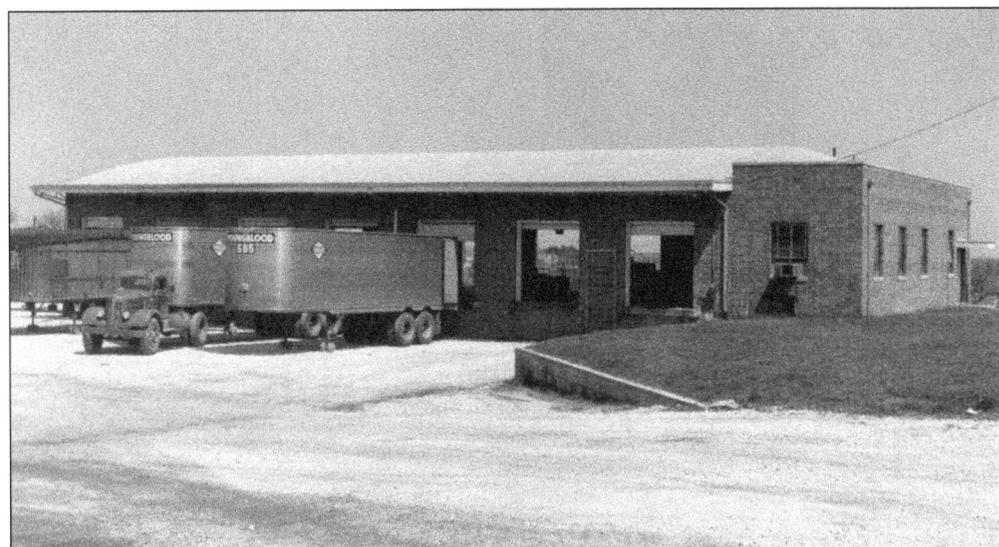

Youngblood Trucking Company, located at 507 East Fairview Avenue, was indicative of the healthy business atmosphere in Greer. (Courtesy of Harold James.)

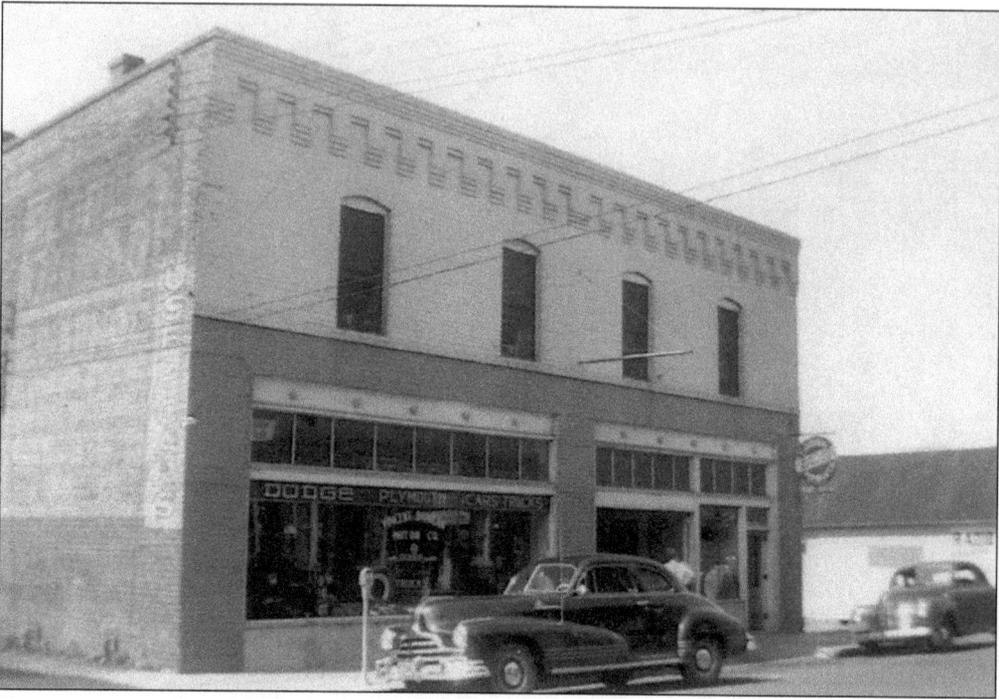

For many years this was the home of the Vincent Duncan Motor Company at 214 Randall Street, and the building still stands. It was originally built in 1909 as a livery for new buggies, horses, and mules. This picture was taken in 1947. (Courtesy of David Duncan.)

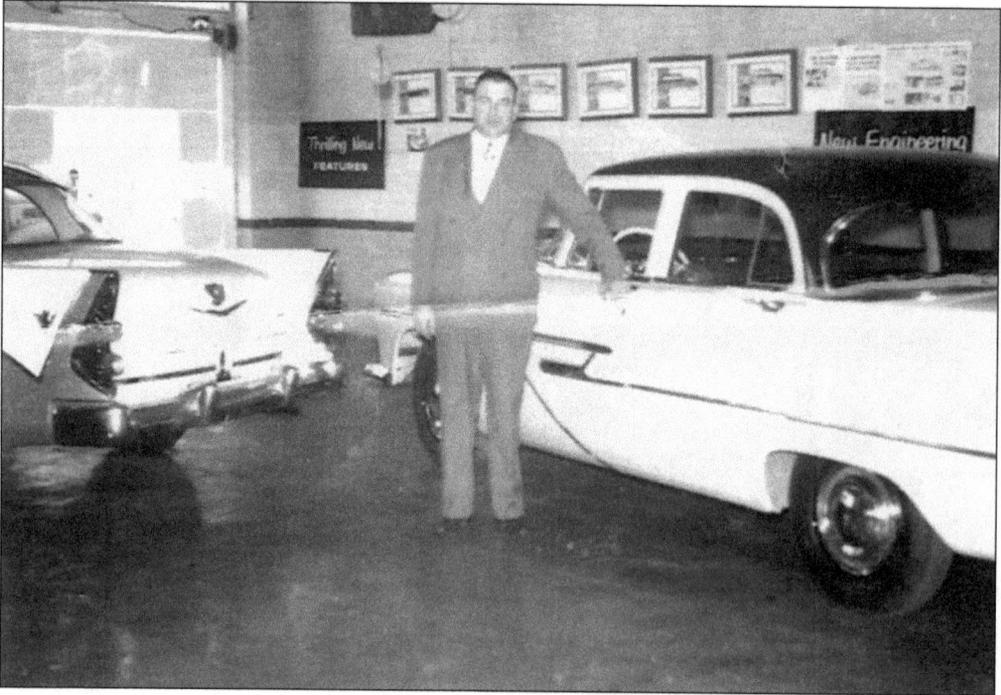

Owner Vincent Duncan is pictured inside his Chrysler dealership in 1955. (Courtesy of David Duncan)

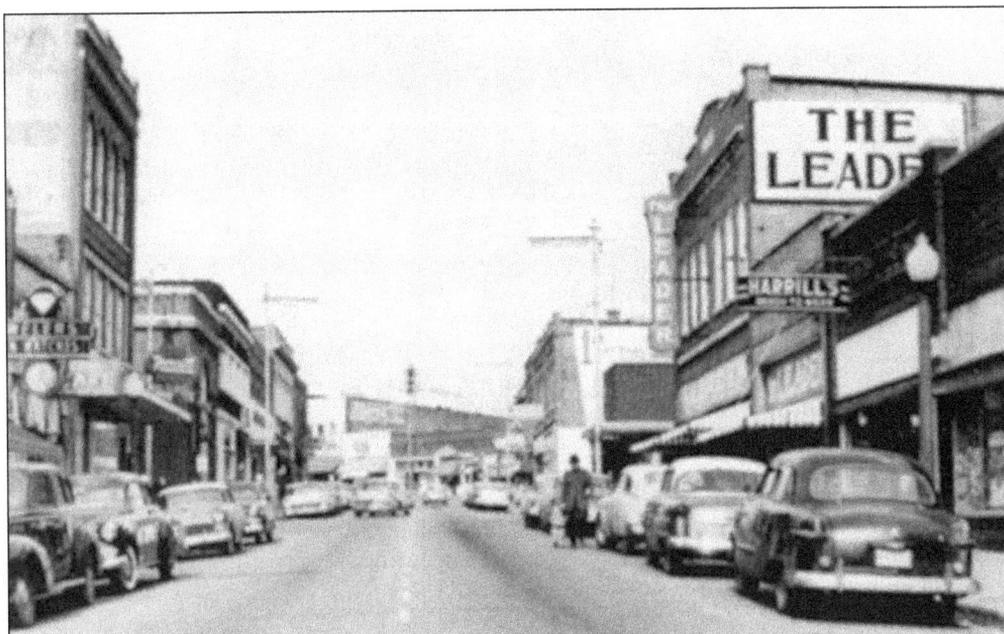

Trade Street is pictured looking toward East Poinsett Street in the early 1950s. The Leader is a dry goods store on the right. (Courtesy of Jean M. Smith Library.)

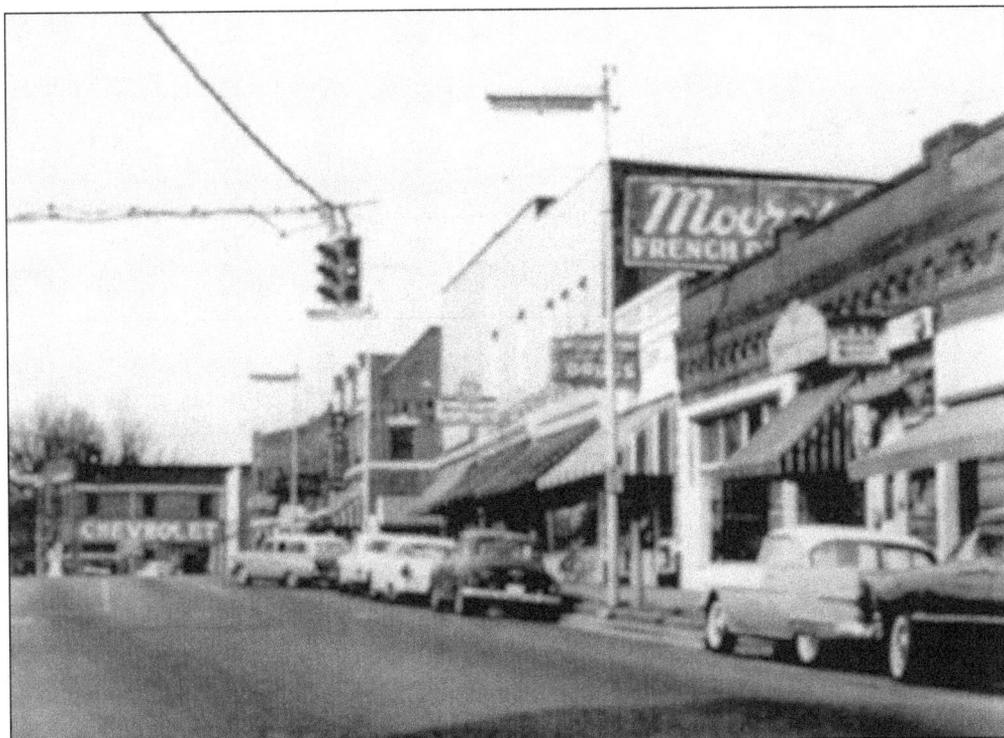

Looking up East Poinsett Street toward Main Street in the 1950s, note C&D Chevrolet across Main Street where Wayside Inn was located. Another landmark, the Dixie Shoe Shop still repairs shoes. (Courtesy of Jean M. Smith Library.)

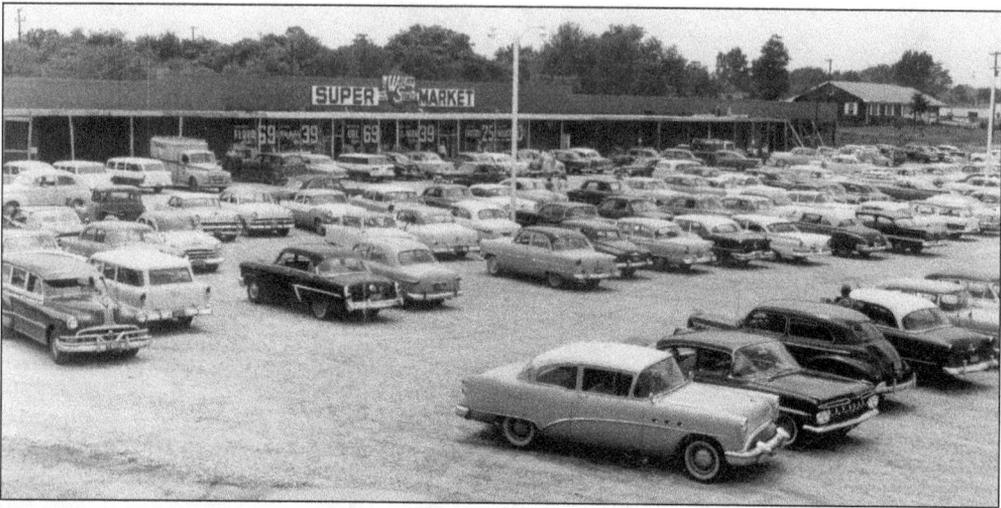

The A&G (Apalache & Greer) Shopping Center at the corner of Highway 29 and Highway 357 was Greer's first, opening in 1959. Note the store window sign displaying that one half-gallon of milk was 39¢. (Courtesy of Walter Rogers.)

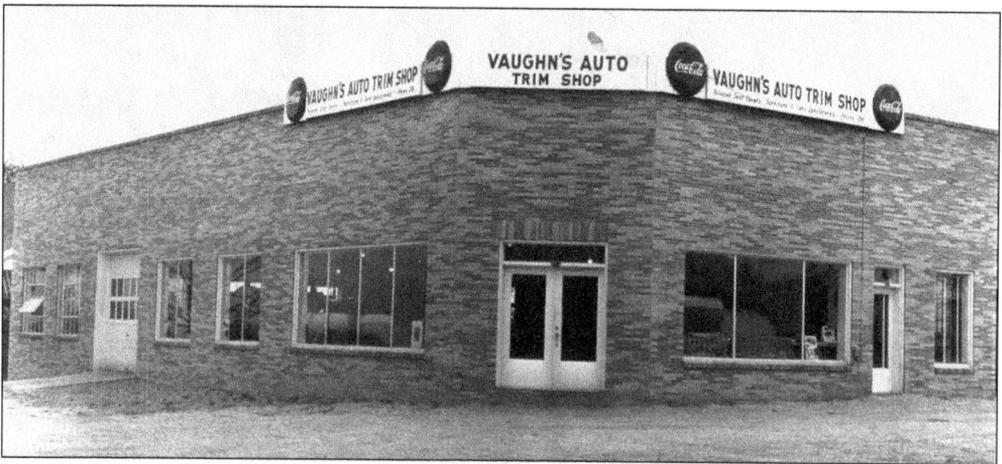

Vaughn's Auto Trim Shop on North Main and US 29, across from the old Greer High School, belonged to Woodrow and Ruby Vaughn.

Two

SERVING GREER

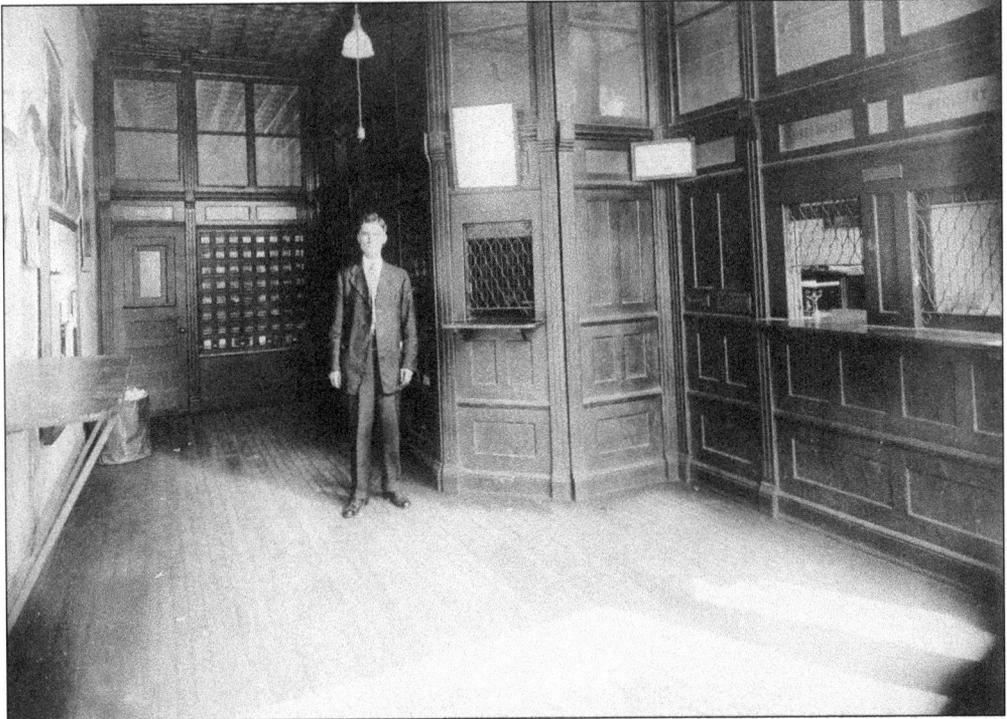

The post office at Greers (the original name) was relocated to the building at 308 Trade (now Price's Feed Store). Walter Ennis James, postmaster, poses in this 1912 picture. (Courtesy of Jeff and Nelle Howell.)

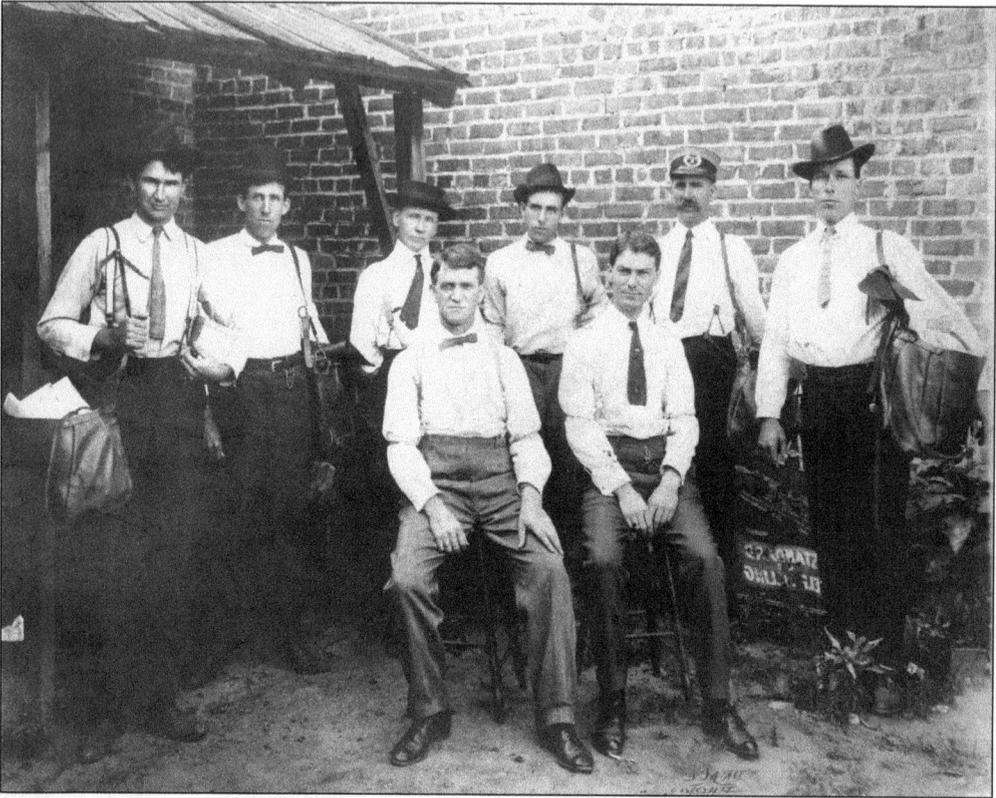

Postal carriers in 1910 included, from left to right, (seated) W.E. James, assistant postmaster, and J.M. Mayfield, postmaster; (standing) Sam Hutchins, J.C. Holland, Claude Berry, Ben Garren, Carlisle Berry, and A.H. Brockman. (Courtesy of Jeff and Nelle Howell.)

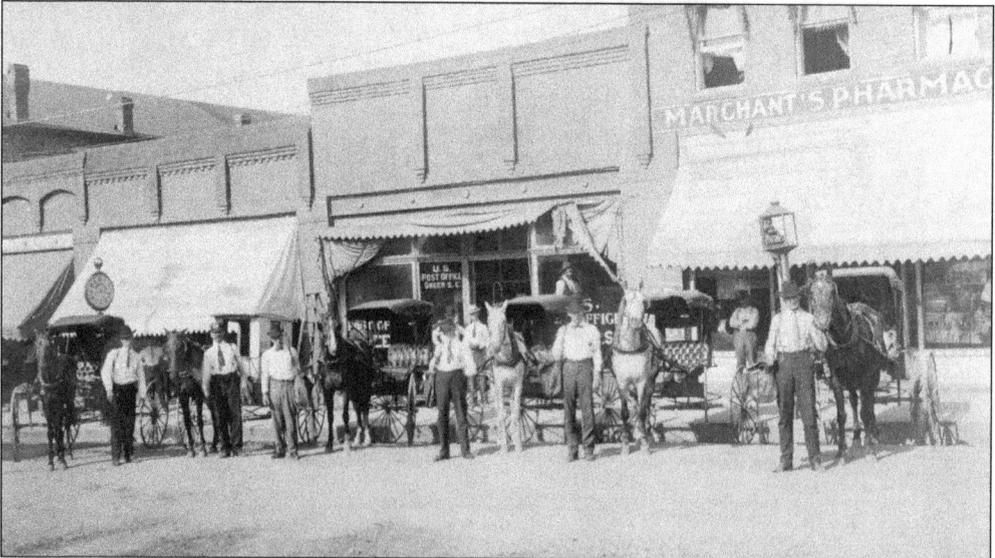

The postal carriers in front of the post office in its 1906 Trade Street location are, from left to right, Sam Hutchins, J.C. Holland, Claude Berry, Ben Garren, Carlisle Berry, A.H. Brockman, W.E. James, and J.M. Mayfield. (Courtesy of Jeff and Nelle Howell.)

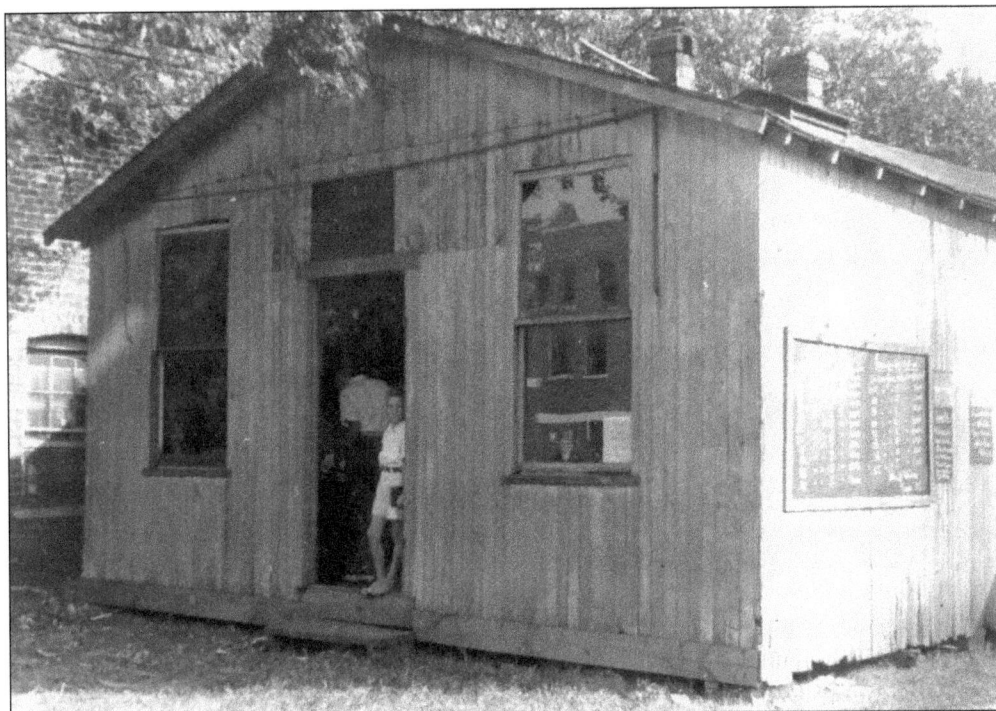

The first library in Greer was established by the Civitan Club and Mrs. E. R. Minus in 1925 in this building facing West Poinsett, then known as Emma Street (near the present fire department). The first Chamber of Commerce had used the building but after disbanding, left its furniture for library use. (Courtesy of Jean M. Smith Library.)

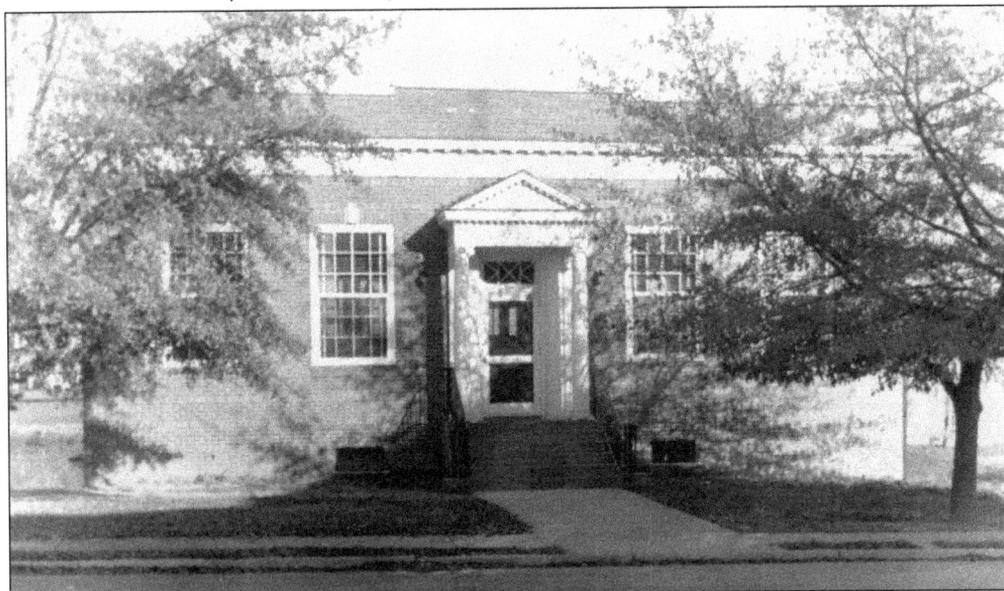

The Davenport Memorial Library, built on School Street for $10,000 with Works Progress Administration labor and the generous donations of the Davenport family and the citizens of Greer, opened on September 23, 1938. This first library branch in Greenville County was designed by architect Eugene Beacham. (Courtesy of Jean M. Smith Library.)

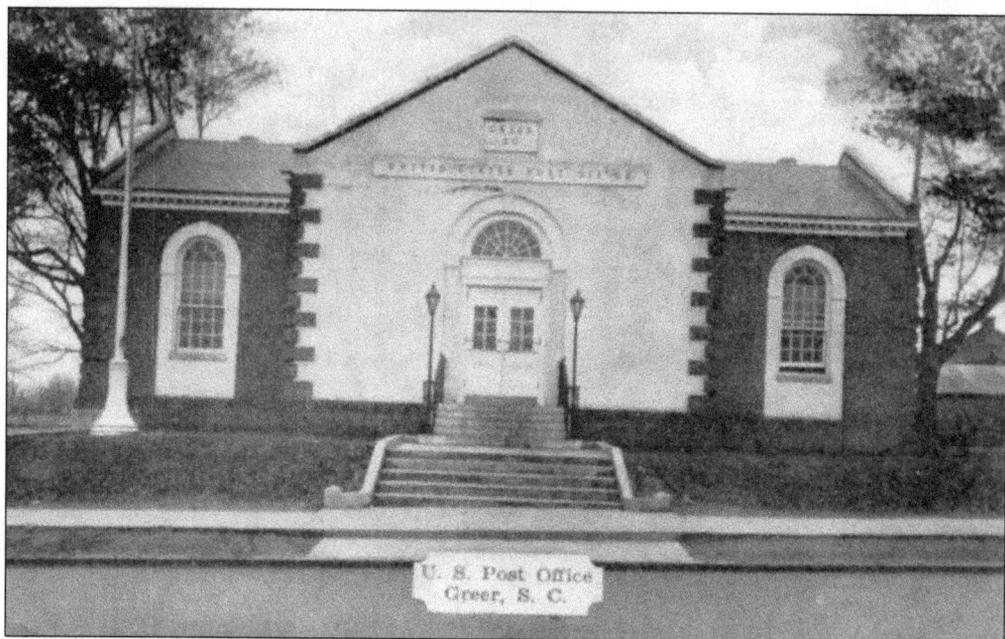

Built in 1935, this building served as a post office until 1964 and is now home to Greer City Hall. (Courtesy of Thomas McAbee.)

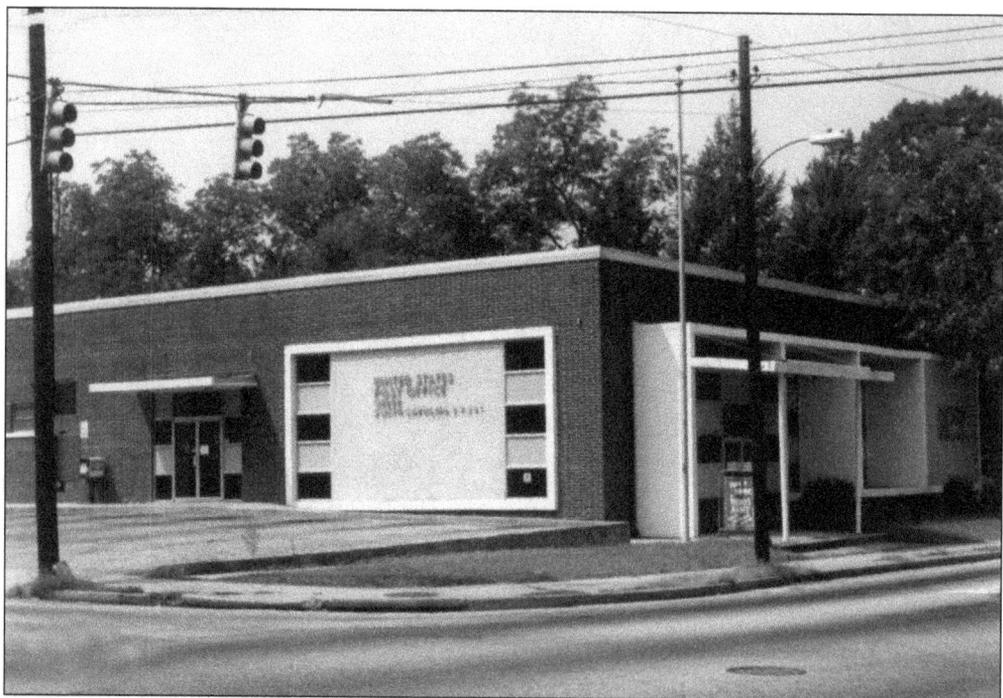

The Greer Post Office on North Main served the city from 1964 to 1988. (Courtesy of Jean M. Smith Library.)

Pictured is the cover of the program used at the 1952 dedication of the Allen Bennett Hospital. (Courtesy of Jean M. Smith Library.)

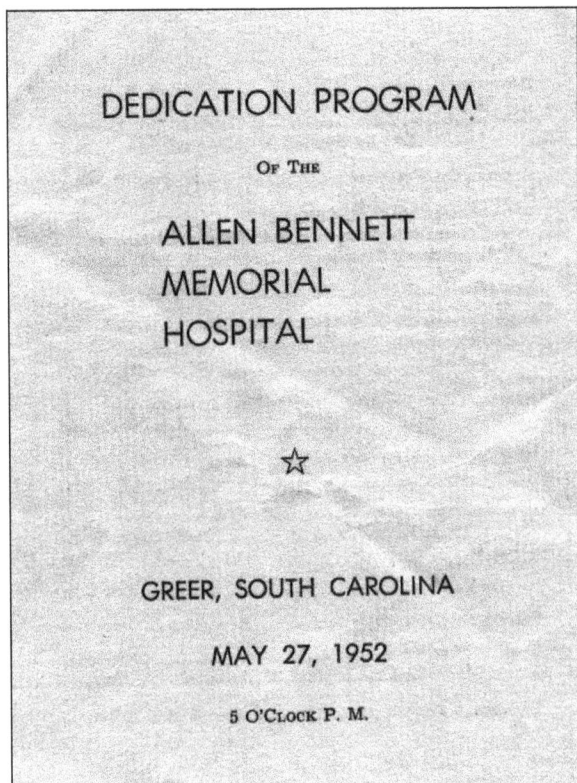

DEDICATION PROGRAM

OF THE

ALLEN BENNETT
MEMORIAL
HOSPITAL

☆

GREER, SOUTH CAROLINA

MAY 27, 1952

5 O'CLOCK P. M.

INVOCATION ... Rev. M. B. Patrick

SONG ... "Faith of Our Fathers"
 Led by Edward W. Shingler

ADDRESS OF WELCOME Mayor W. Paul Brannon

INTRODUCTION OF P. C. GREGORY, JR., *Chairman*
 of Greenville County Hospital Board of Trustees,
 As Master of Ceremonies Mayor W. Paul Brannon

REMARKS ... P. C. Gregory, Jr.

INTRODUCTION OF J. S. McCLIMON, *Local Member*
 of Greenville County Hospital Board of
 Trustees ... P. C. Gregory, Jr.

REMARKS AND INTRODUCTION OF FRED L. CROW,
 Former Mayor ... J. S. McClimon

HISTORY OF ALLEN BENNETT MEMORIAL
 HOSPITAL ... Fred L. Crow

INTRODUCTION OF
 DR. W. L. ESTES, JR. P. C. Gregory, Jr.

DEDICATION AND UNVEILING
 OF PLAQUE ... Dr. W. L. Estes, Jr.

PRAYER OF DEDICATION Rev. John K. Johnston

SONG (First Verse) ... "America"
 Led by Edward W. Shingler

DISMISSAL PRAYER Rev. J. Roy Robinson

Pictured is the inside of the program used at the 1952 dedication of the Allen Bennett Hospital.

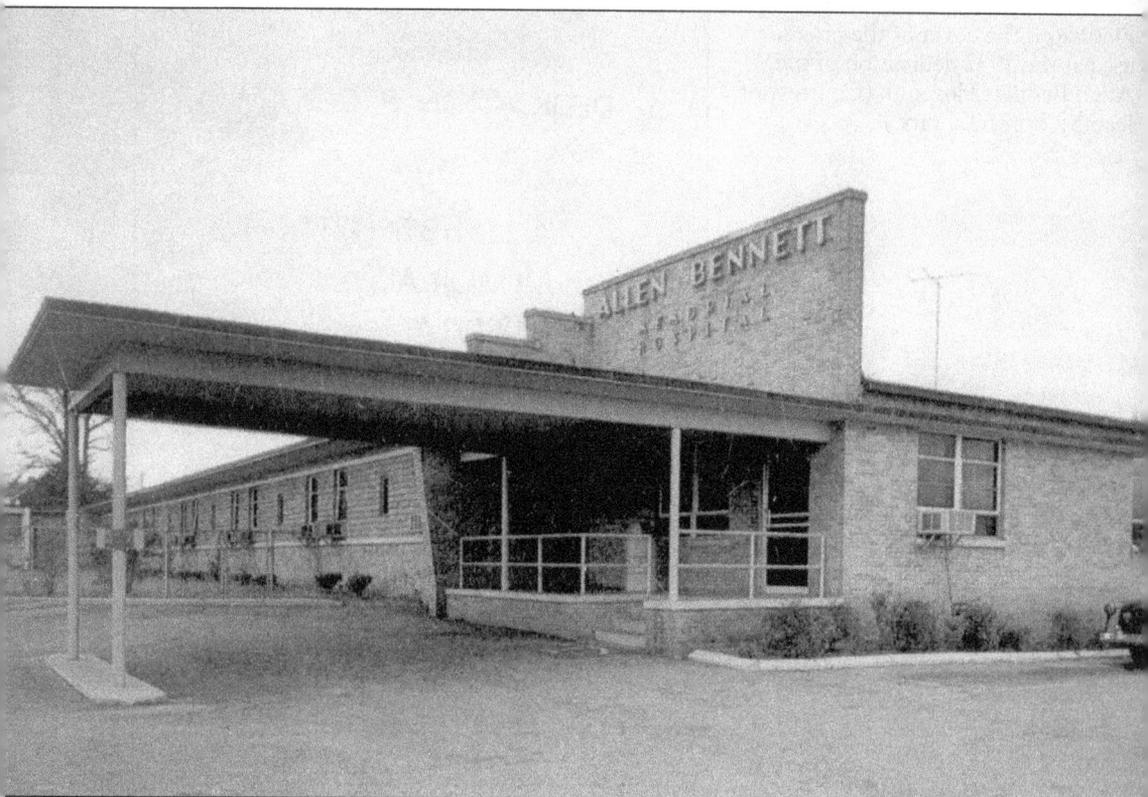

Allen Bennett Memorial Hospital was dedicated on May 27, 1952. It was named for Dr. Belton Allen Bennett Jr. who died in World War II in 1944. (Courtesy of Jean M. Smith Library.)

Three

AT HOME IN GREER

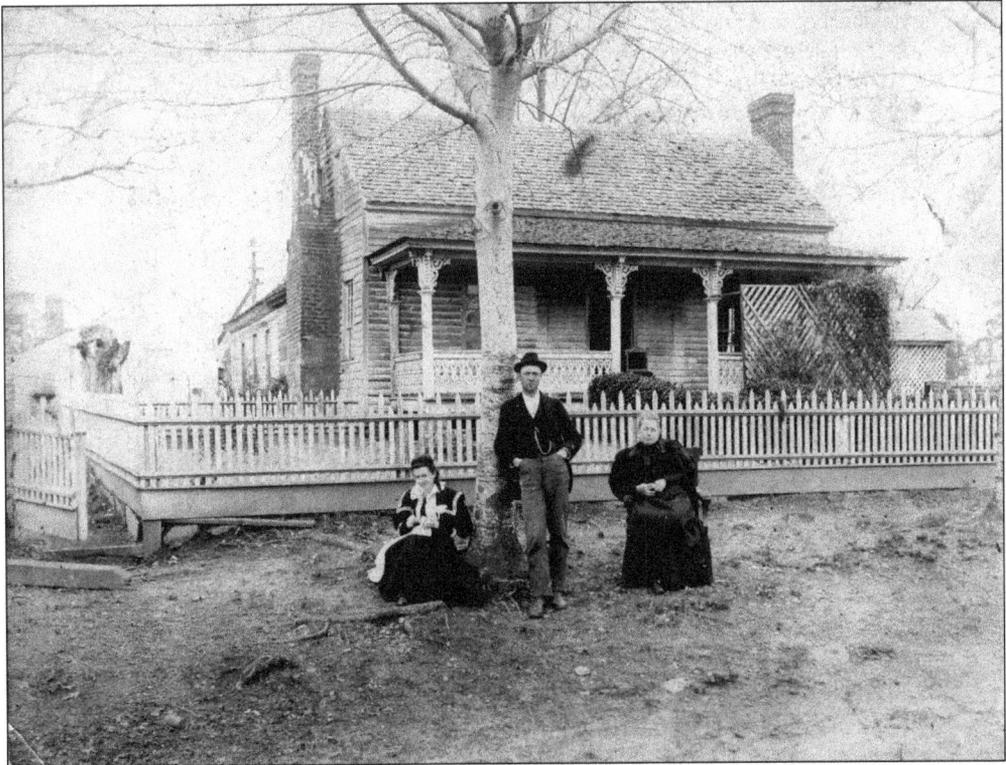

Westmoreland House on South Main Street is pictured just south of where State Auto Insurance now stands. This photo was taken is 1896. (Courtesy of Harold James.)

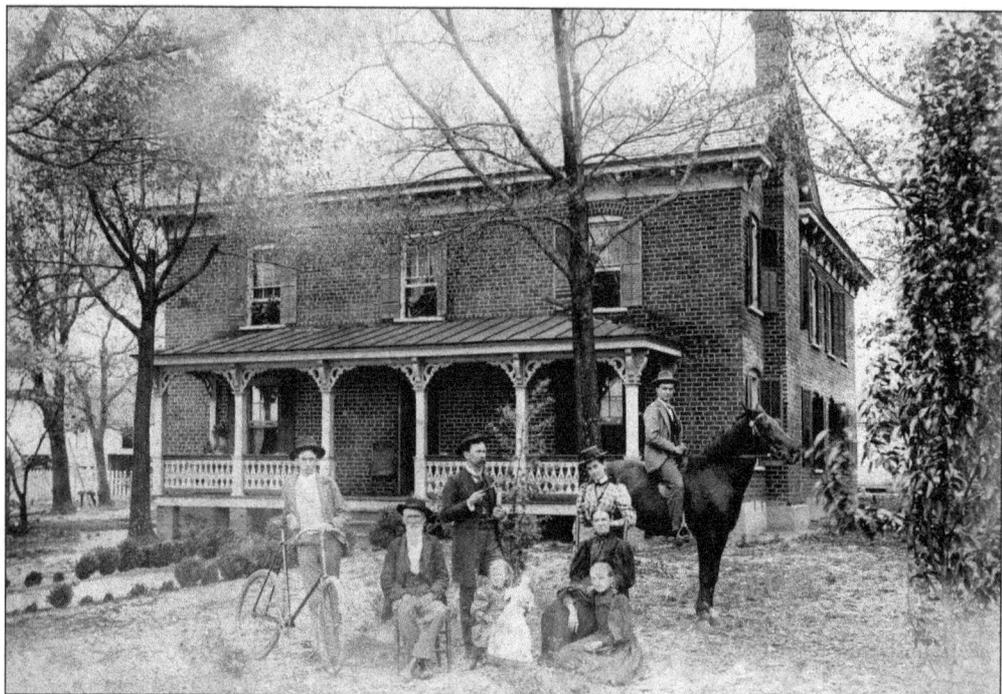

The home and family of Simeon Hughes are pictured at the turn of the century on South Main Street. The site became the old post office and current city hall. Seated in chairs are Simeon Hughes, a Confederate war veteran and his wife, Thurza Jane Hughes. Seated on the ground in front is May Hughes (Mrs. Ira Garrett) and on the horse is Robert Murray Hughes. Standing by the bicycle is Julius Hughes. (Courtesy of Dr. Theron Walker.)

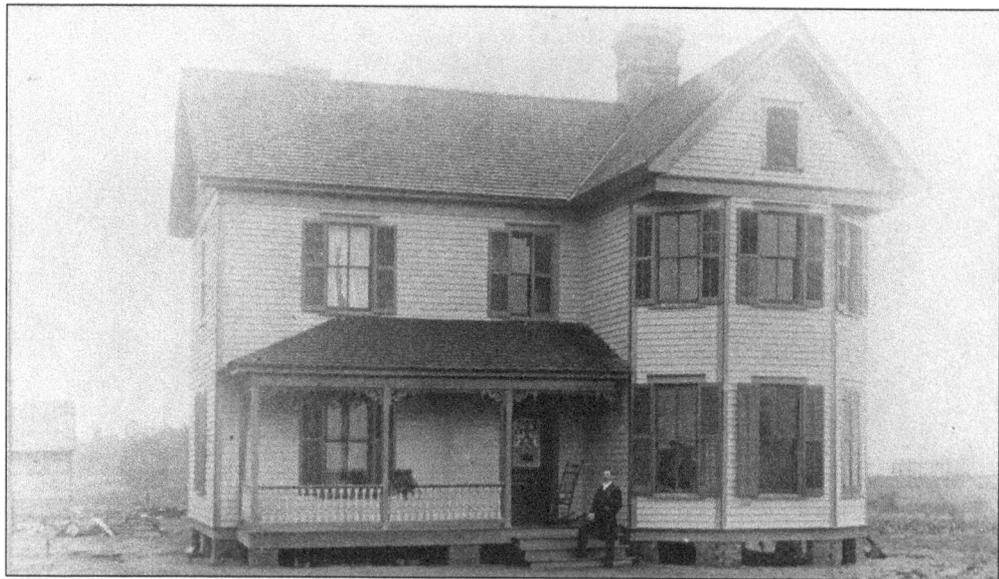

The first parsonage of the First Baptist Church of Greer was built in 1901 and was located at 307 West Poinsett Street. In this photograph, Rev. J.E. McManaway, who was pastor from 1896 to 1900, poses in the front yard of the house, which is no longer standing. (Courtesy of First Baptist Church, Greer, SC.)

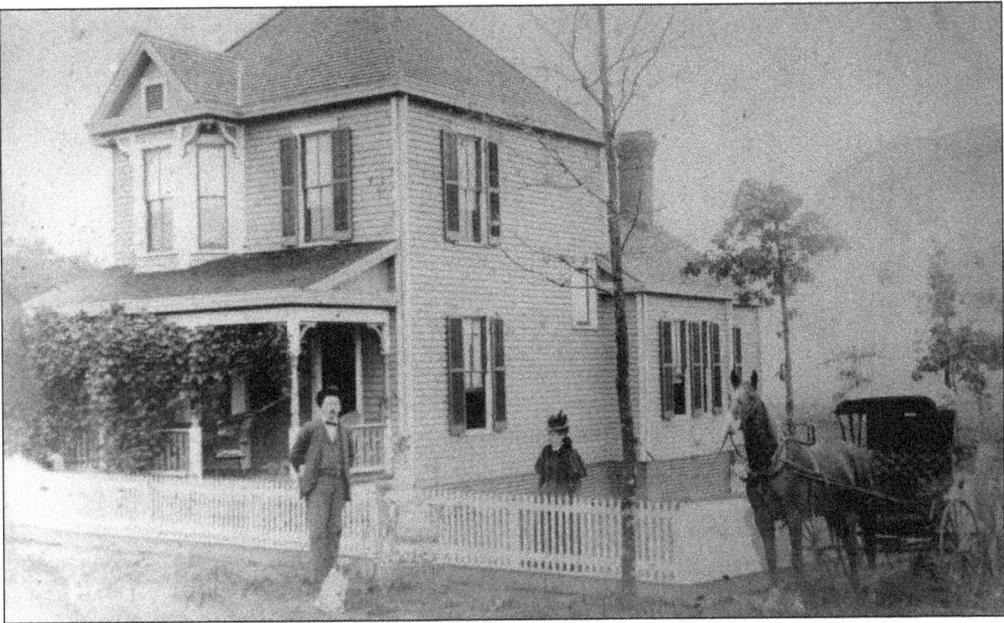

Charles and Fanny Drace are seen in front of their home at 210 West Arlington Avenue. The child in the carriage is Pearl. The house was built in 1897, and this picture was taken in 1898. Drace was the father of a well-known family of Greer photographers. (Courtesy of Jeff and Nelle Howell.)

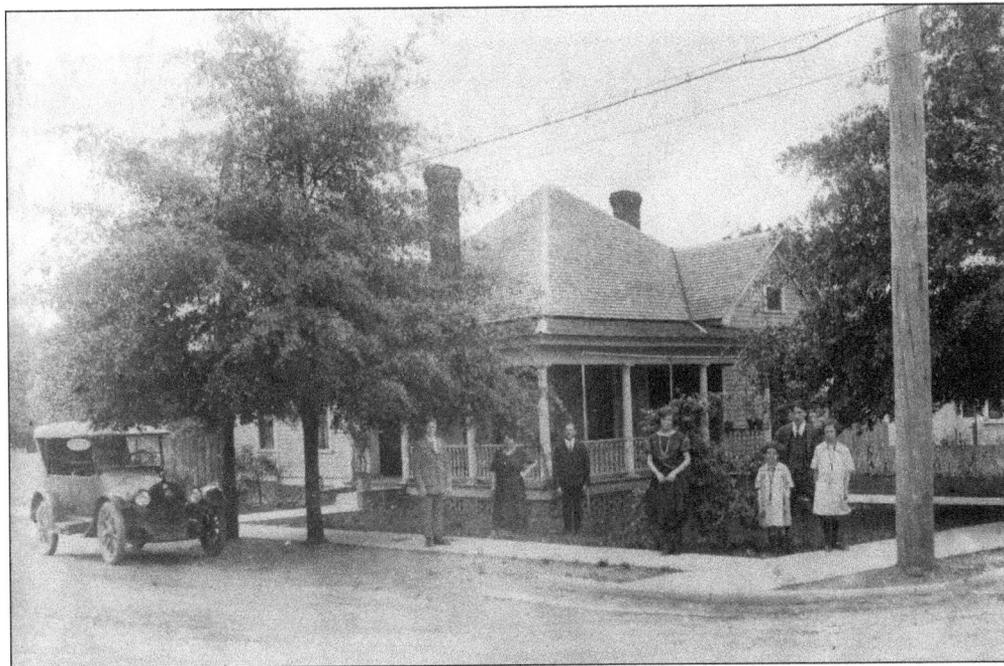

The Switzer family is pictured in front of their house on the corner of Church and Davenport Streets, c. 1924. From left to right are Milton, Mrs. and Mr. Switzer, Gertrude, Helen, Julius, and Hannah. (Courtesy of George Beason.)

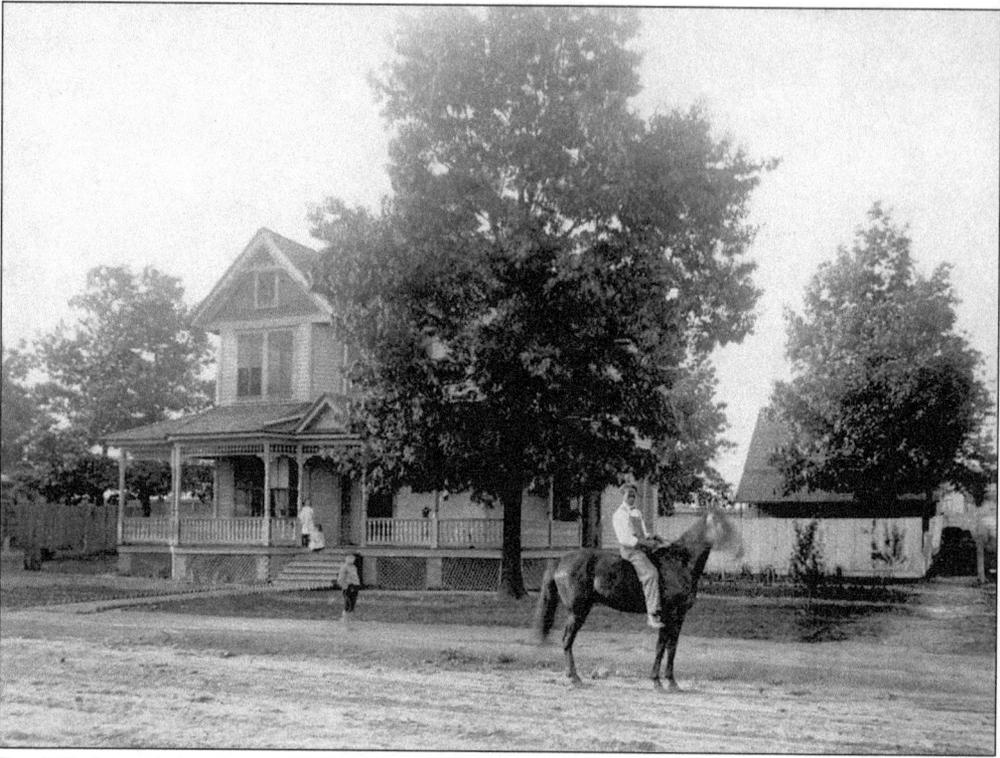

Dr. F.G. James's house at 208 West Poinsett Street is pictured here *c.* 1905. The man on the horse is Ben Jackson. (Courtesy of Harold James.)

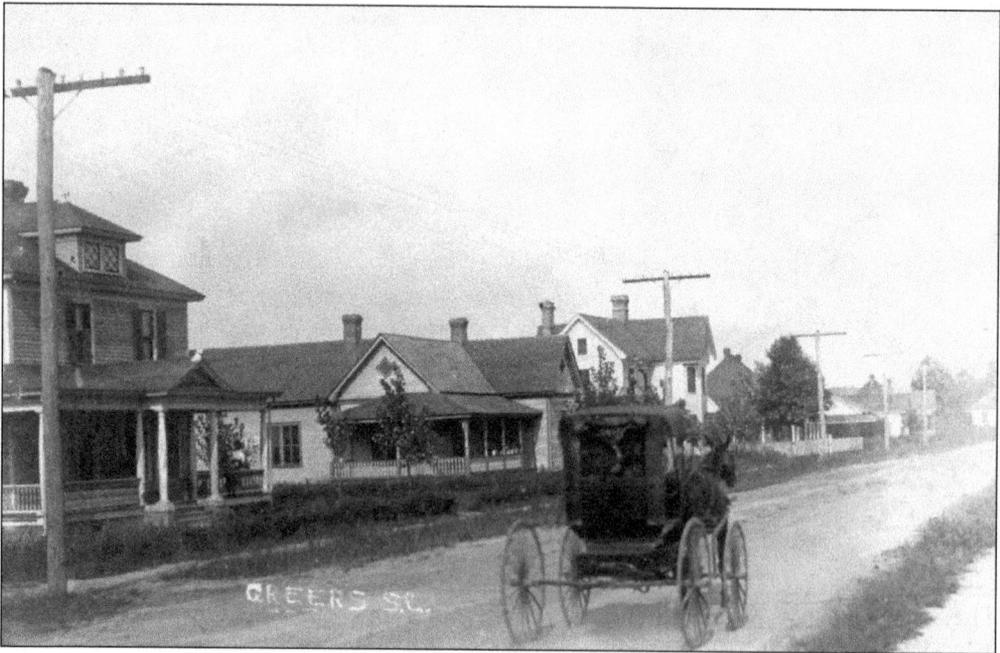

Seen here is the 300 block of Emma Street (West Poinsett). (Courtesy of Joe Bearden.)

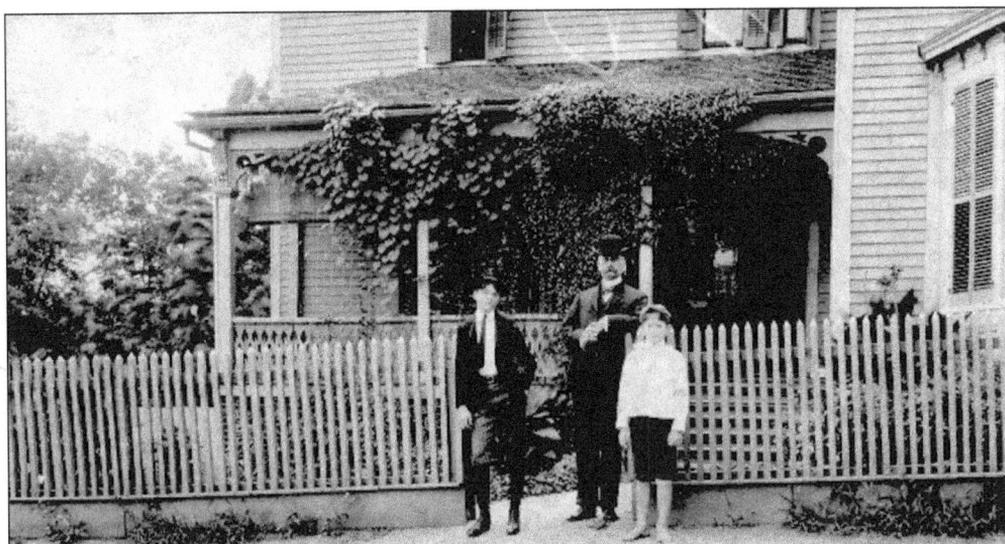

This house on the corner of School and Randall Streets was the temporary residence for the Davenport family while a new home was being built. The current house was started in 1917 and finished in 1921. (Courtesy of George Davenport.)

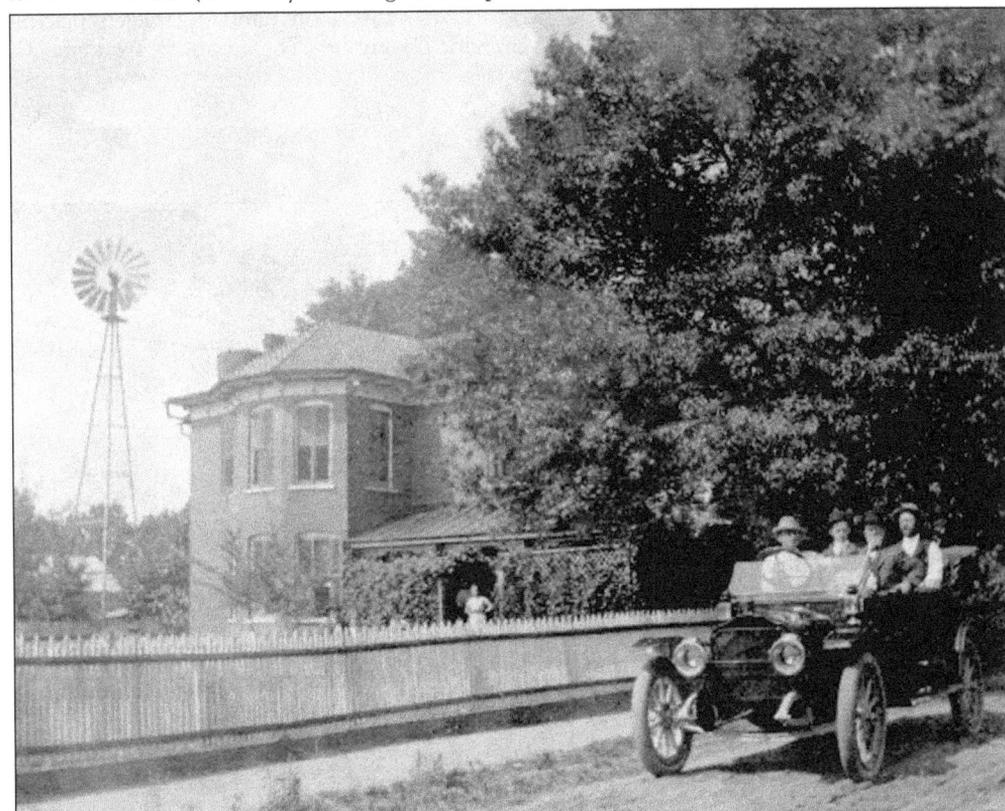

The original Davenport house on Randall Street is pictured about 1910. This house was torn down in 1917 to make way for the new and current house on the same location. (Courtesy of George Davenport.)

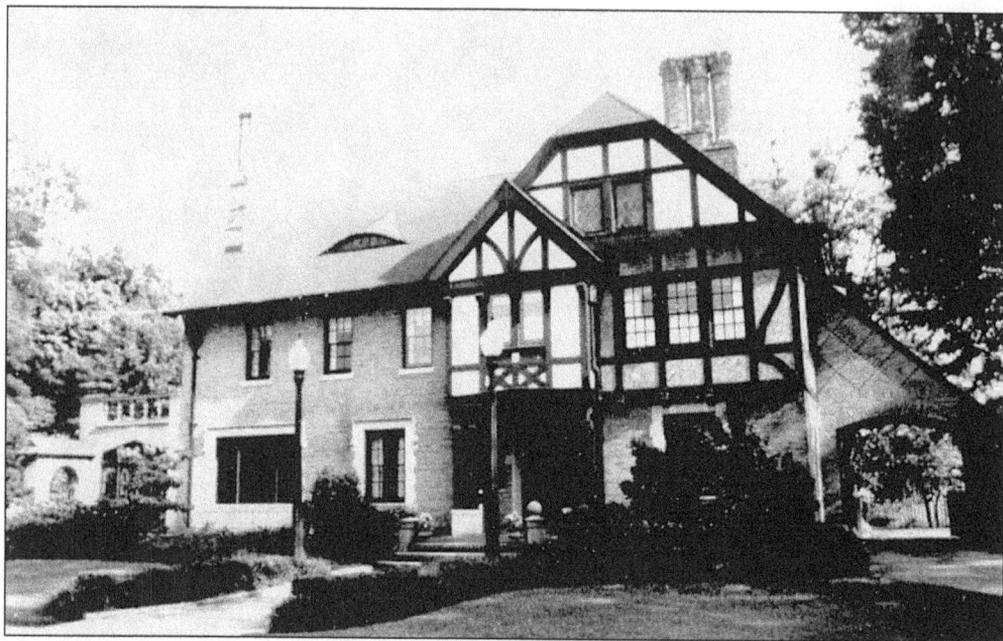

This 6,000-square-foot English Tudor house was built in 1921 on Randall Street, replacing the former home of Malcolm C. and Clare Marchant Davenport. The architect was James D. Beacham. (Courtesy of Harold James.)

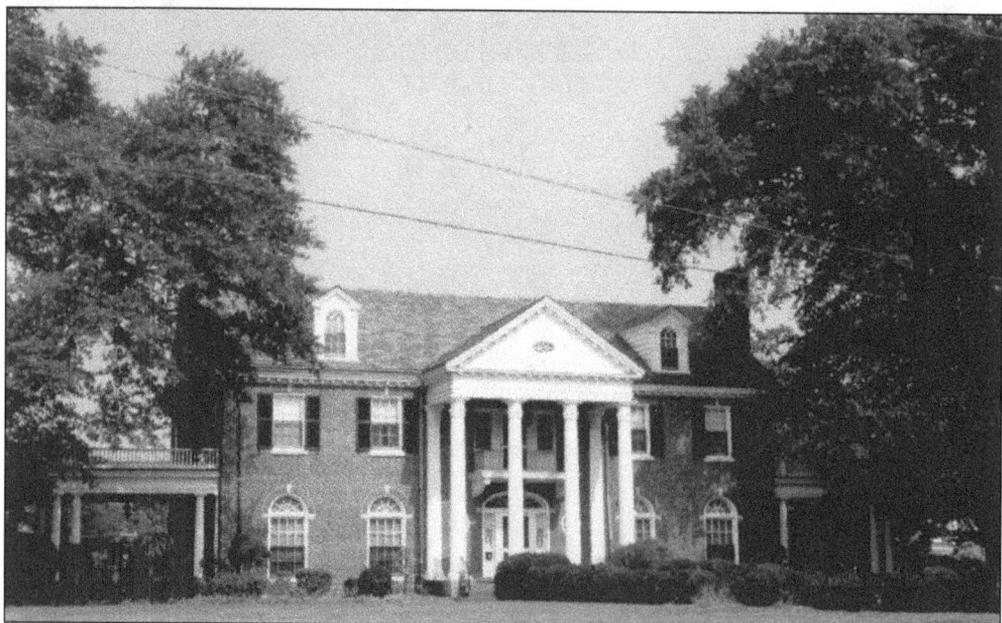

Architect William Ward designed this Colonial Revival–style home, built in 1937, for R. Perry Turner. Turner was a wholesale grocer at the corner of North Main and East Poinsett Streets. (Courtesy of Harold James.)

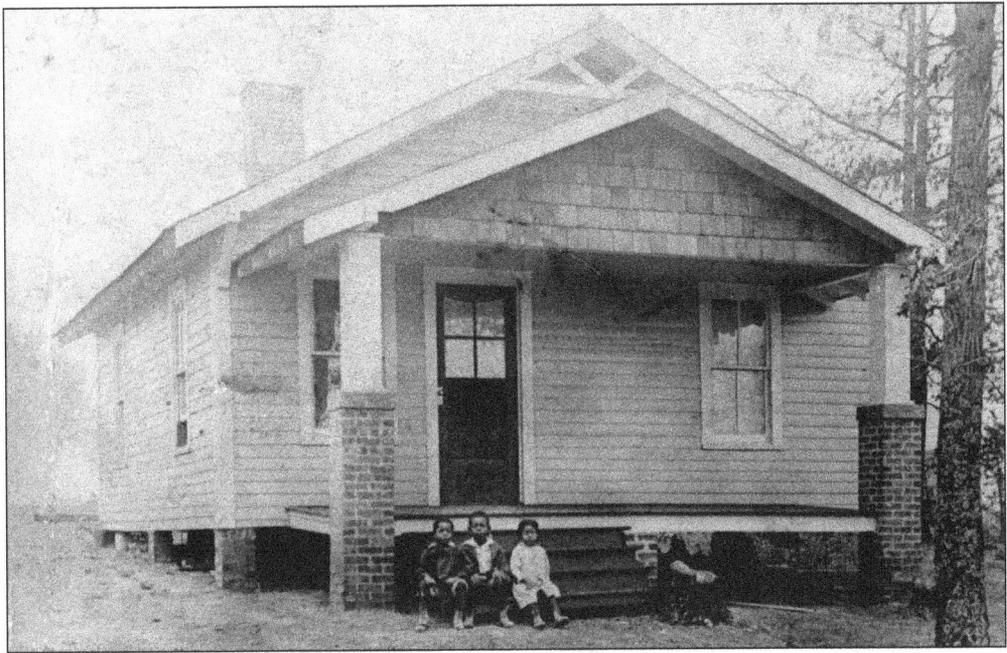

When this picture was taken in 1926, this house on Pelham Street was new. Pictured from left to right are Case, Homer, and Grace Bious. (Courtesy of Margarett Turner.)

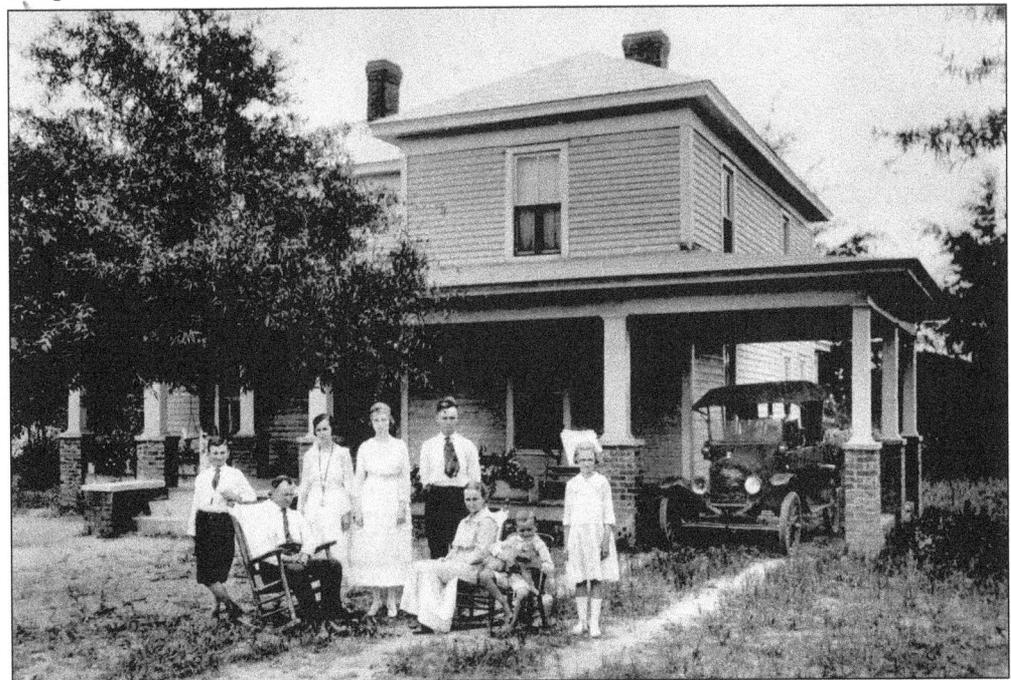

The William Lemuel Dillard family lived at 506 South Buncombe Road, pictured here in 1915. The house still stands today. Note that the automobile has one broken headlight. Mr. Dillard ran into a tree on his first outing and refused ever to drive a car again. Standing from left to right are Palmer, Mary, Perrit Leonard (a relative), Robert, and Lula. Seated are William Lemuel Dillard, Cassie Nelle Williamson Dillard, and Walter. (Courtesy of Ann Withrow.)

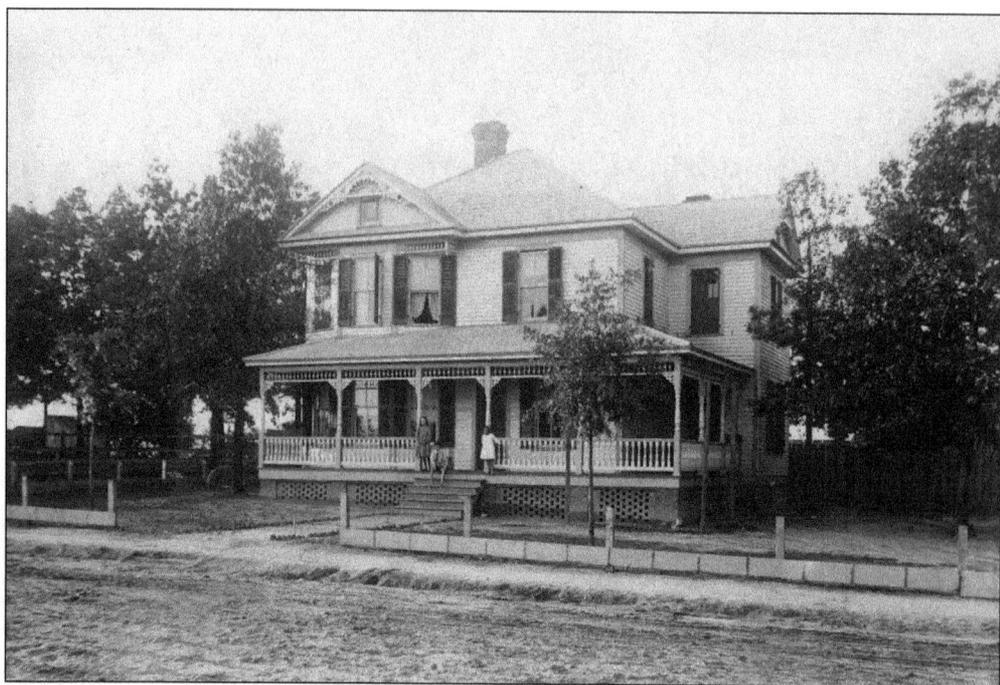

This photo of the Tandy Walker home (grandfather of Dr. T.O. Walker Jr.) on the corner of West Poinsett and North Avenue was taken around 1905. (Courtesy of the estate of Robert S. Hughes.)

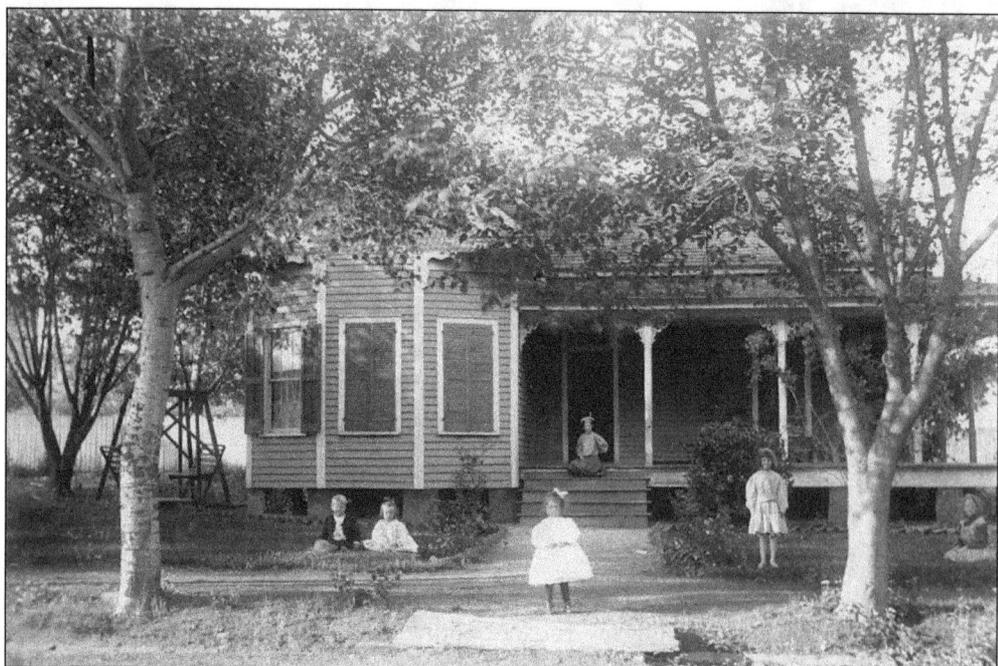

Taken around 1905, this picture shows the M.B. Cunningham home on East Poinsett (later the site of the Poinsett Cafe). This was the first home of Frank Burgess before he built on Emma Street. (Courtesy of the estate of Robert S. Hughes.)

Four

FAMILY AND FRIENDS

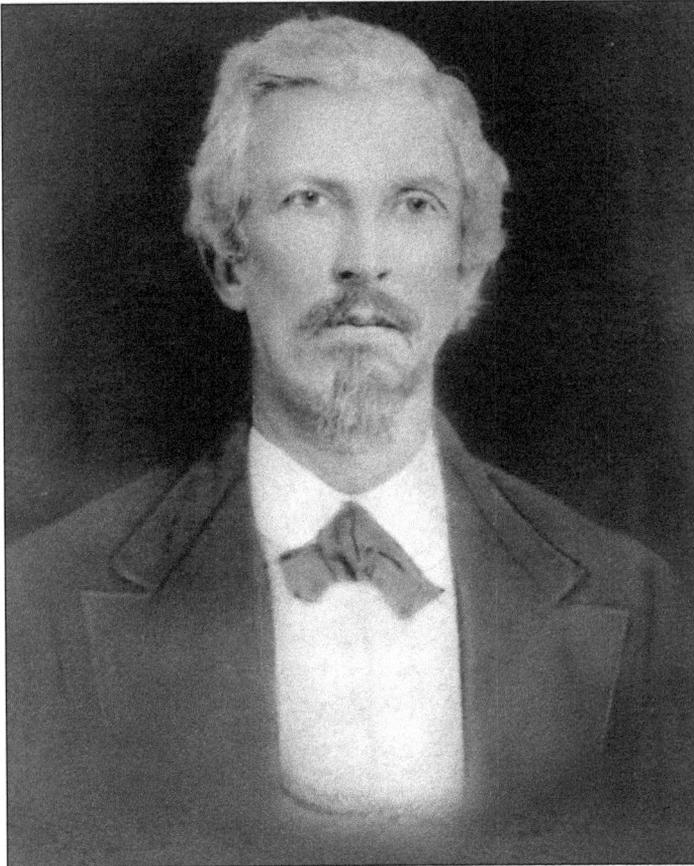

William Clark Bailey was the first mayor of Greer. (Courtesy of Mrs. Edward C. Bailey.)

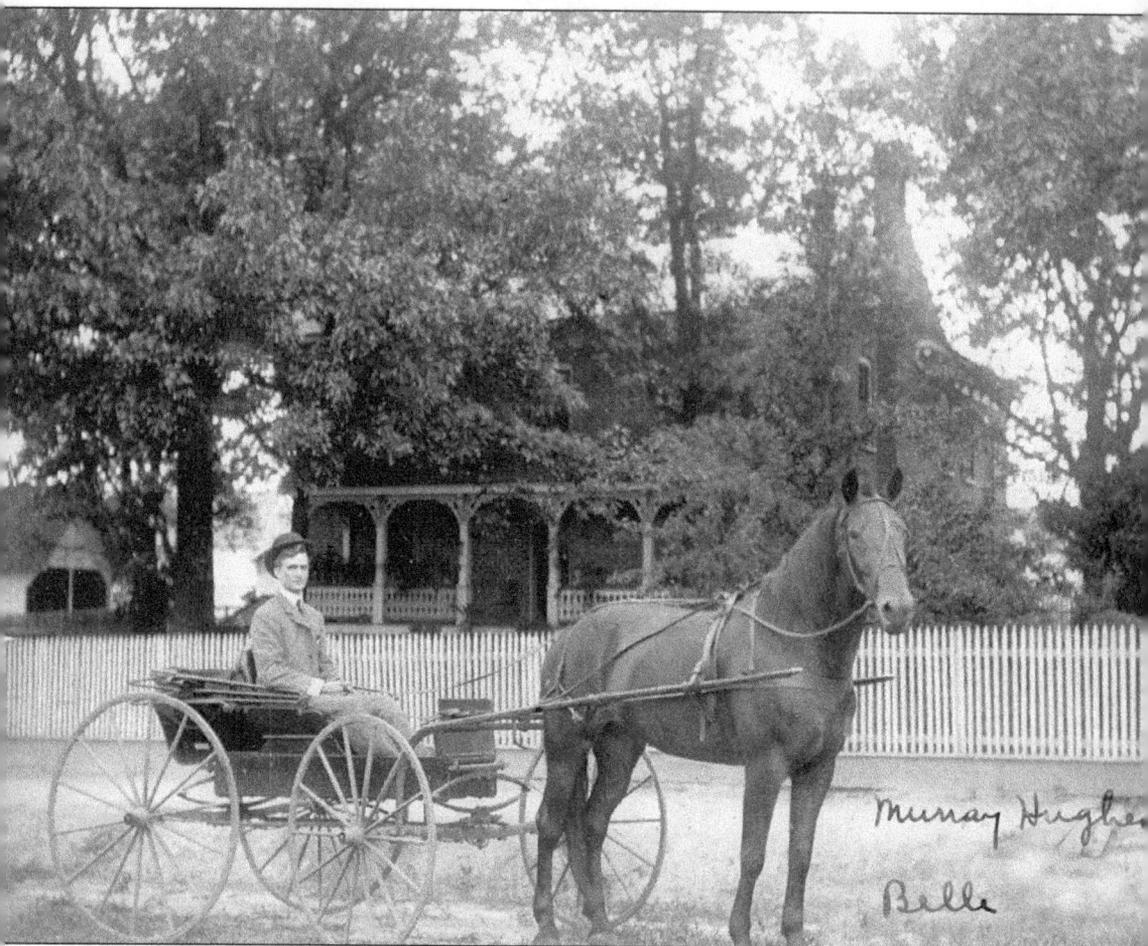

Robert S. Hughes is pictured in front of this South Main Street home (now the site of city hall) in 1900. (Courtesy of the estate of Robert S. Hughes.)

Edward "ECE" Bailey is seen in front of the Bailey family cemetery near the intersection of Buncombe and Brushy Creek Roads. Among others, the first mayor of Greer, William Clark Bailey, is buried here. (Courtesy of Mrs. Edward C. Bailey.)

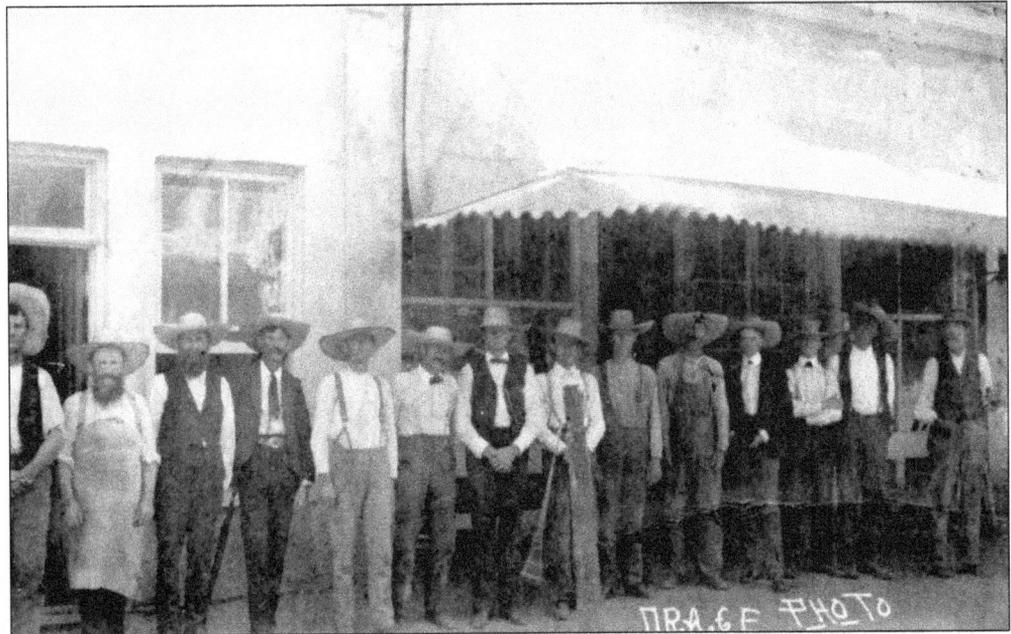

An early 1904 Drace photo on Trade Street shows, from left to right, Tom Baswell, John Bates, L. Jackson Green, Bob Hawkins, Gus Green, Jim Green, Dallie Green, Doug McCorkle, unidentified, Riley Roe, Jean Roe, Murray Hughes, unidentified, and ? Gaccet. (Courtesy of Joe Bearden.)

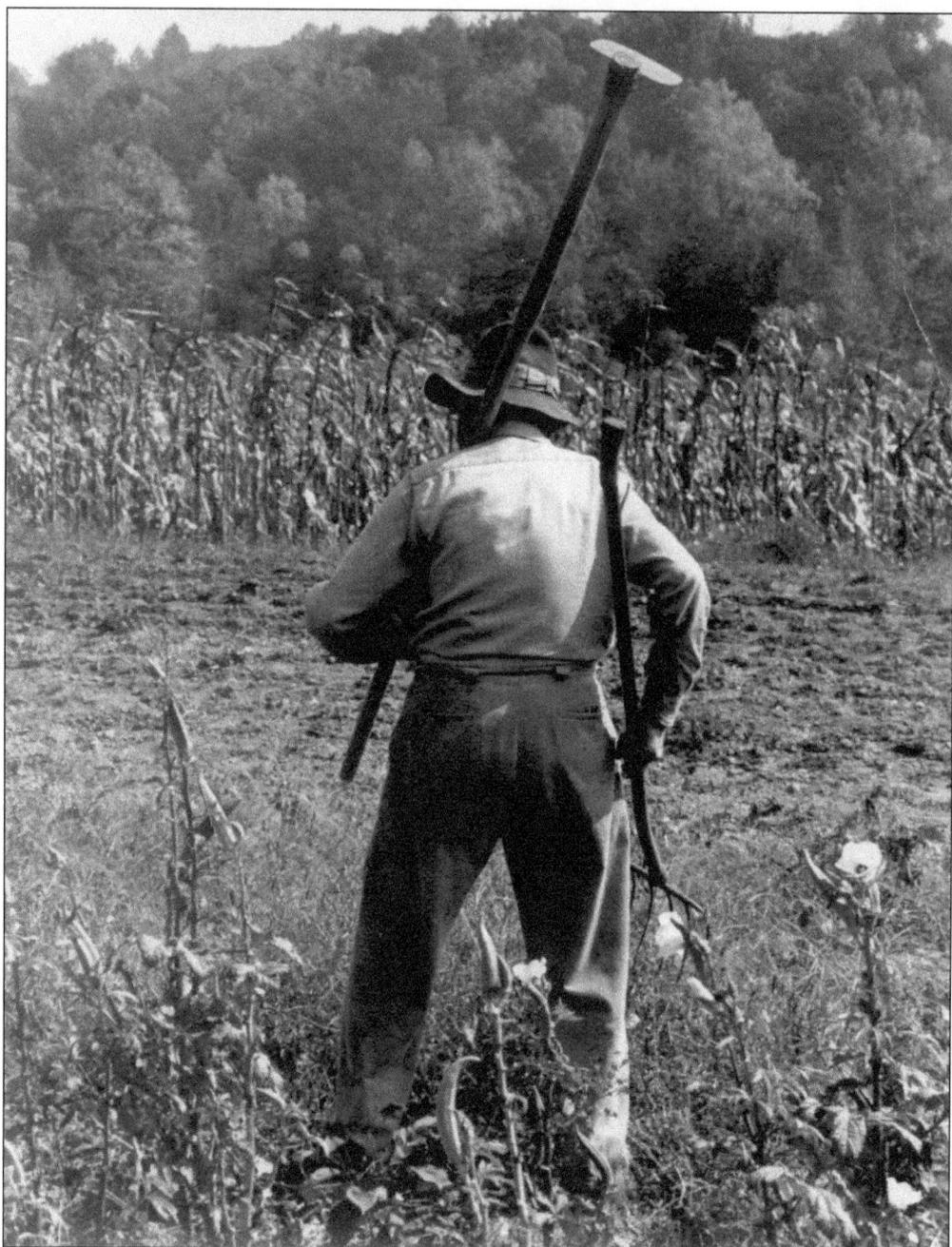

Mr. Tommy Ballenger farmed the area along Taylor Road in the simple style of a turn-of-the-century farm. Here, he heads to the field with his homemade implements some time in the late 1950s. (Courtesy of Jean M. Smith Library.)

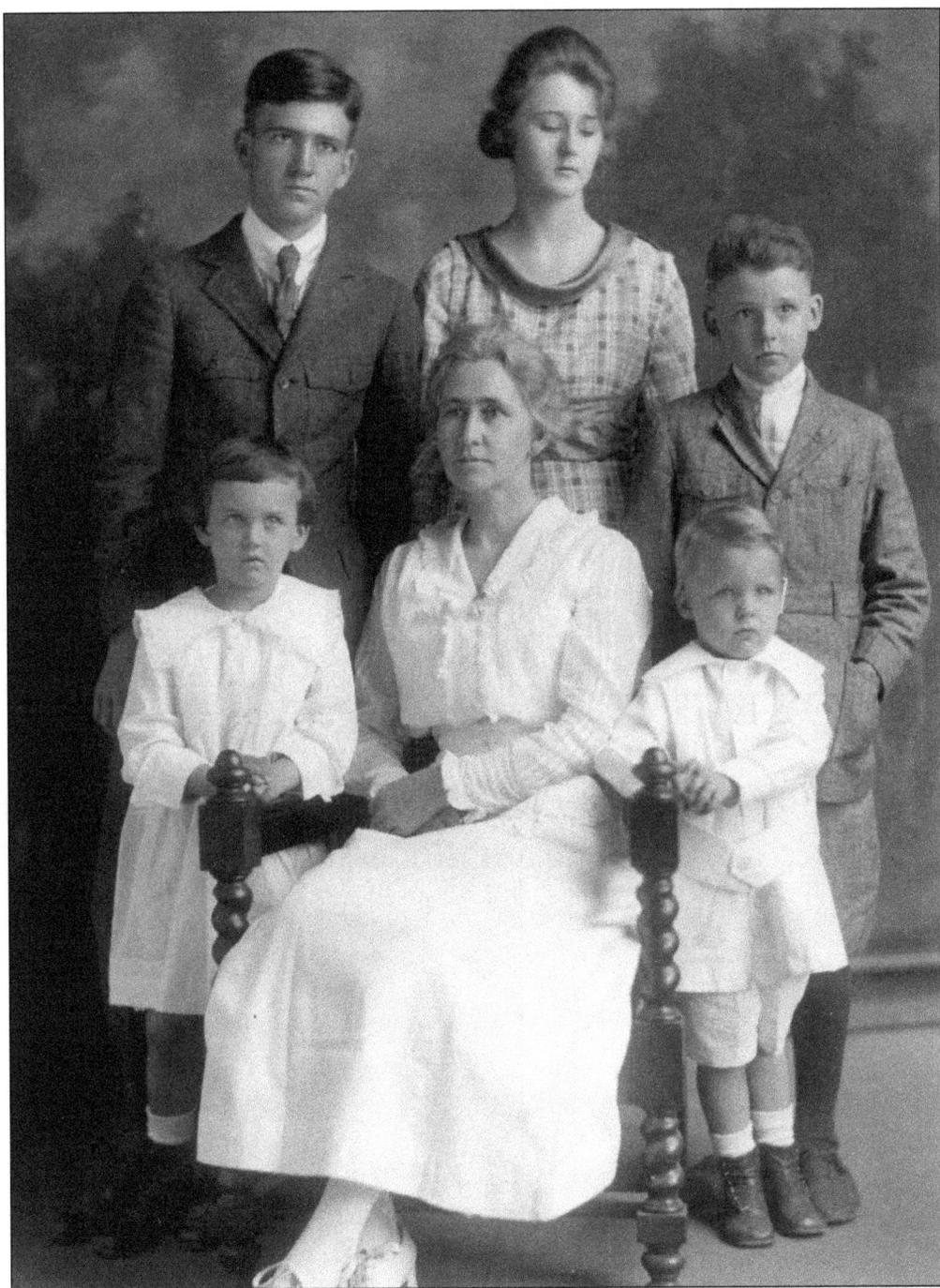

A family portrait shows Clare Davenport (center) and children. Pictured, from left to right, are (front row) Martha, Clare, and Dan D. (the father of George Davenport); (back row) Pete, Constance, and Malcolm. (Courtesy of George Davenport.)

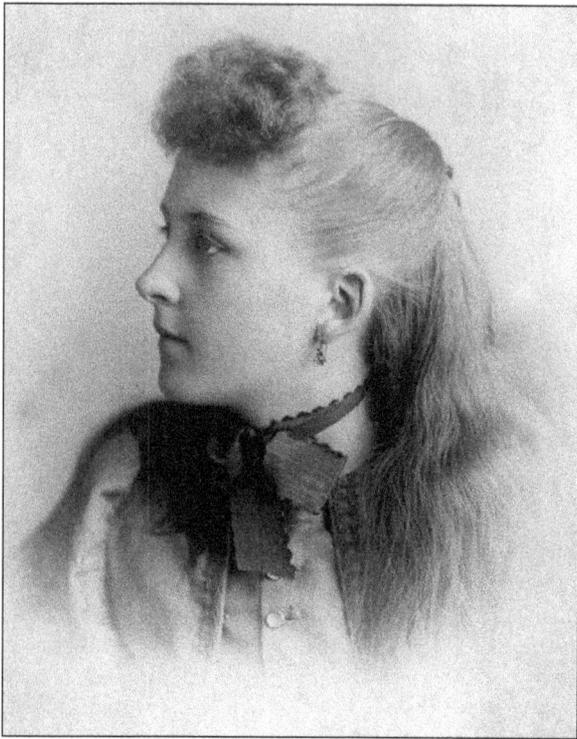

An 1884 portrait shows May Davenport Wood. (Courtesy of George George Davenport.)

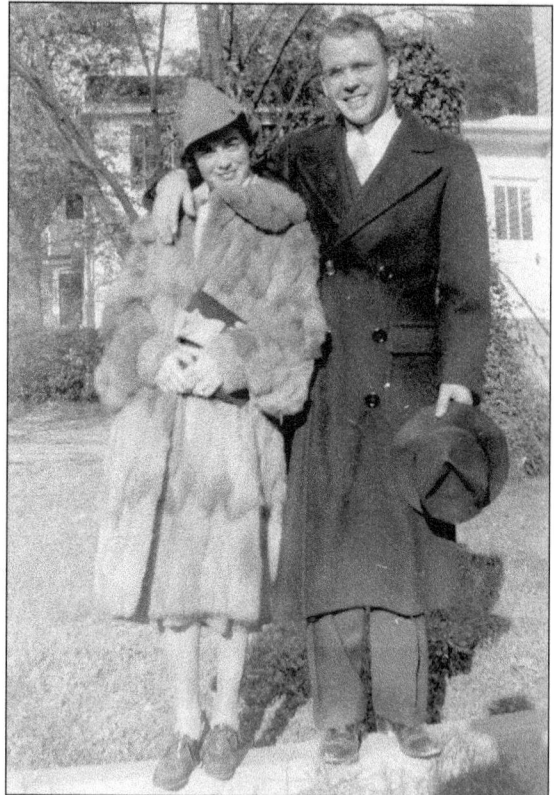

Ellen and Dan D. Davenport are pictured here in 1936, the year they were married. (Courtesy of George Davenport)

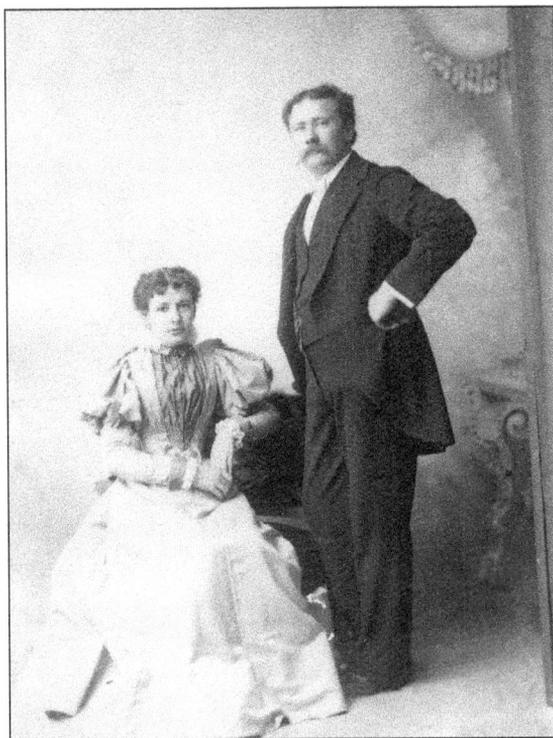

Famous photographer Charles Drace is seen here with his wife, Fanny. (Courtesy of Jeff and Nelle Howell.)

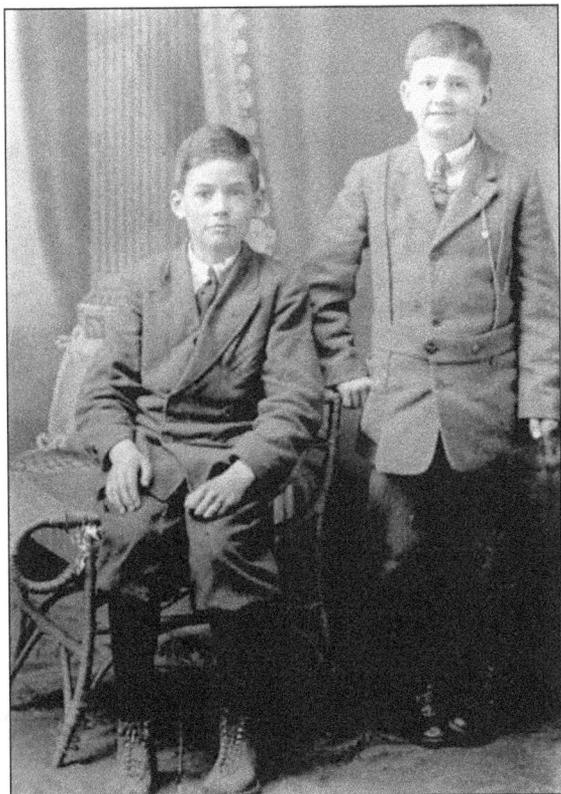

Bill Ballenger (left) and Malcolm Davenport are pictured about 1925. (Courtesy of George Davenport.)

55

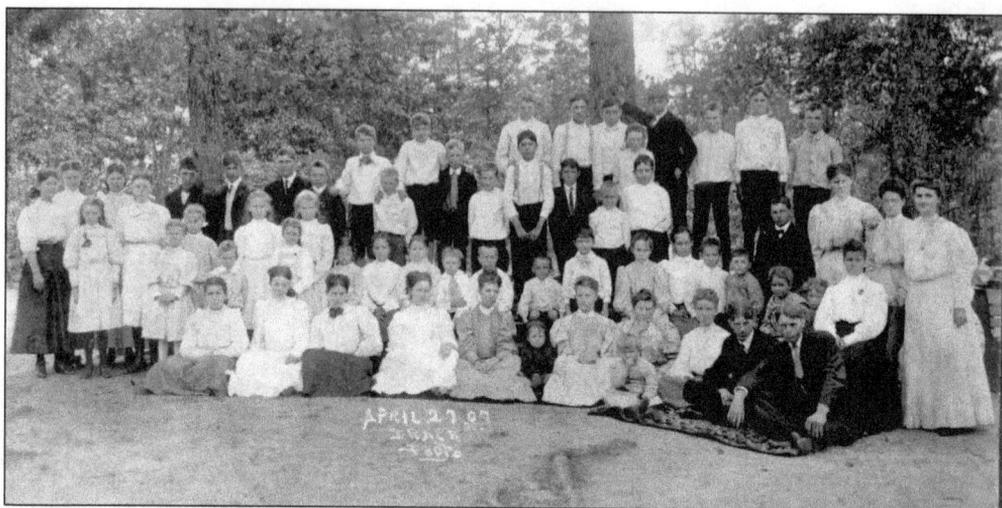

The Dillards gathered for a 1907 reunion at the family farm on Gibbs Shoals Road. The photograph was made by well-known Greer photographer Charles Drace. (Courtesy of Moise Dillard Smith.)

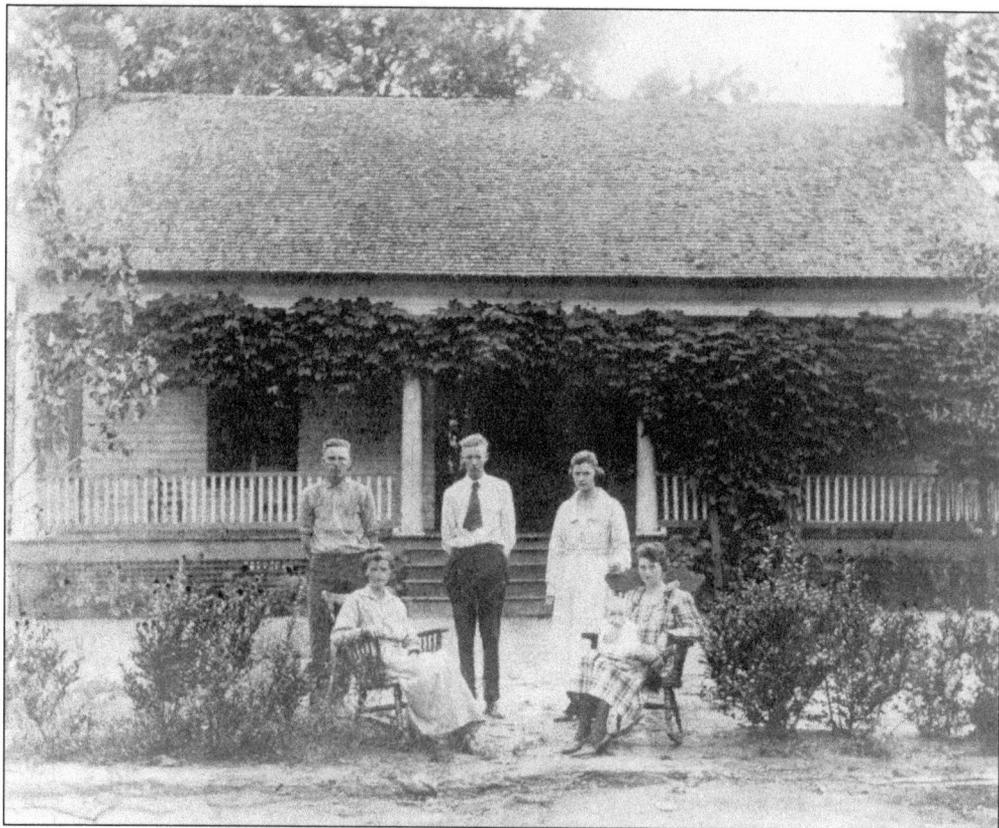

The Troy M. Dillard family posed in 1918 at their home on Gibbs Shoals Road. Seated, from left to right, are Minnie Wood Dillard and William's wife, Linda Verdin Dillard, holding son William M. Dillard Jr. Standing, from left to right, are Minnie's sons William M. and Herbert O., and Herbert's wife, Ila Smith Dillard. (Courtesy of Moise Dillard Smith.)

Vincent Duncan (left) and Claude
Duncan are seen in front of their Randall
Street Chrysler automobile dealership.
(Courtesy of David Duncan.)

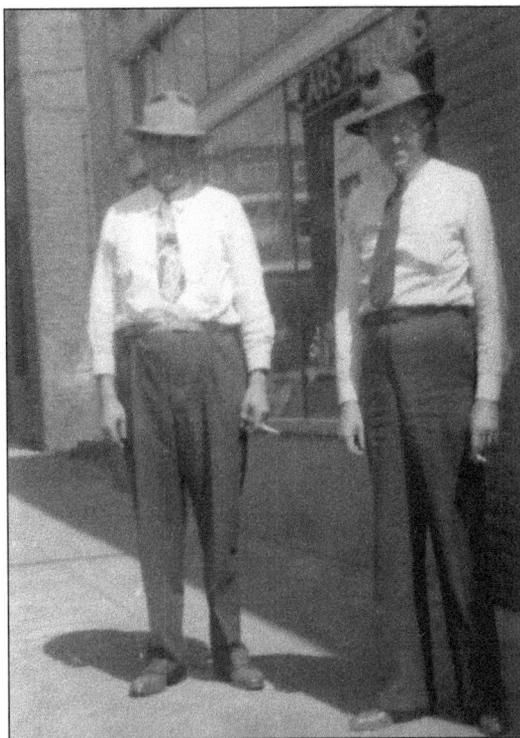

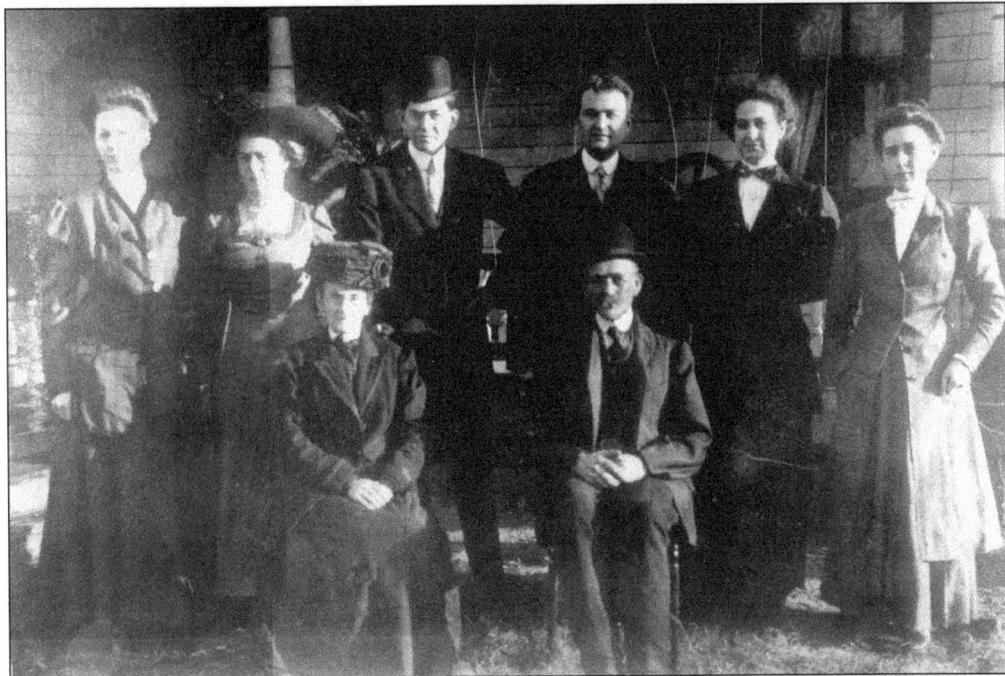

The Robert Joshua Ellis family is pictured in 1910. From left to right are (front row) Robert J.
and "Lou" Ellis; (back row) Maude Ellis Jameson, Carrie Hortense Ellis McClure, Dr. Robert
Ellis, Claude Alexander Ellis, Adeline Inez Bomar, and Cora Eva Ellis Williams. (Courtesy of
Sylvia Pitts.)

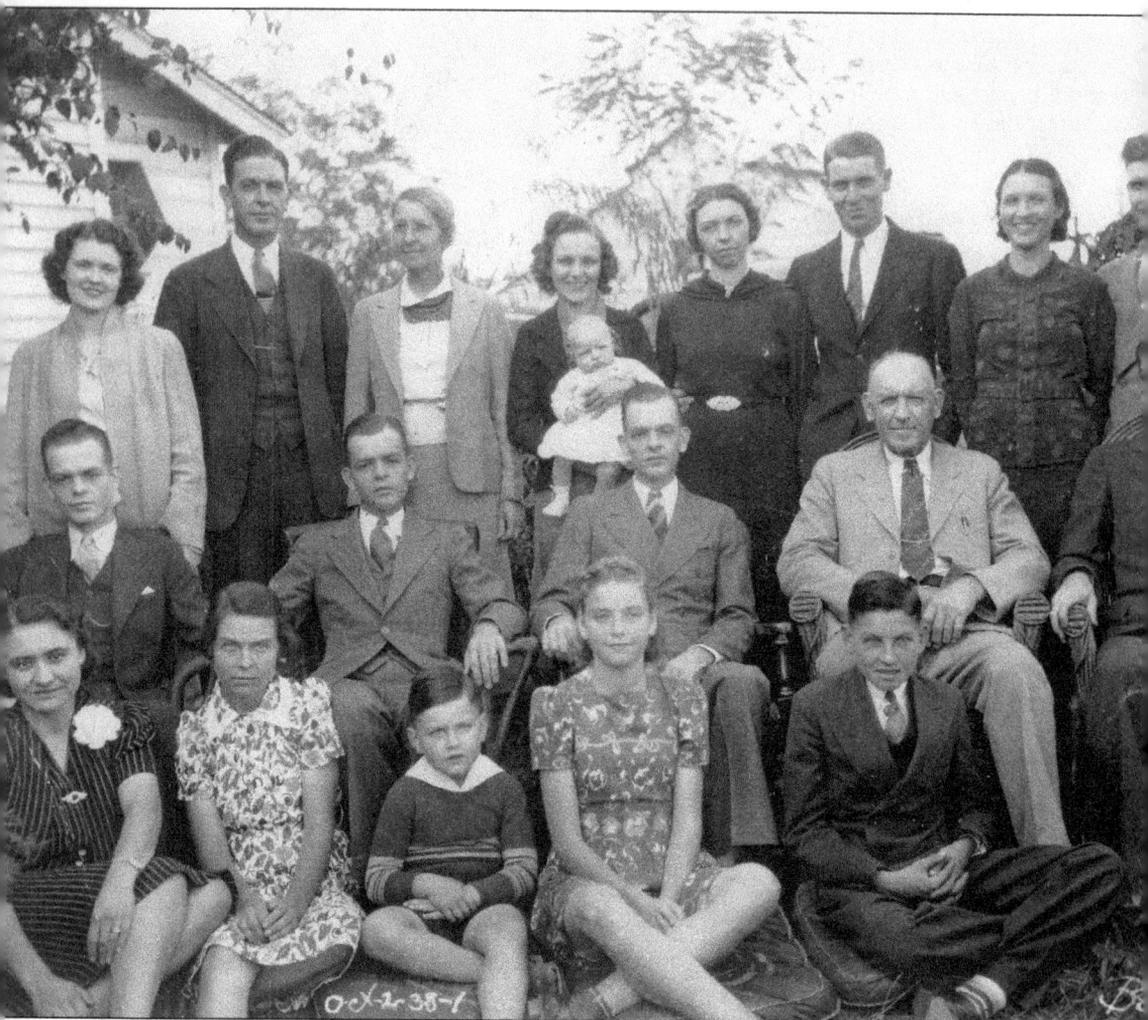

The family of John Edgar Bishop and Sue Payne Bishop are pictured in October 1938. From left to right are (front row) Virgie Lee Lynn Bishop, Lucy Bishop, Bobby Mason, Frances Sue Mason, and Max Bishop; (middle row) Fred Bishop, Frank Bishop, Furman Bishop (triplets), John E. Bishop, and William Bishop; (back row) Margaret Phillips Bishop, Dean Bishop, Sue Payne Bishop (wife of John E.), Ruth Williams Bishop, Sylvia Sue Bishop (baby), Flora Bell Bishop Mason, Edgar Mason, Ellen Bishop Mason, and Stanyard Mason. John E. Bishop owned a large farm on Highway 290 and Locust Hill Road. (Courtesy of Sylvia Pitts.)

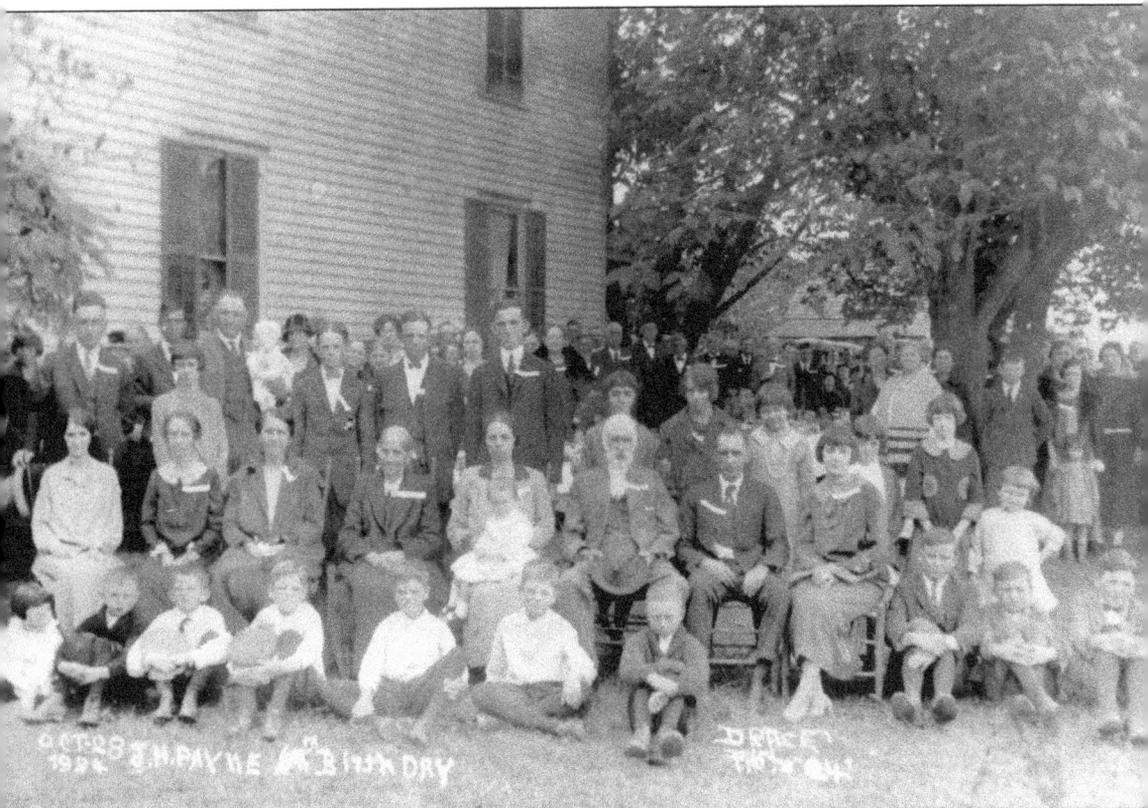

A birthday party for John H. Payne took place in October 1924. Mr. Payne's original home was located near the old Bank of Greer on Trade Street. He also had homes on North Main Street and at 502 Hampton Road. Payne had three wives—Ida Ashmore (1886), Anna Ellis (c. 1900) and Hattie McOuley (1930s). (Courtesy of Sylvia Pitts.)

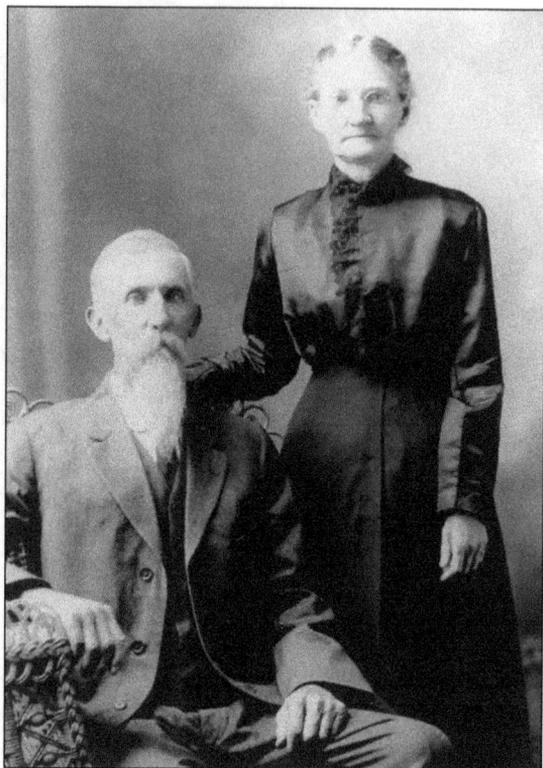

Mr. and Mrs. George Flack are pictured here. Flack, a Civil War veteran, was born in Chimney Rock, North Carolina, and lived and died in Greer. He was under 16 years old when he joined his two brothers and father in the War. (Courtesy of Don Whitmire.)

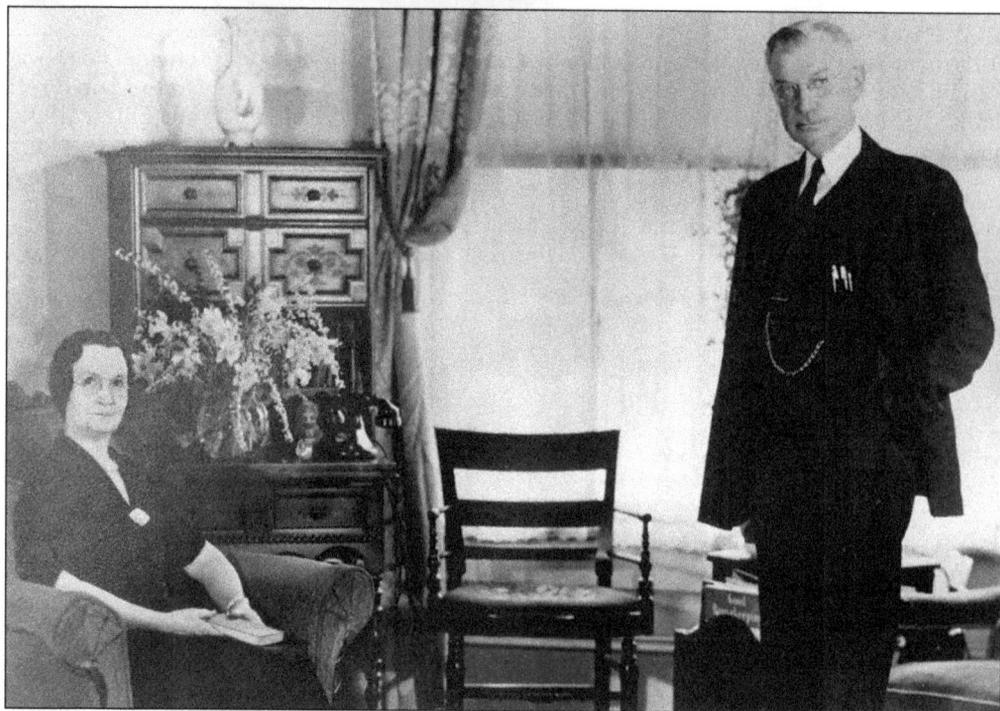

Dr. and Mrs. F.G. James are pictured in their home at 208 West Poinsett Street. (Courtesy of Harold James.)

Pictured on the left is J. Verne Smith Sr., father of State Senator J. Verne Smith. Reared on a farm, he became assistant cashier of the Bank of Greer. He was a partner in the Greer Furniture Company with Douglas McCorkel and Wren Stone. He also partnered with Terry Wood to sell caskets in the two-story brick building that is now the Tire Exchange. He sold the casket and funeral business to John D. Wood, and it is now Woods Mortuary. On the right is E.C. Bailey Sr., then cashier with the Bank of Greer. He lost his job in the stock market crash of 1929 and became the first paid employee (director) of the Greer Chamber of Commerce, at a salary of $12 a week. He later became director of the Draft Board in Greer. This picture was taken in 1890 on a trip to Hot Springs, Arkansas. (Courtesy of Sen. J. Verne Smith.)

Sen. J. Verne Smith Jr. is seen here at four months old. (Courtesy of Sen. J. Verne Smith.)

61

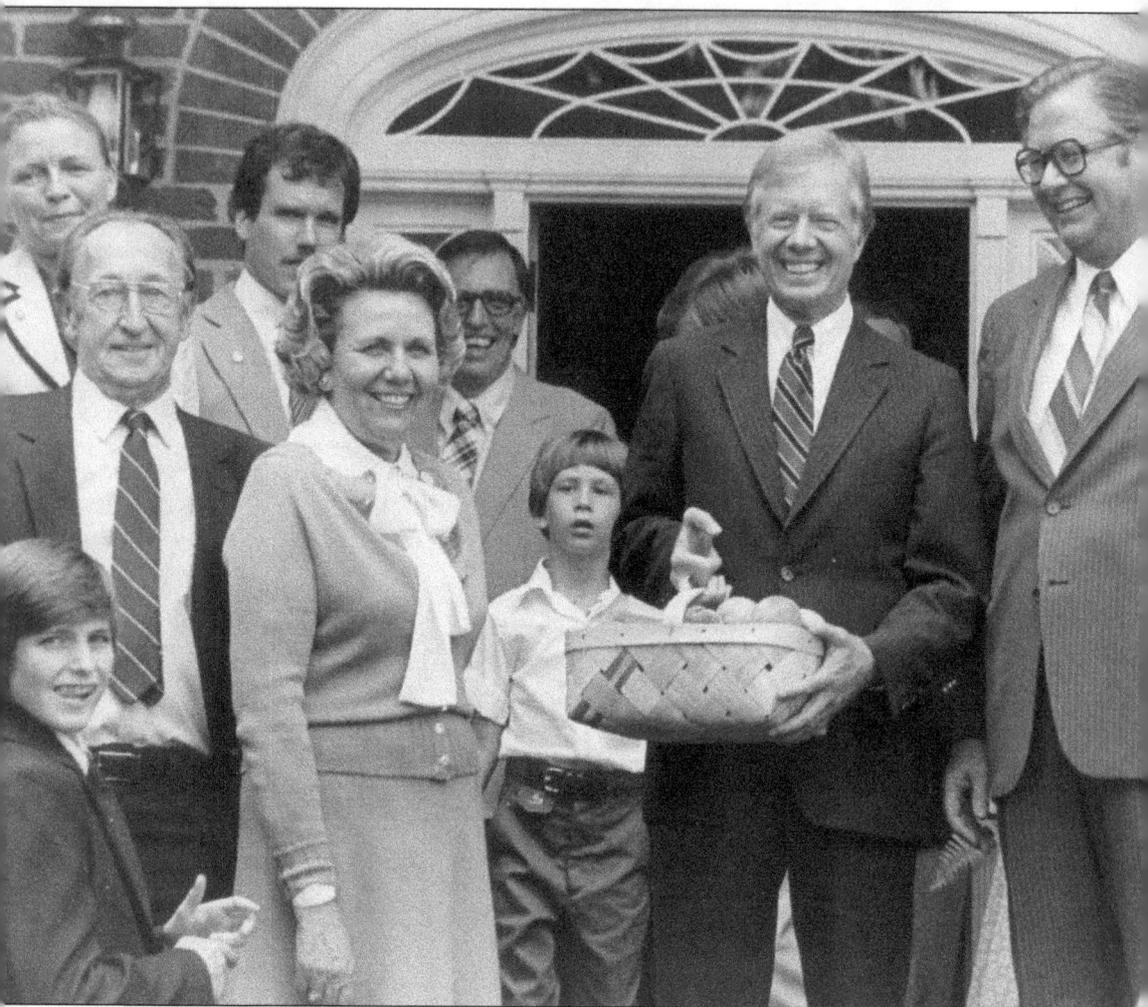

President Jimmy Carter visited his good friend State Senator J. Verne Smith during Carter's re-election campaign. Since President Carter was identified with peanuts, Jean M. Smith presented him with a basket of peaches, provided by peach grower Richard Taylor. Standing in the front row are, from left to right, Mayor Don Smith, Jean Smith, President Carter, and Sen. J. Verne Smith. (Courtesy of Sen. J. Verne Smith.)

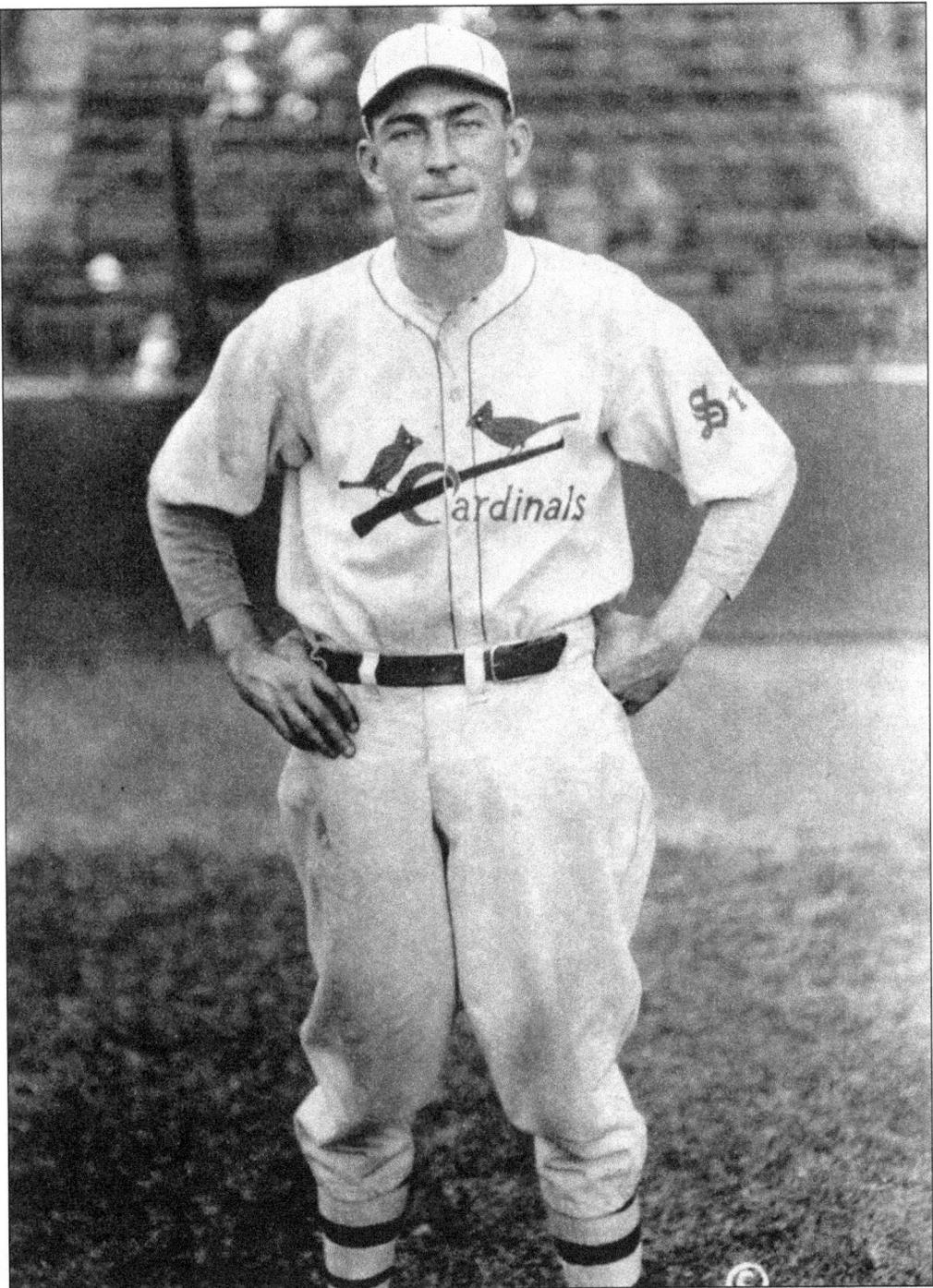

Originally from Rhems, South Carolina, and retired to Greer after baseball, Flint "Shad" Rhem is first remembered as an outstanding Clemson ballplayer. He quit Clemson to pitch for the St. Louis Cardinals in 1924. His banner year was 1926, when he won 20 games and helped the Cardinals to their first National League pennant. He pitched for 10 seasons, including the 1928 World Series. (Courtesy of Marlea Rhem.)

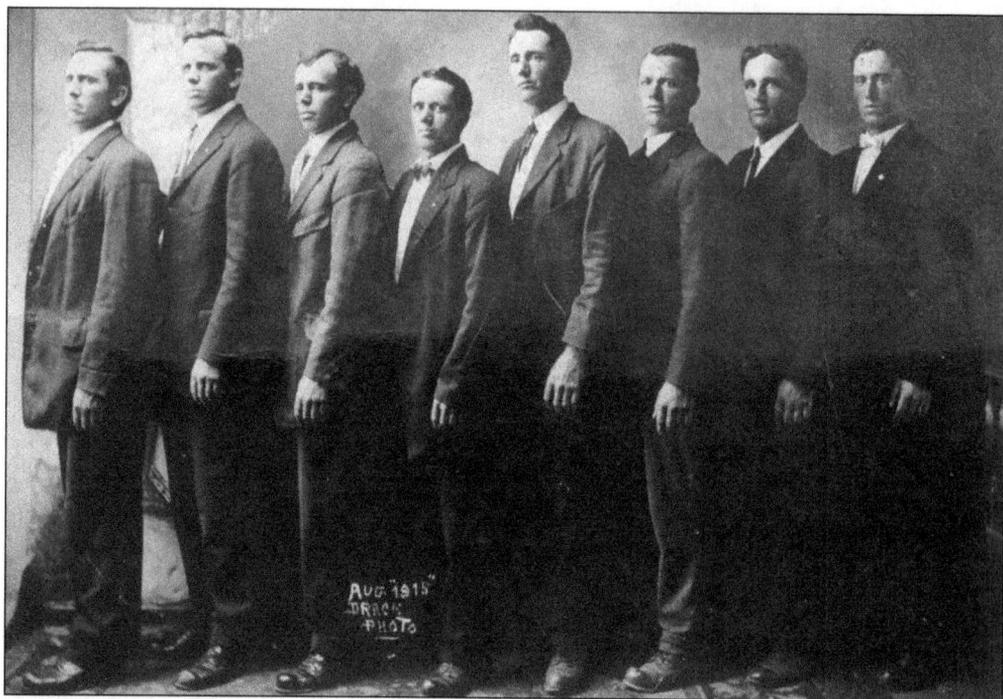

The Sloan brothers, from left to right, are Berry Columbus, John Henry, Sampee Babb, William Pliney, James Furman, Clarence Ervin, Richard Florence, and Thomas Smiley. Clarence Ervin Sloan, known as "Mt. Lion," was elected to the South Carolina House of Representatives in 1924. In 1932, he was elected to the state senate and served until 1936. (Courtesy of Myra Weatherly.)

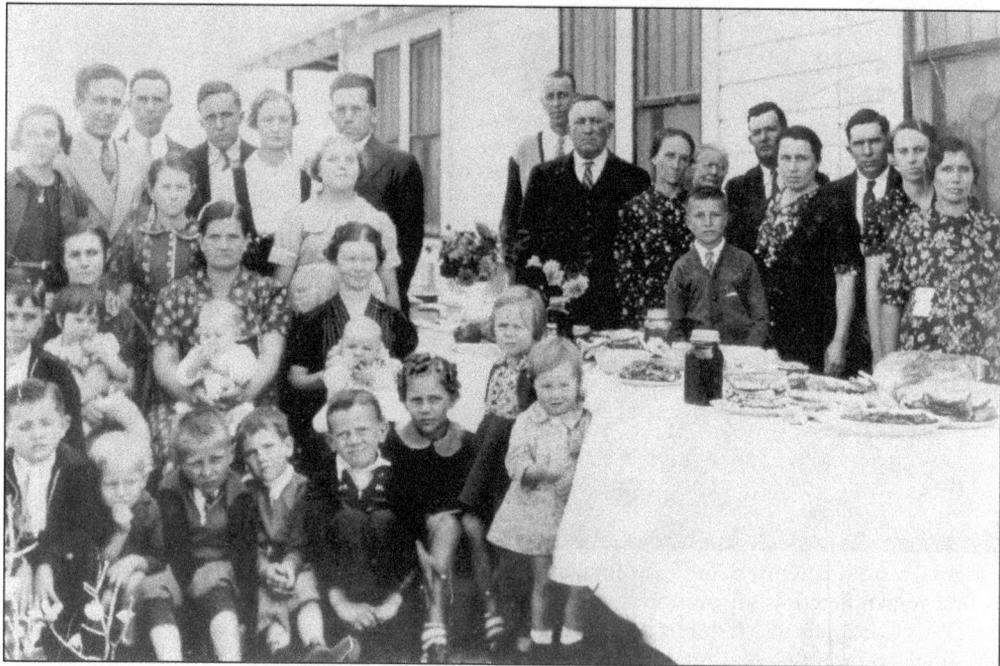

The Berry Sloan family gathered in 1938 for a family dinner. (Courtesy of Myra Weatherly.)

Five

SCHOOL DAYS

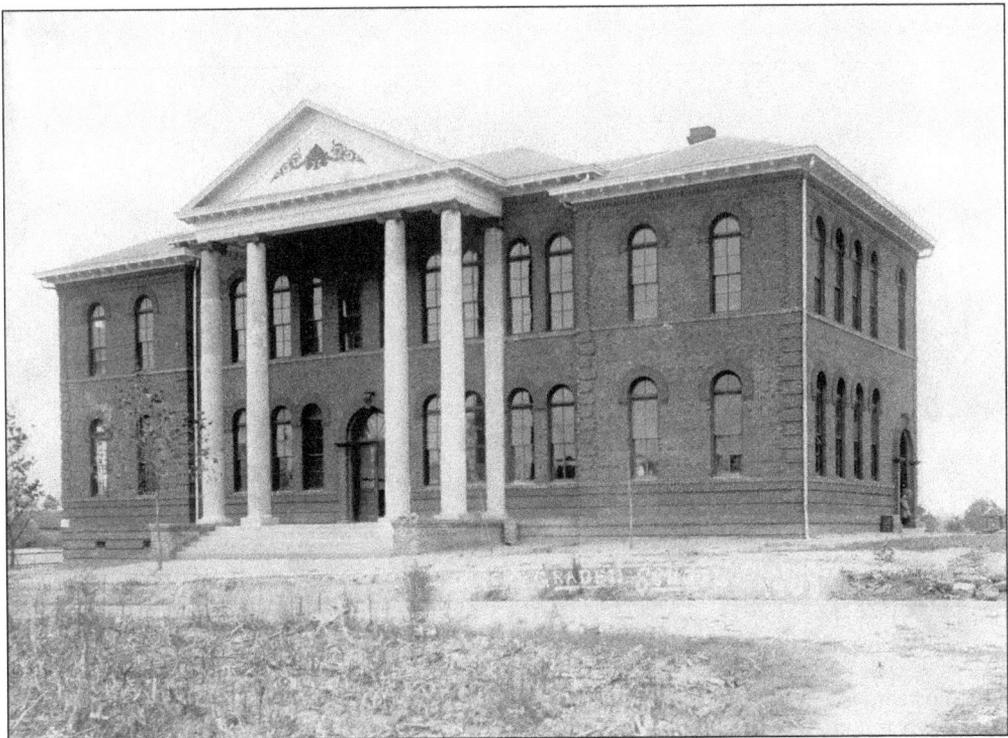

Central Elementary School is pictured in 1905. (Courtesy of the estate of Robert S. Hughes.)

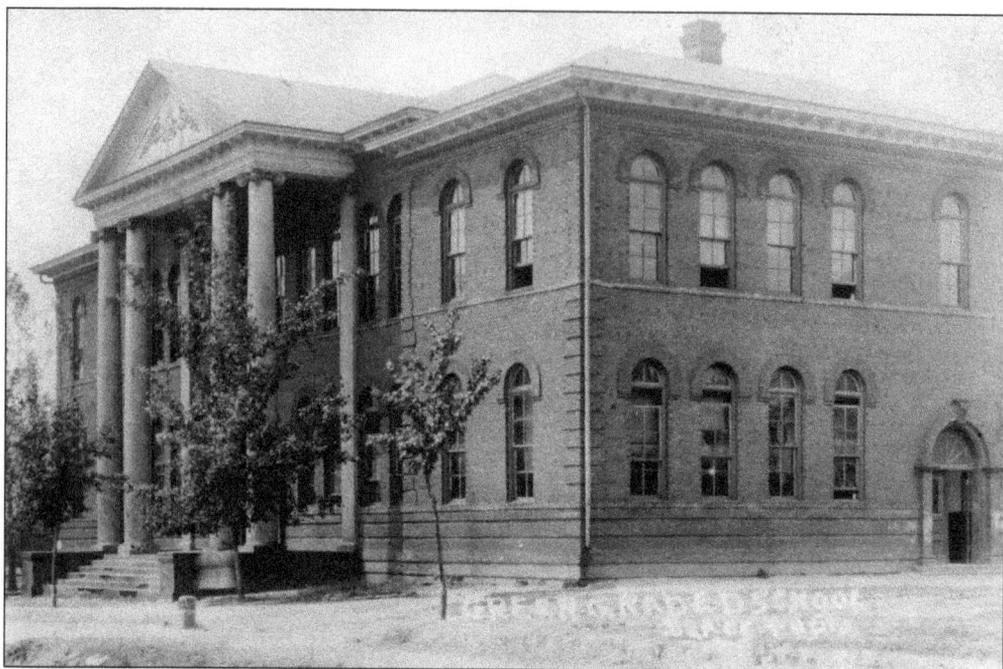

Greer children first learned their ABCs in a log cabin and various store buildings until Central School was built in 1905. (Courtesy of Jean M. Smith Library.)

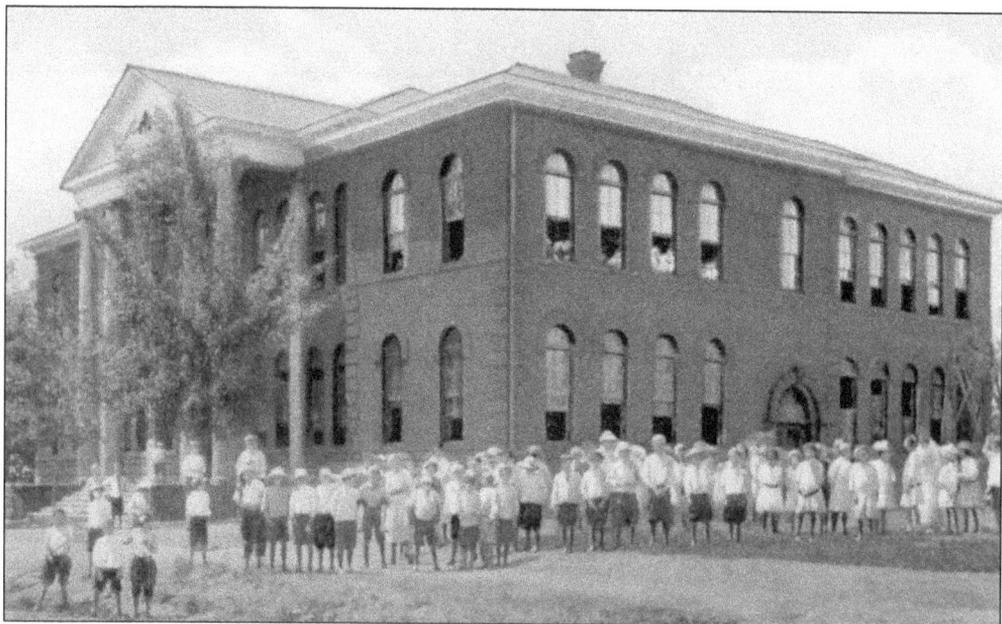

This postcard scene of Central Elementary School and students shows the school after an addition was completed. The school was built in 1905 and served all eight grades. (Courtesy of Thomas McAbee.)

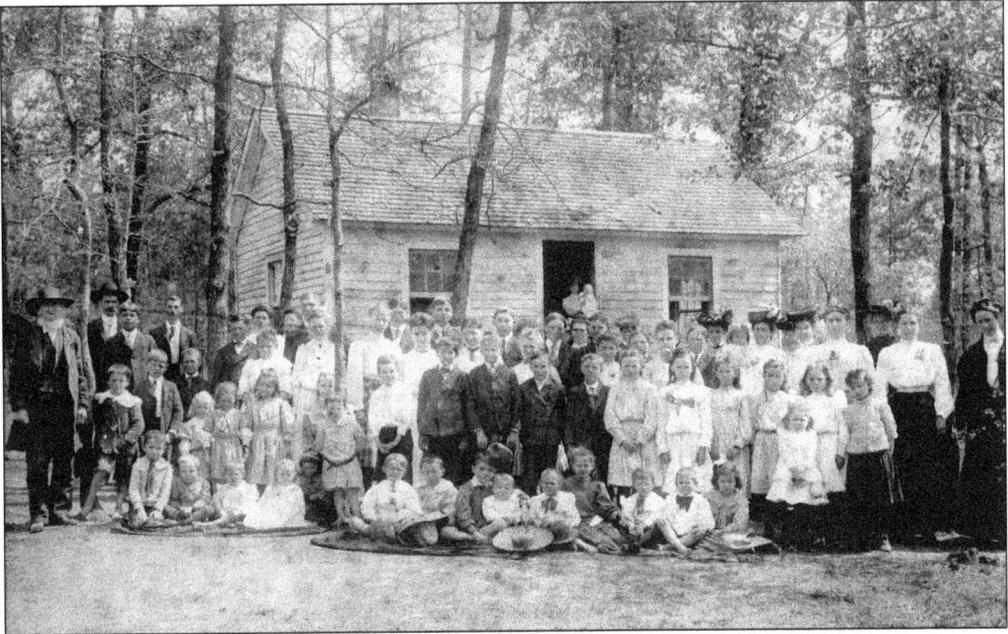

The Center Point School was located near Pelham and the Dillard homeplace. This school photo was taken c. 1900. (Courtesy of Ann Withrow.)

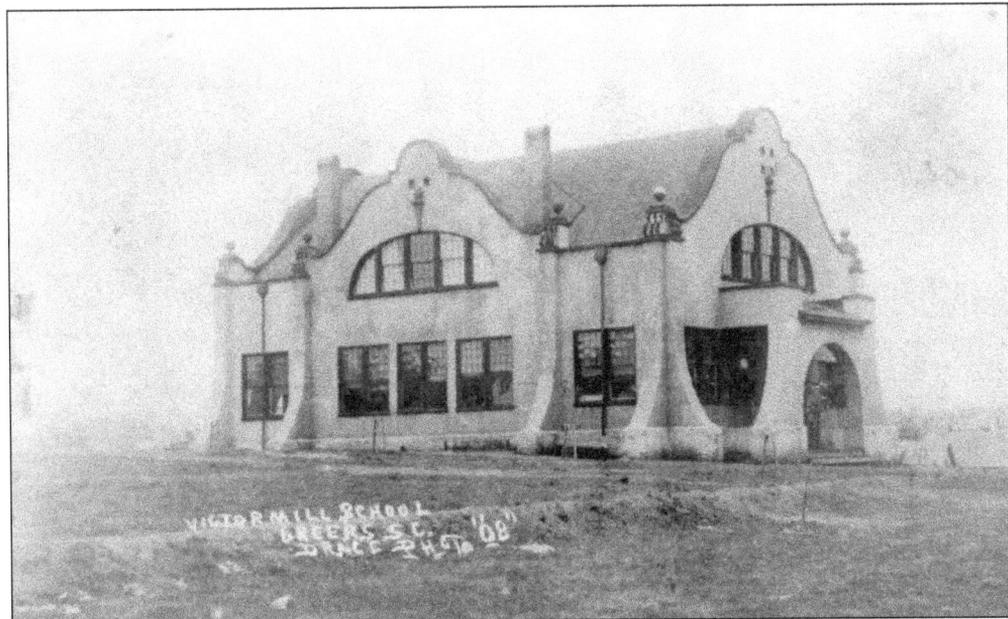

Victor Mill School, pictured here in 1908, served the children of the mill workers. In 1919, teachers were paid $100 a month. (Courtesy of South Caroliniana Library, University of South Carolina, Columbia.)

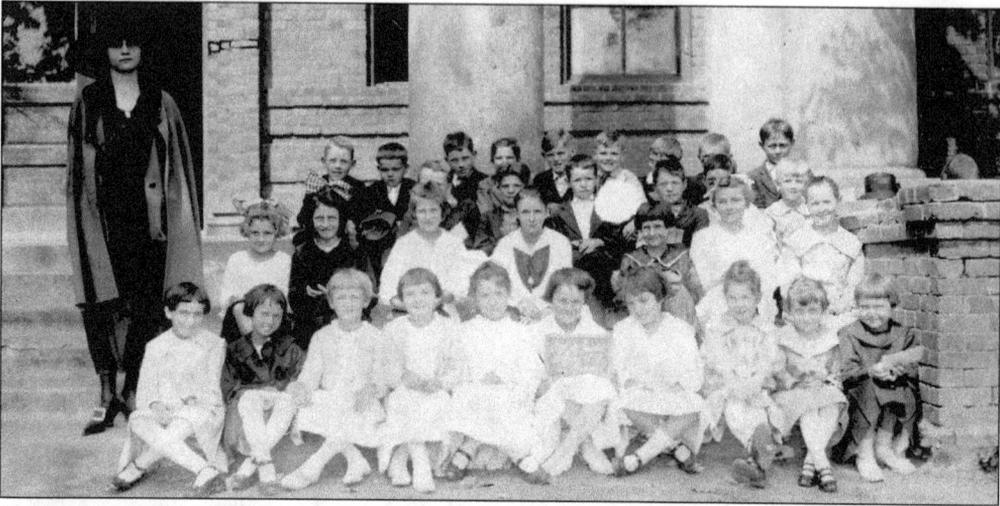

The Central School Class of 1919 poses with teacher Miss Nell Simpson. Pictured, in no particular order, are (first row) Ruby Shore, Pearl Bramlett, Mildred ?, Minnie Lee McCarter, Myrtle Jones, Ruth Wilson, and Mable Floyd; (second row) Carolyn Arnold, unidentified, Myrtle Ross, Eunice McAbee, Mabel Waldrop, Byril Ponder, and Grace ?; (third row) Glenn Smith, Egbert Littlefield, L.V. Mullins, unidentified, and James DeShields; (fourth row) Ansel Bailey, Fred Wood, Louis Duncan, Albert ?, Odell Woodward, Hugh Clayton, Robert Hyatt, Samuel Liester, and Henry Few. (Courtesy of Jean M. Smith Library.)

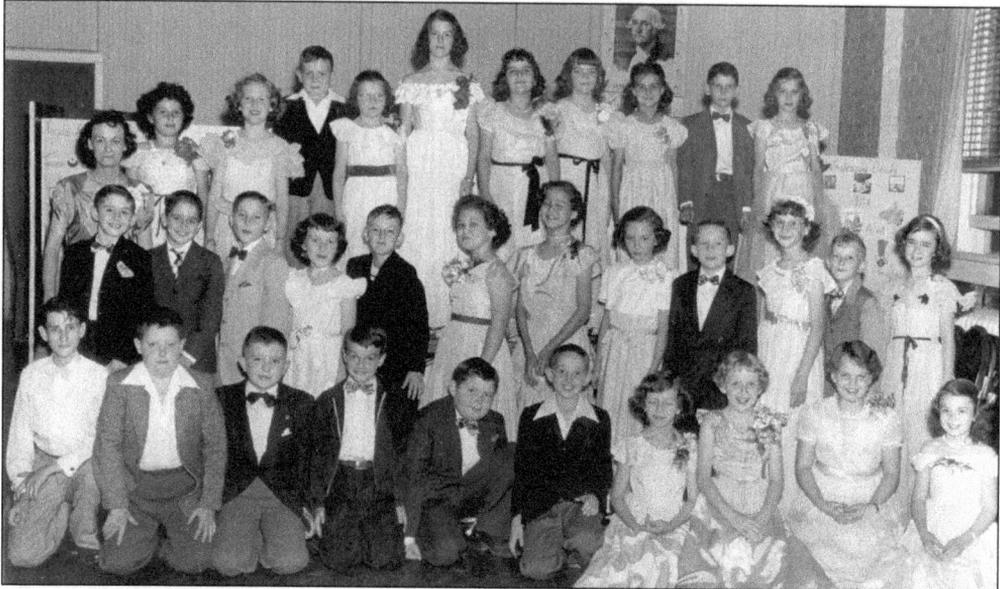

Miss Propes's fourth grade class at Central Elementary School is pictured c. 1950. From left to right are (front row) Hugh Ward, Billy Smith, Sammy Clayton, Mickey Terry, Michael Wynn, Perry Paris, Judy Henson, Abbie Frick, Brenda Jones, and Francis Payne; (middle row) Robert Duncan, Bobby Burgess, Steve Sullens, Faye Bruce, Don Massey, Joyce Thompson, Eula Mae Neely, Ann Dillard, Donnie Honeycutt, Alice Dempsey, Billy Beason, and Becky Smith; (top row) Miss Propes, Jean Edwards, Doris Godfrey, Jerry Massingale, Grace Stroud, Phillis Parker, Sarah Sanders, Barbara Howard, Mildred Christopher, Perry Jones, and unidentified. Not pictured are Jane Grant and Elenor Hannah. (Courtesy of Ann Withrow.)

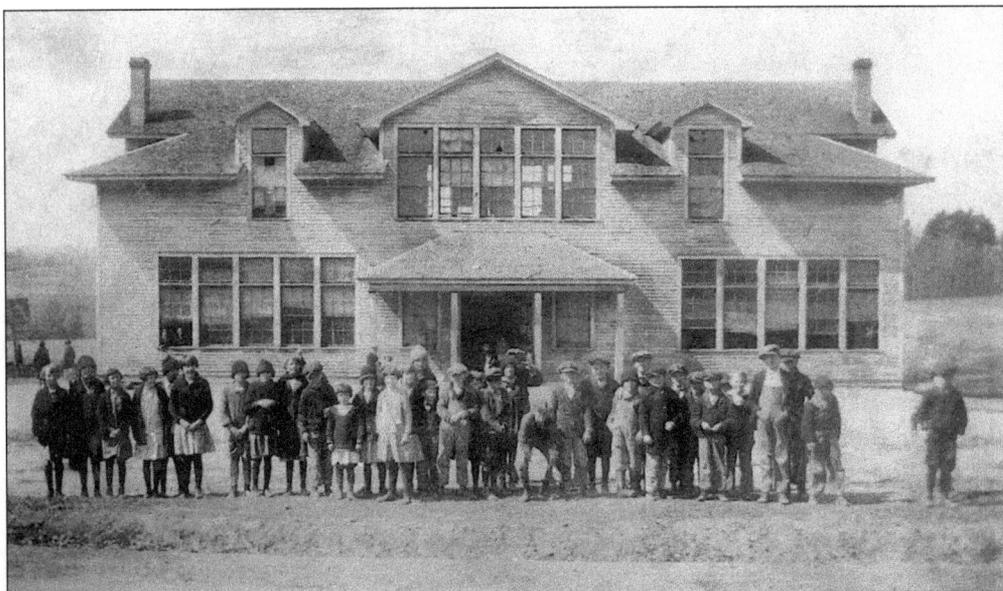

In 1900, the first schoolhouse in Pelham was converted from the existing clubhouse of the Pelham Mill. The mill hired a teacher until a new school could be built in 1914. (Courtesy of Francis Merritt and Evelyn George.)

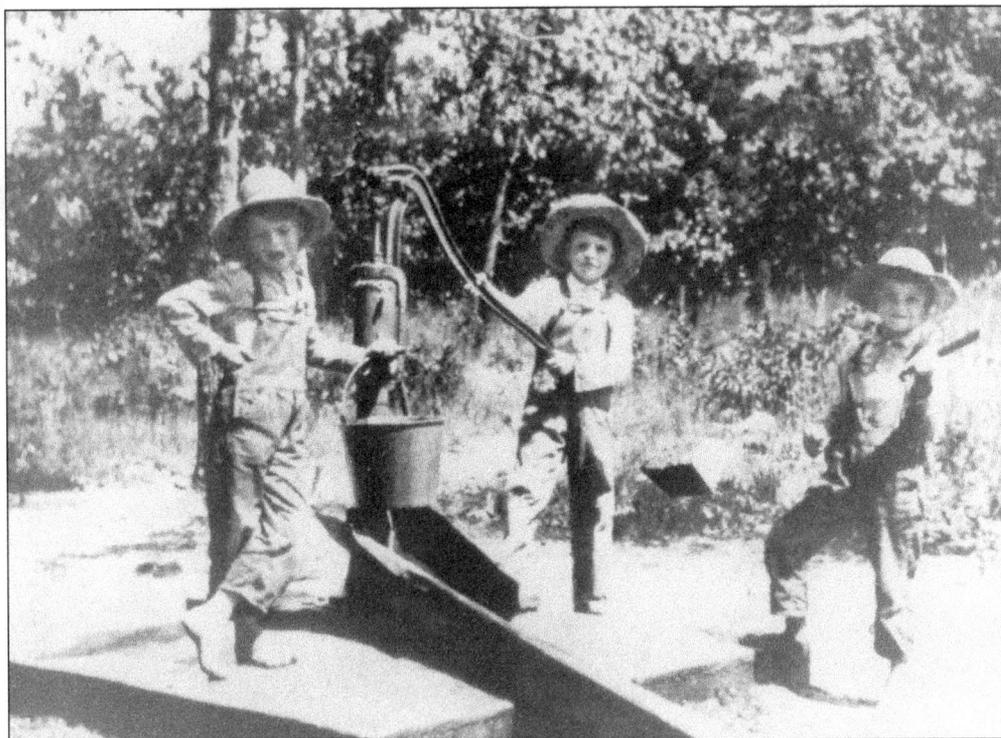

The Bishop triplets, pictured in this photo taken in 1921 at the old Fairview Elementary School, are pumping water for the classroom. From left to right are Frank, Fred, and Furman. (Courtesy of Sylvia Pitts.)

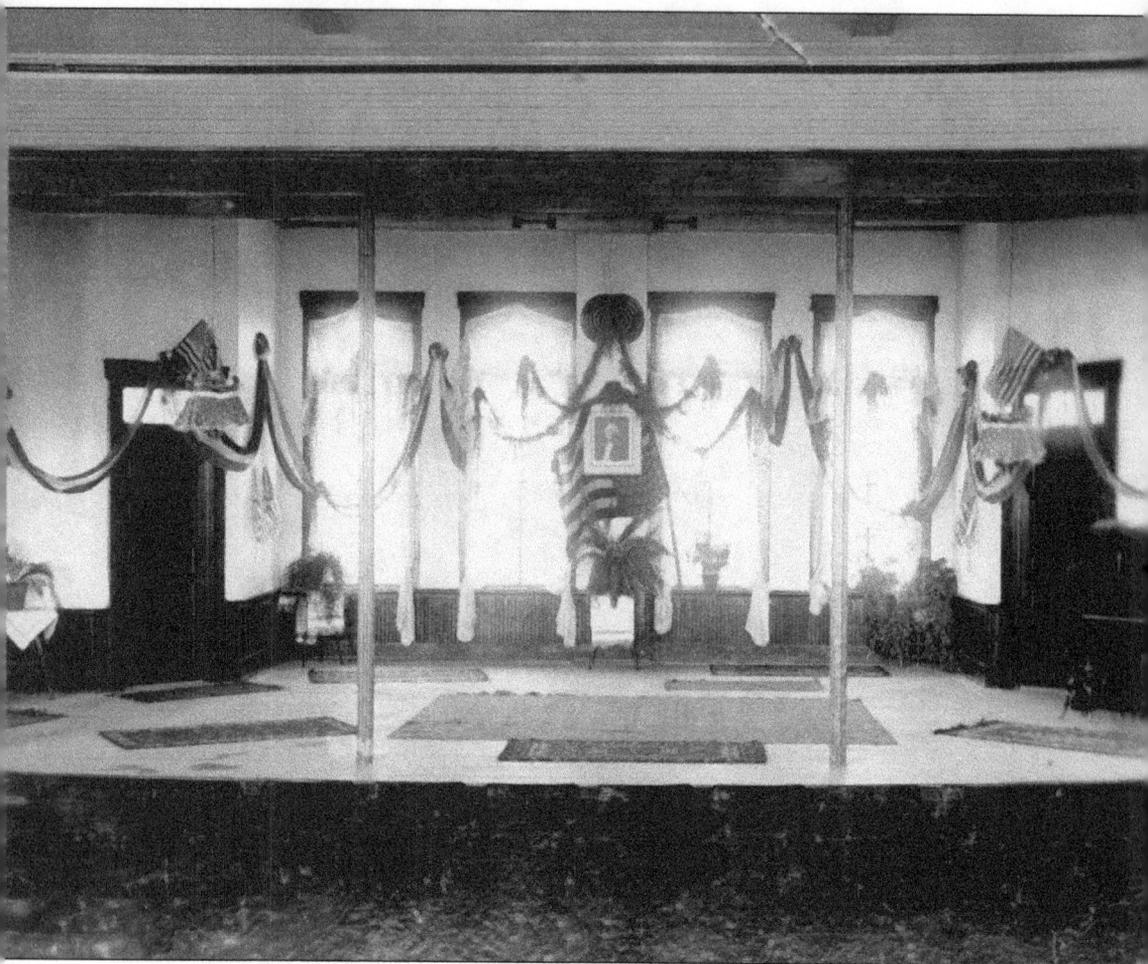

Central School auditorium is decorated for a patriotic occasion, probably Washington's birthday. (Courtesy of the estate of Robert S. Hughes.)

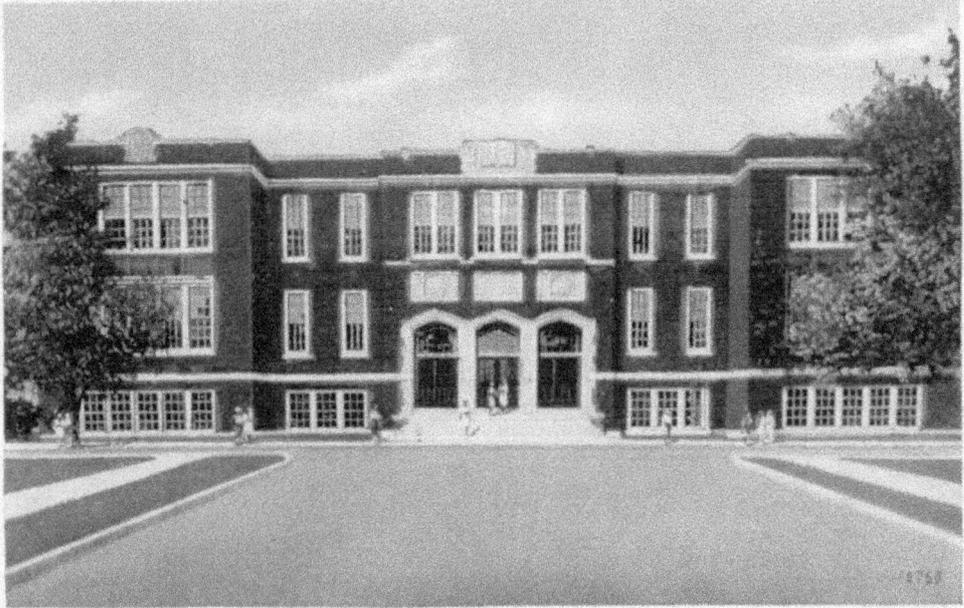

D.D. Davenport High School was built in 1925 on West Church on land donated by the Davenport family. It served as the junior high school after the new high school on North Main Street was built in 1952. (Courtesy of Thomas McAbee.)

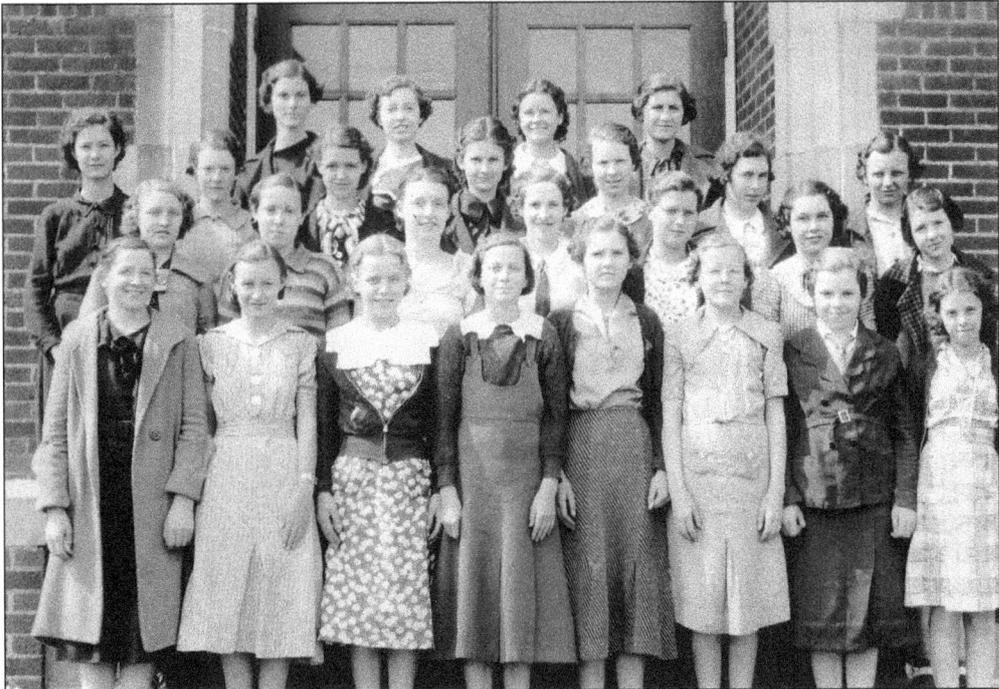

These young ladies pose for the camera in 1936 in front of Davenport High School, which was located on West Church. (Courtesy of Moise Dillard Smith.)

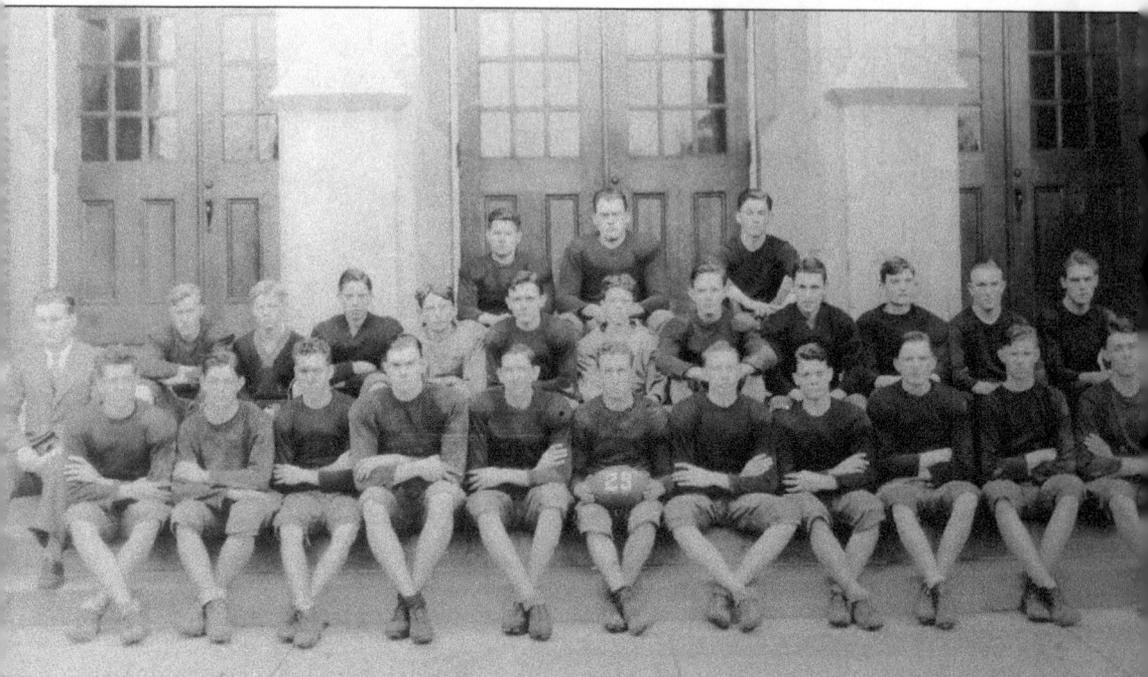

Seen here is the 1929 football team at Davenport High School. (Courtesy of George Beason.)

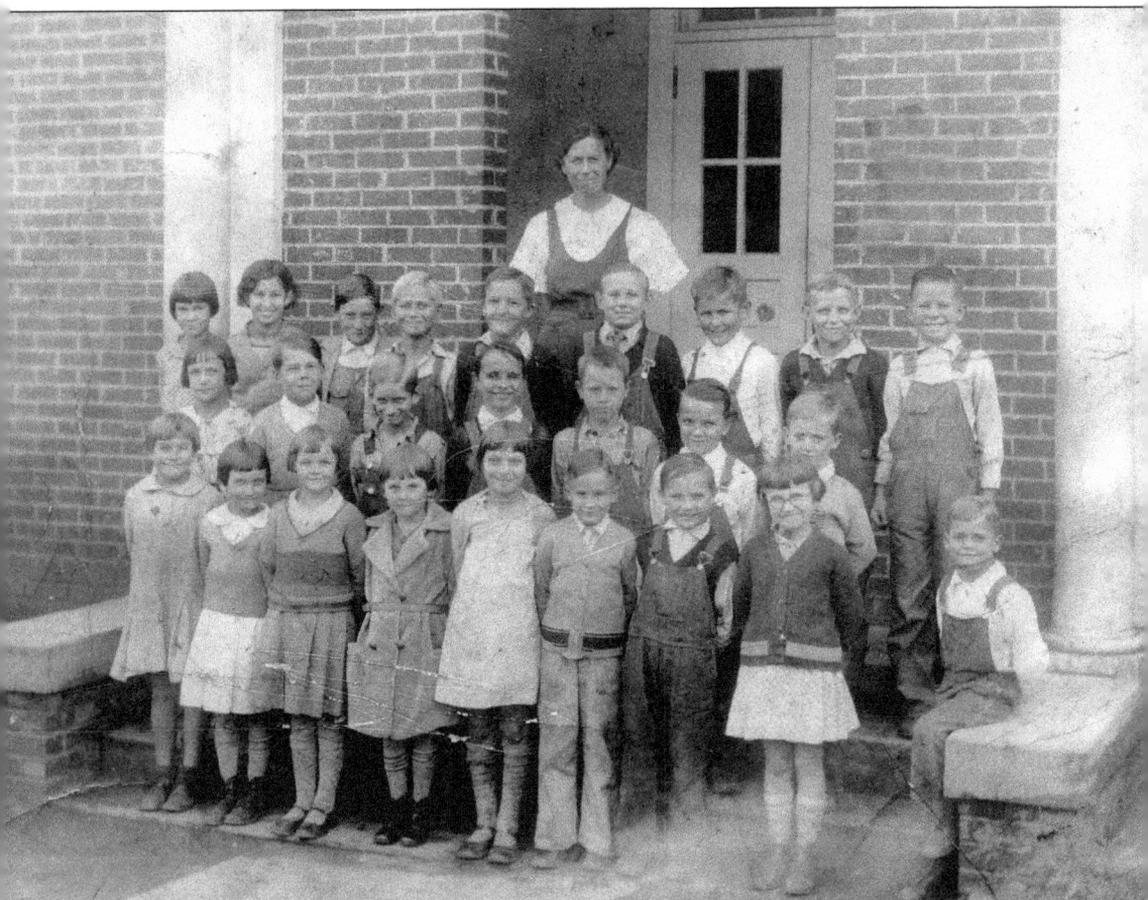

Apalache Elementary School is pictured in 1932. They did not have enough pupils that year for the first grade so the principal allowed five children to start at five years old. The teacher is Theo Marchant. In the front row are, from left to right, unidentified, Mary (Rector) Crower, Joyce (Ashmore) Smith, Madge Ashmore, three unidentified children, Peggy (Hester) Smith, and Bus Belue (seated). Belue, who retired as president and CEO of Citizen Building & Loan Association, also served on the Greer City Council for one three-year term, 1969–1971. (Courtesy of Bus Belue.)

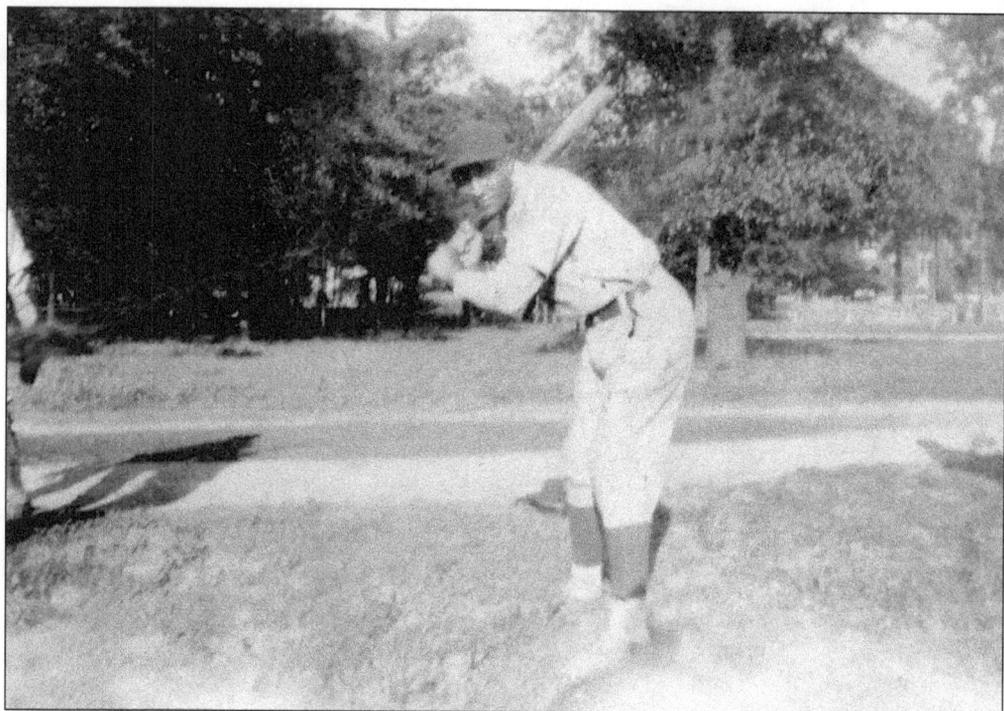

Holmes Thompson was the first principal of Lincoln High School. (Courtesy of Margarett Turner.)

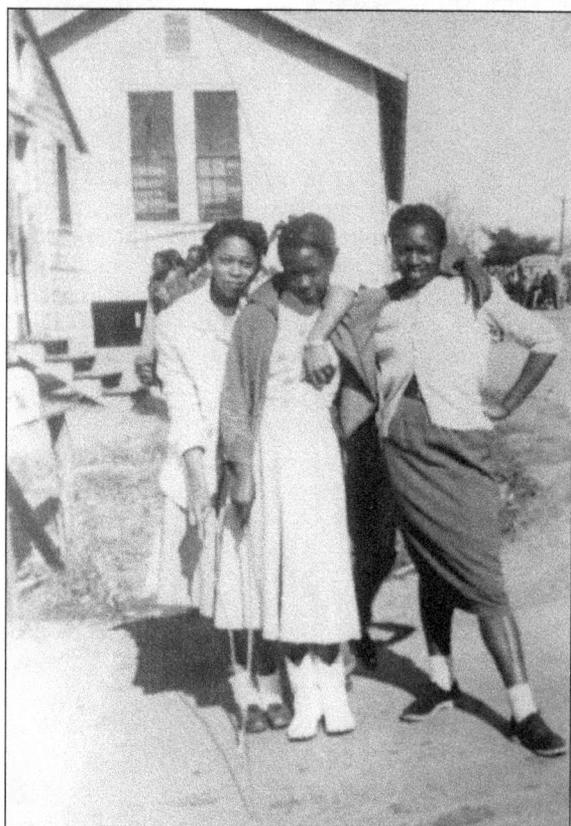

Three friends outside Dunbar High School are Joe Ann Smith (left), Hattie Mae Martin (center), and Mary Ann Williams. (Courtesy of Margarett Turner.)

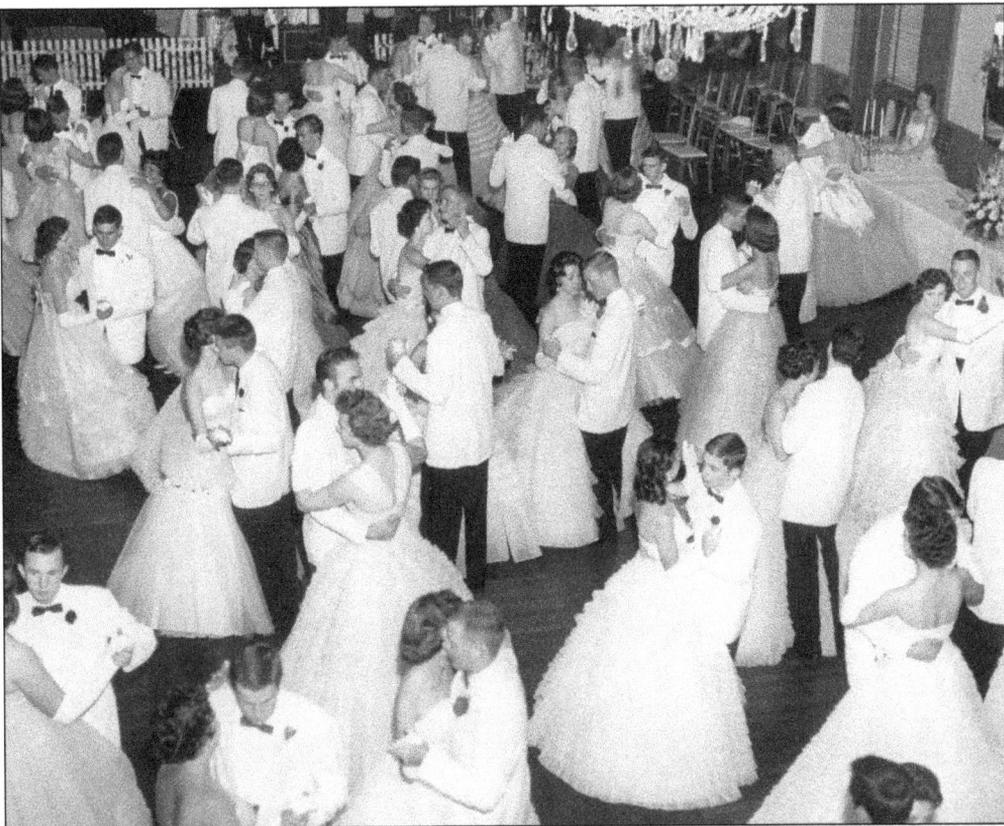

The junior-senior prom at Greer High School is pictured in 1960. (Courtesy of Marsha Strong.)

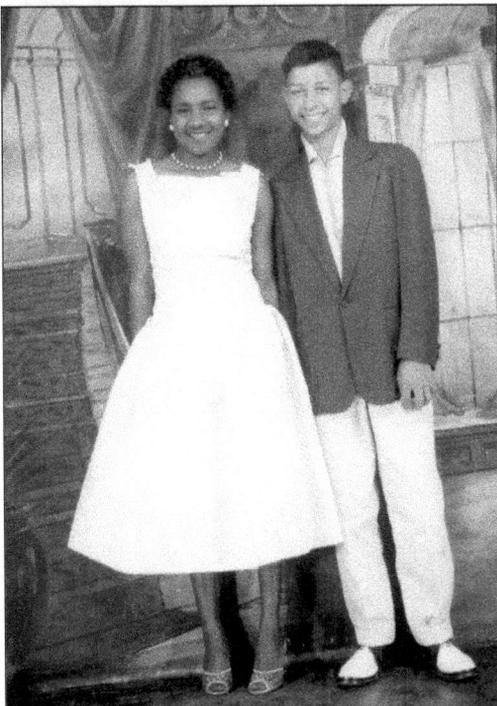

Getting ready for the 1957 Prom at Lincoln High School are Thomaseena Duckett and Everett Gregory. (Courtesy of Margarett Turner.)

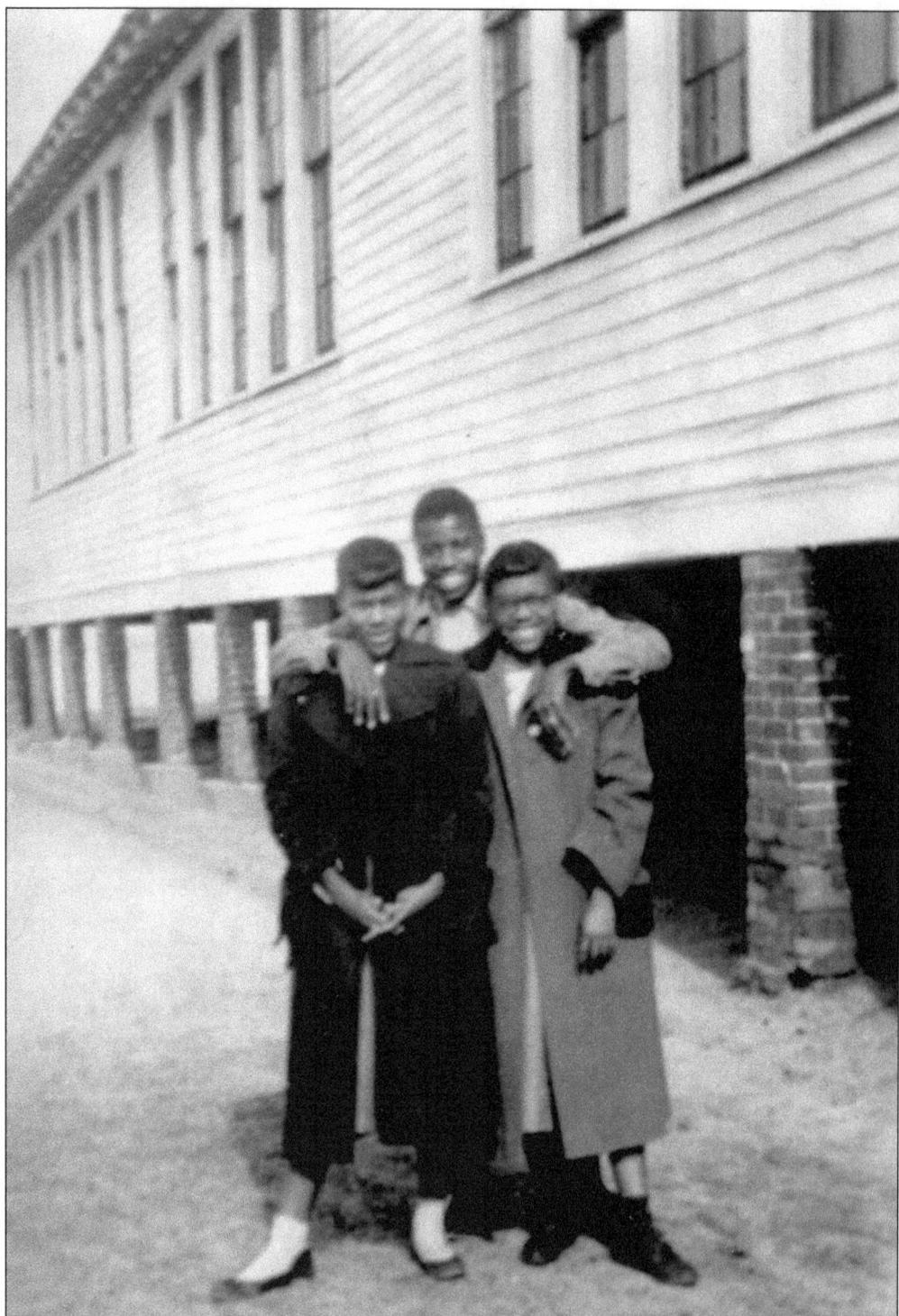

Three friends ham it up for the camera outside of Dunbar High School in the 1950s. From left to right are Maxine Goldsmith, Bobby Everett, and Doris King. (Courtesy of Margarett Turner.)

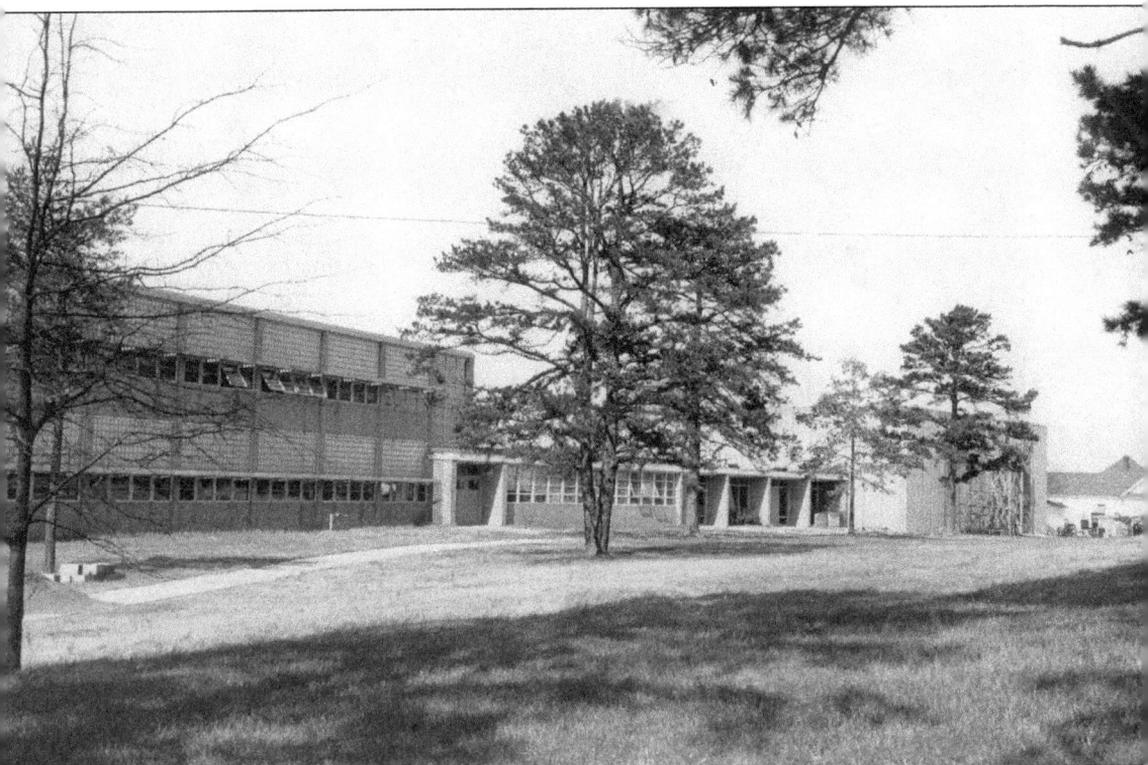

This photo of the old Greer High School on North Main Street was taken in 1957. Note the auditorium, which is under construction. (Courtesy of Harold James.)

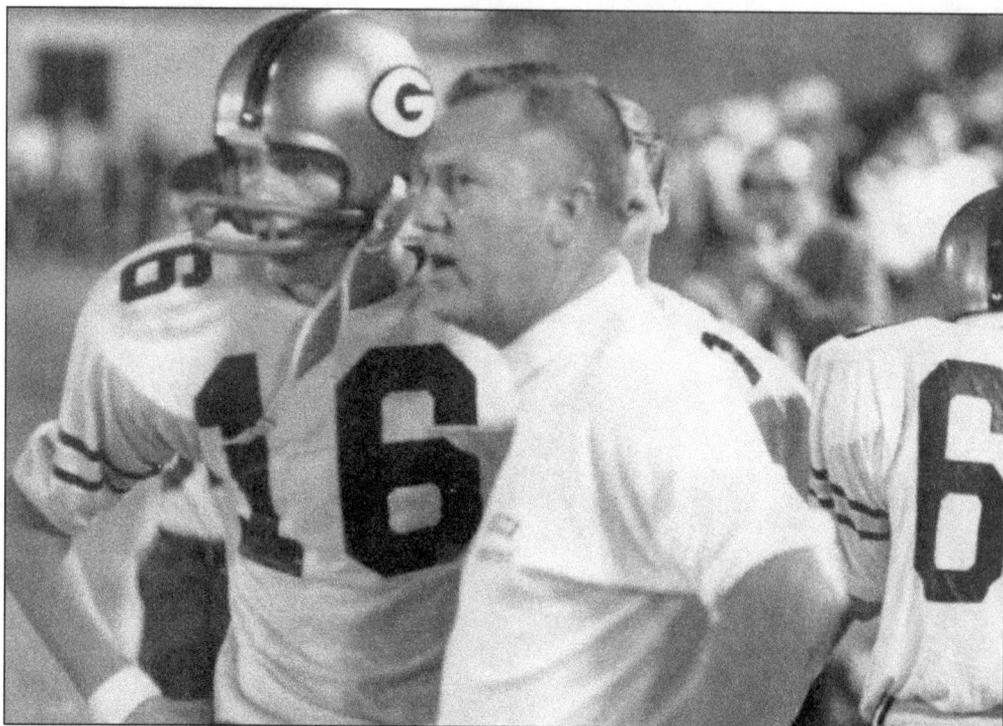

Phil Clark coached at Greer High School from 1950 to 1969 and was athletic director until 1978. He won 126 games in his career. The player pictured with Coach Clark is Billy Joe Stewart, an outstanding quarterback. (Courtesy of Phil Clark.)

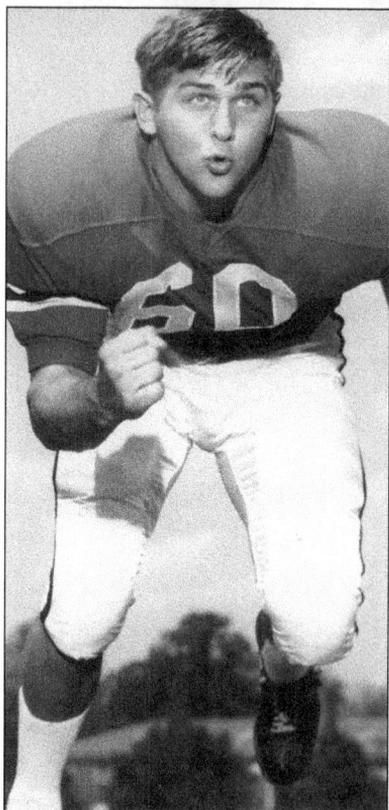

Greer High School standout Steve Greer was honored as an All American at the University of Georgia. (Courtesy of Phil Clark.)

Six

WORSHIP IN GREER

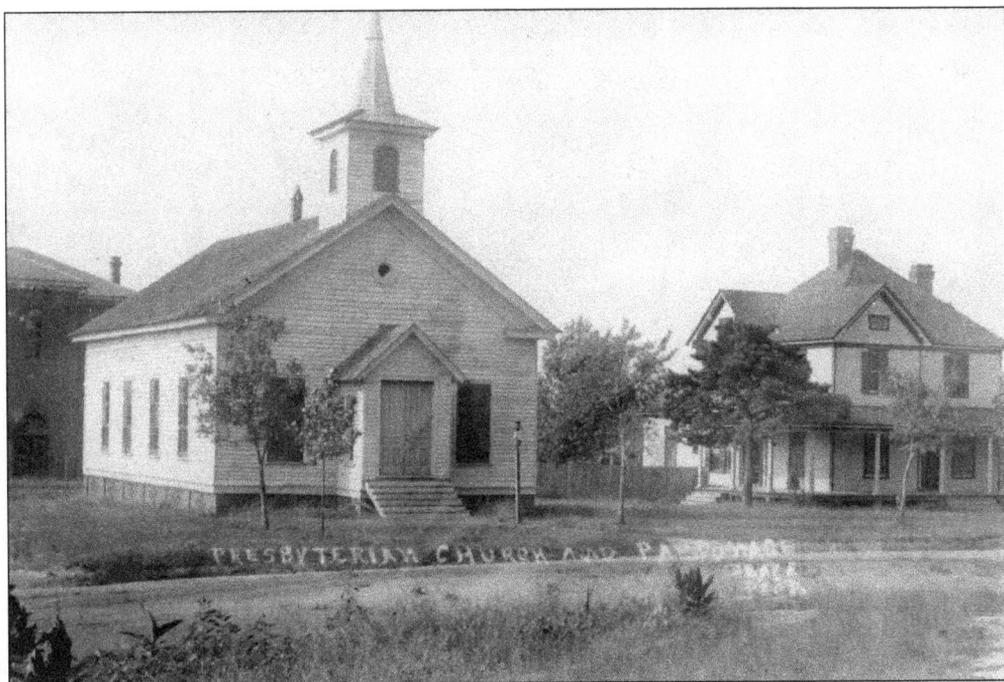

The first church in Greer was the Mt. Tabor Presbyterian Church, pictured here in a 1912 postcard. The wooden church was dragged by mules to town from Bailey's Crossroads when the members moved into Greer as the town was being developed near the train depot. It became the First Presbyterian Church of Greer and has remained at the same site on South Main Street to the present day. Beside the church is pictured the parsonage, which is no longer standing. (Courtesy of Joe Bearden.)

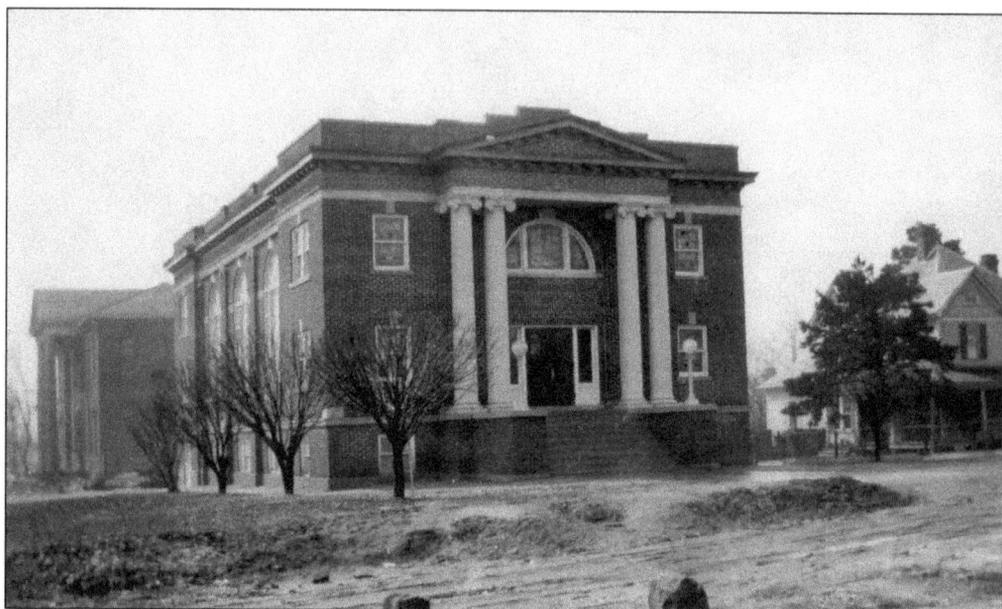

Organized in 1840 as Mt. Tabor Presbyterian Church, the First Presbyterian Church of Greer literally moved to Greer in 1880 when the white frame building was rolled onto logs and pulled to town by mules. The new 1923 building shown here was built in front of Central School, seen in the rear. (Courtesy of Jean M. Smith Library.)

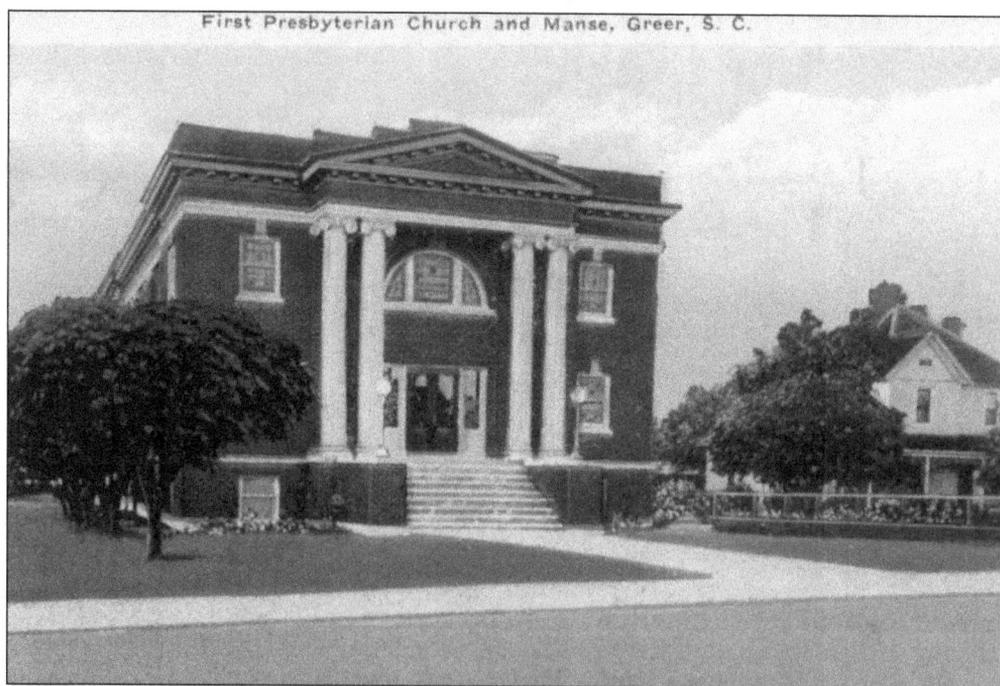

In 1840 the First Presbyterian Church was organized as the Mt. Tabor Presbyterian Church. In 1880 the church was relocated to land, donated by W.T. Shumate, near the depot. It was torn down in 1922, and the present structure, pictured here, was built in 1923. (Courtesy of Thomas McAbee.)

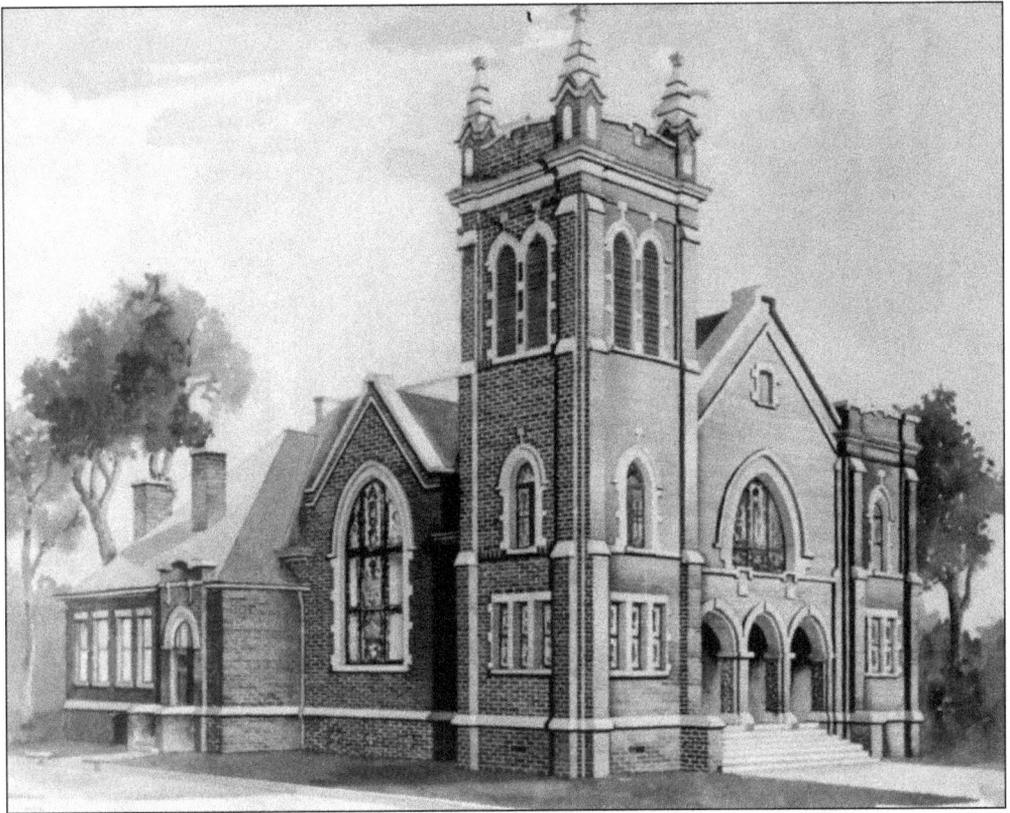

Memorial Methodist Church was founded in 1882. In 1912 the Methodists built this second building on North Main under E. Toland Hodges, pastor. In 1922, the name was changed from Greer Methodist Church to Memorial Methodist. (Courtesy of Joe Bearden.)

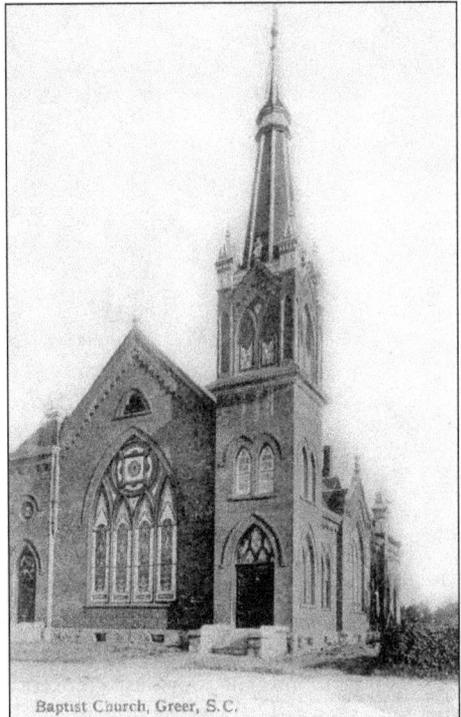

Baptist Church, Greer, S.C.

In 1906 this building was erected across from the present First Baptist Church, on the righthand corner of Miller and West Poinsett. The pastor was H.L. Riley. (Courtesy of Joe Bearden.)

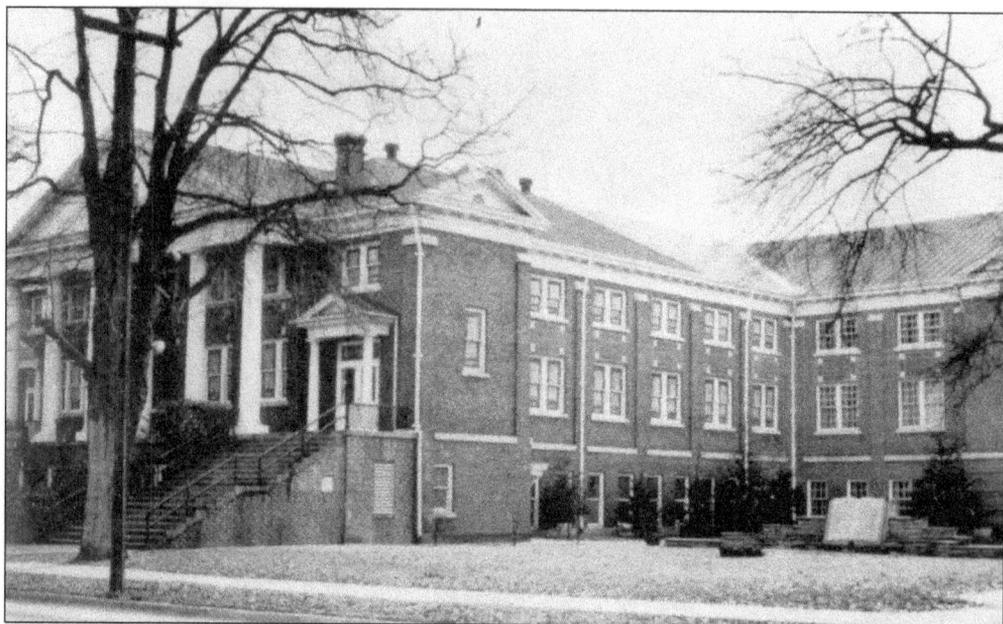

Greer First Baptist Church, organized in 1880 by Rev. J.C. Furman, dedicated its third building at 200 West Poinsett Street in 1924. (Courtesy of Thomas McAbee.)

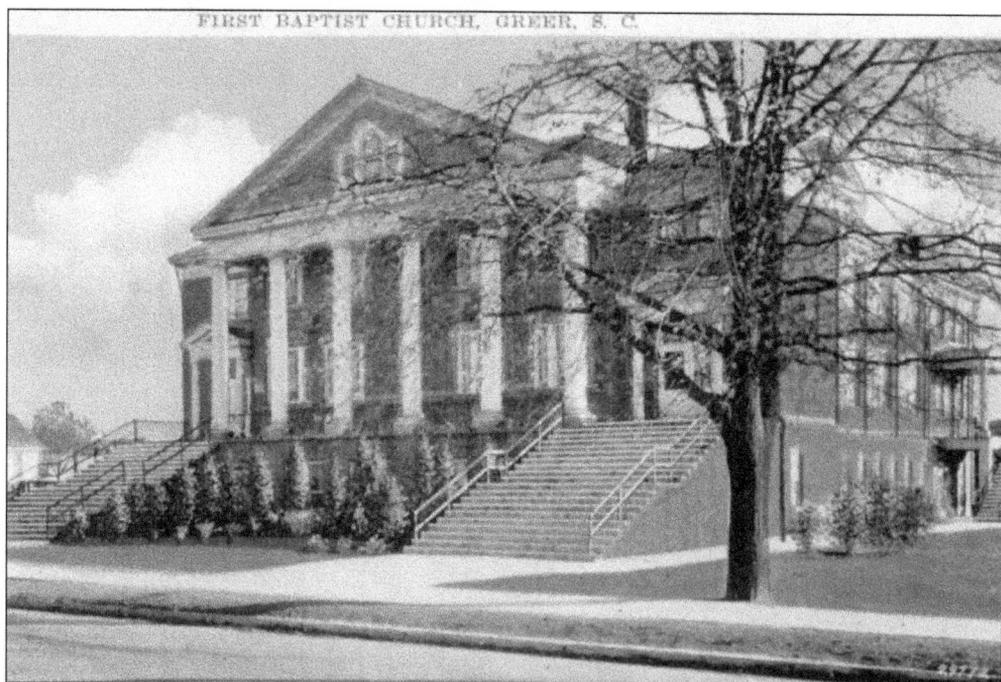

First Baptist Church at 200 West Poinsett Street added the educational wing in 1950, shown in this 1958 postcard. (Courtesy of Jean M. Smith Library.)

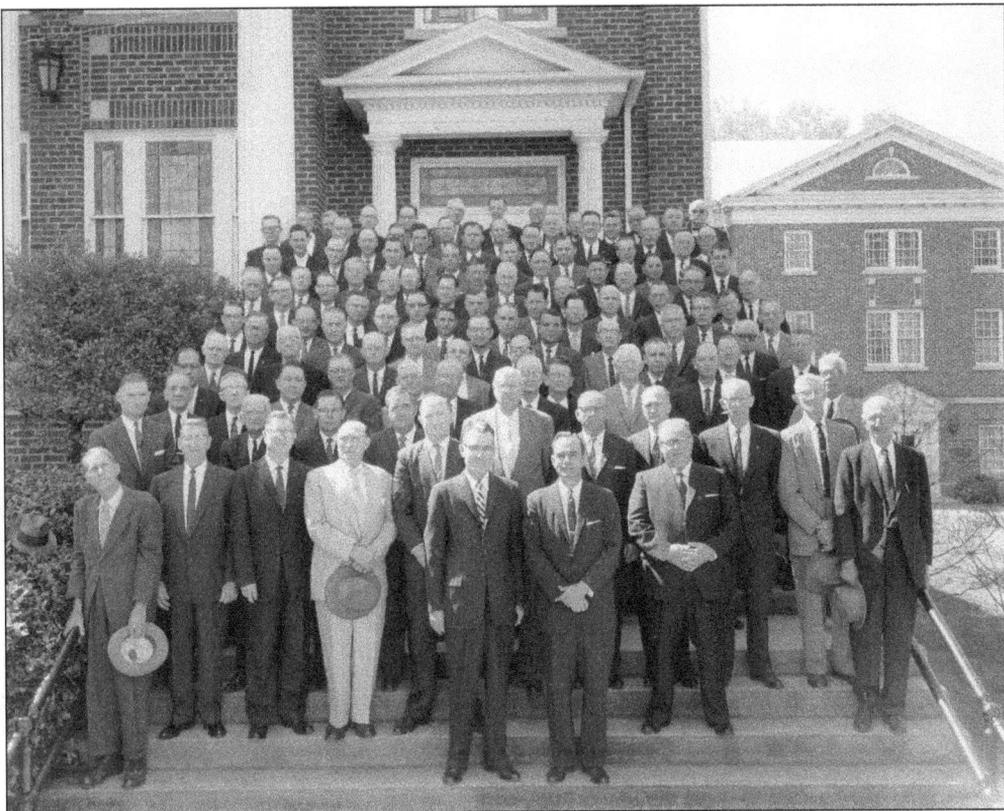

The Baraca Sunday school class is pictured at the First Baptist Church. (Courtesy of Marlea Rhem.)

Another photo shows the Baraca Sunday school class in 1961. (Courtesy of Marlea Rhem.)

Cedar Grove Baptist Church was organized in the late 1920s by Brother ? Amos and Sister Florence Amos. The first sanctuary was on Lorla Street and Rev. W.A. Anderson was pastor. (Courtesy of John McCarroll.)

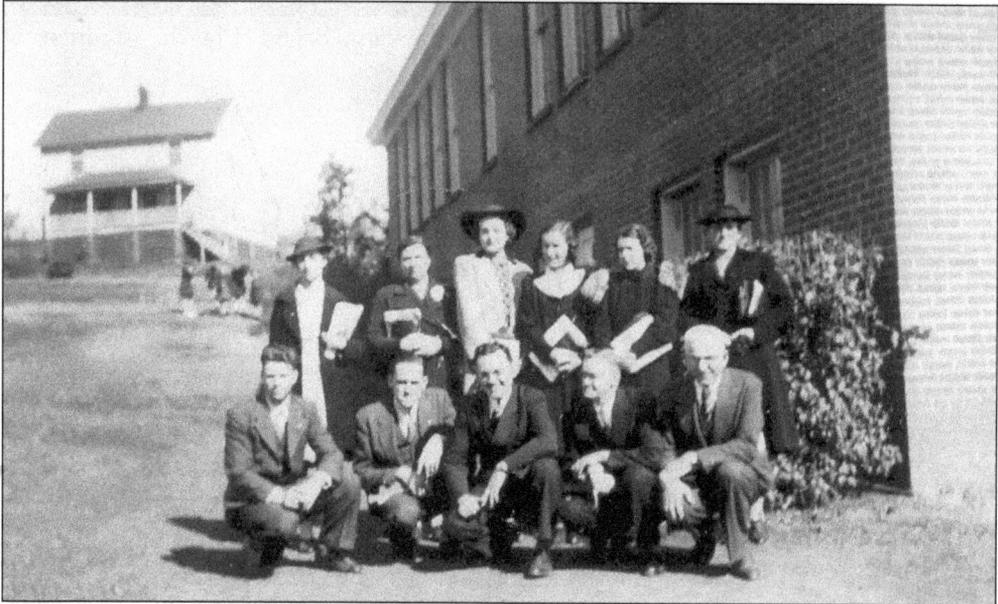

Apalache Baptist Sunday school teachers pose behind the church in early 1941. On the front row are, from left to right, Charlie Belue, Festus Patton, Earl Shelton, Tom Ammons, and "Big" Bill Wilson. On the back row are, from left to right, Mrs. Festus Patton, Irene Wilson, Annie Kate Farmer, Ruby Wilson, Ruby Belue Shelton, and Dolly Farmer. (Courtesy of Jean M. Smith Library.)

Seven

PEACHES

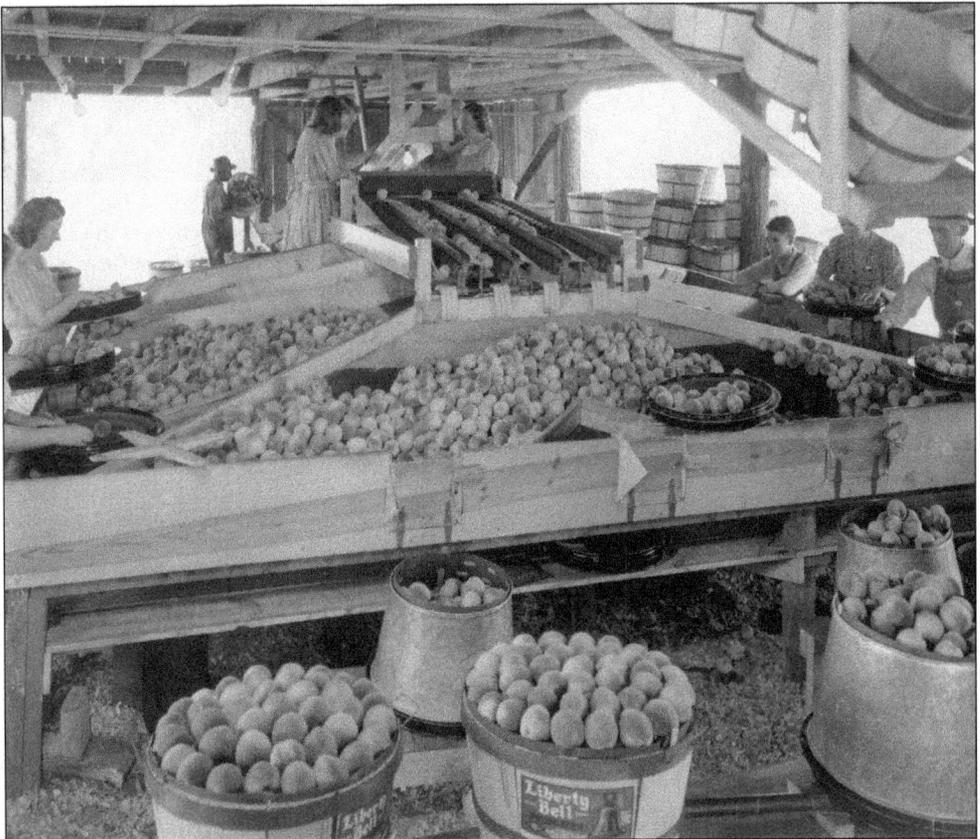

The Troy Dillard Peach shed was a busy place during the mid–1940s. Moise Dillard Smith is ringing peaches on the far left while Inez DeShields Kinard (third from left) is at the peach grading machine. (Courtesy of Moise Dillard Smith.)

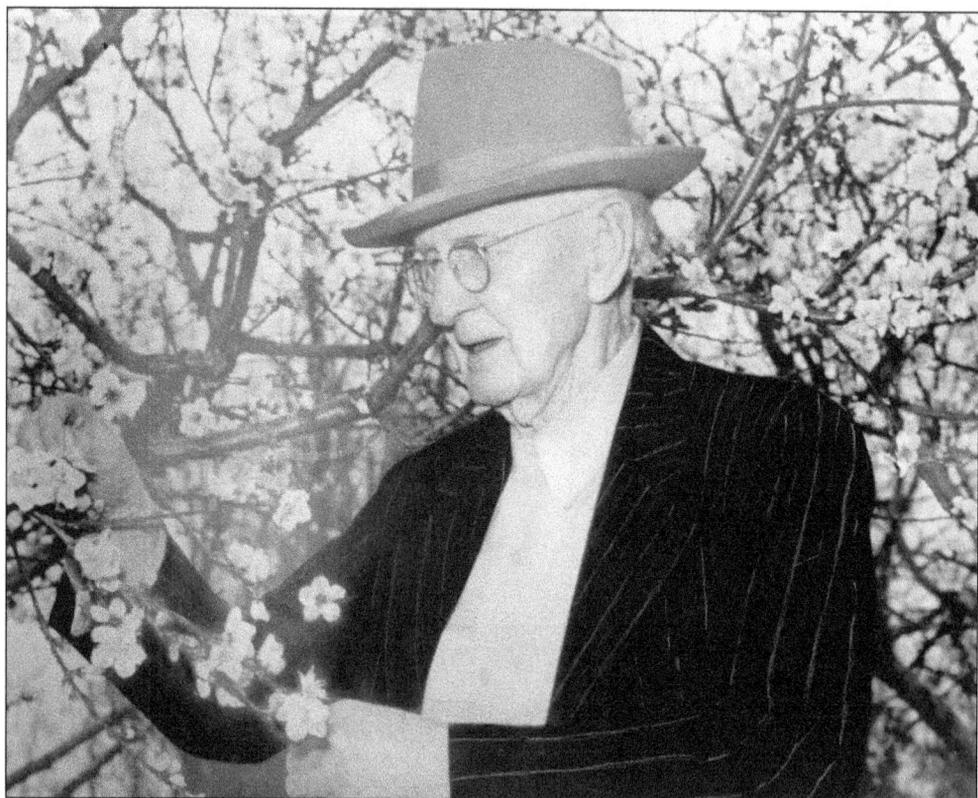

James P. Taylor (1867–1958) was one of the early peach growers in Greer, at Taylor Orchards. (Courtesy of Karolyn Taylor.)

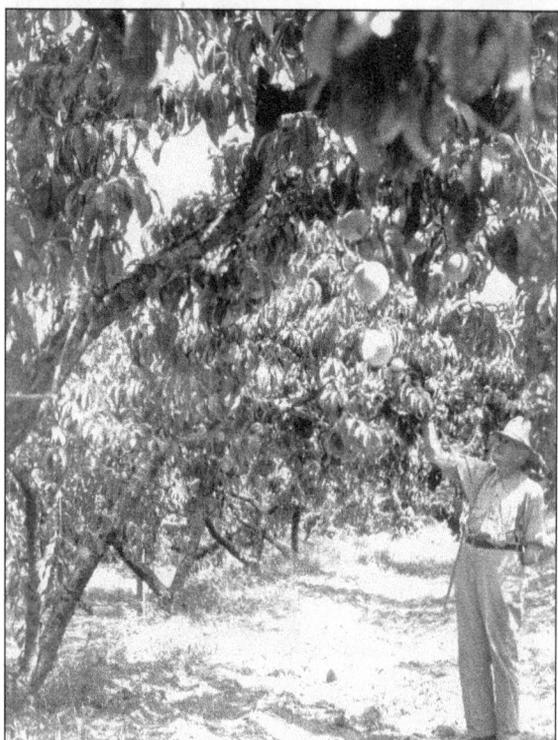

The Mt. Vernon Orchards, the oldest peach orchard in South Carolina, were planted in 1901 by J. Verne Smith Sr. The trees were 10 feet apart and the rows were 20 feet apart. Pictured is Will Holtzclaw in 1939. Mr. Holtzclaw lost his left forearm in a cotton gin. (Courtesy of Sen. J. Verne Smith.)

Peach baskets loaded on a Dillard farm truck head to the fields. (Courtesy of Moise Dillard Smith.)

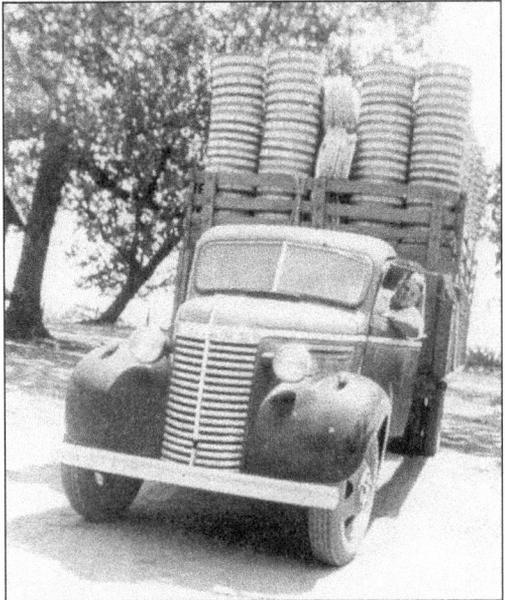

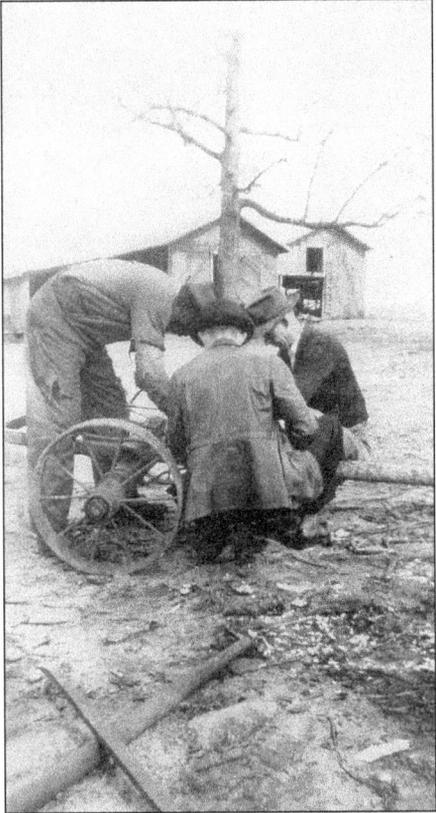

This photo was taken on the Troy Dillard farm on Gibbs Shoals Road. From left to right are Troy M., Ben H., and Perry Dunbar Dillard, working on a harrow. (Courtesy of Moise Dillard Smith.)

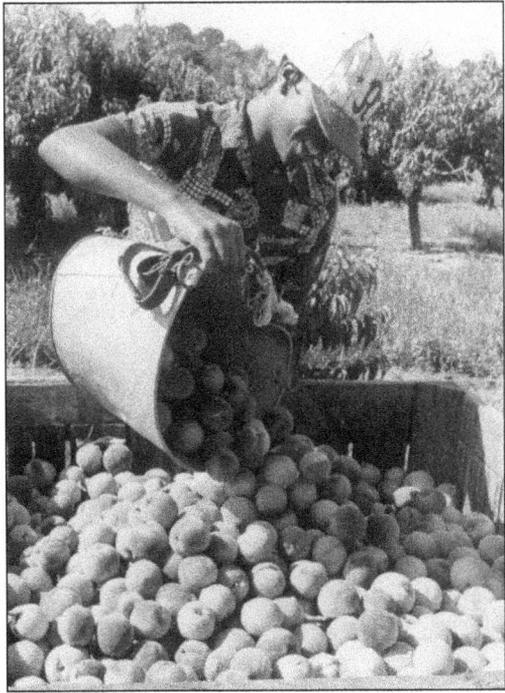

Melvin Mansell Powers was one of the dedicated peach harvesters/pickers at Taylors Orchard. (Courtesy of Karolyn Taylor.)

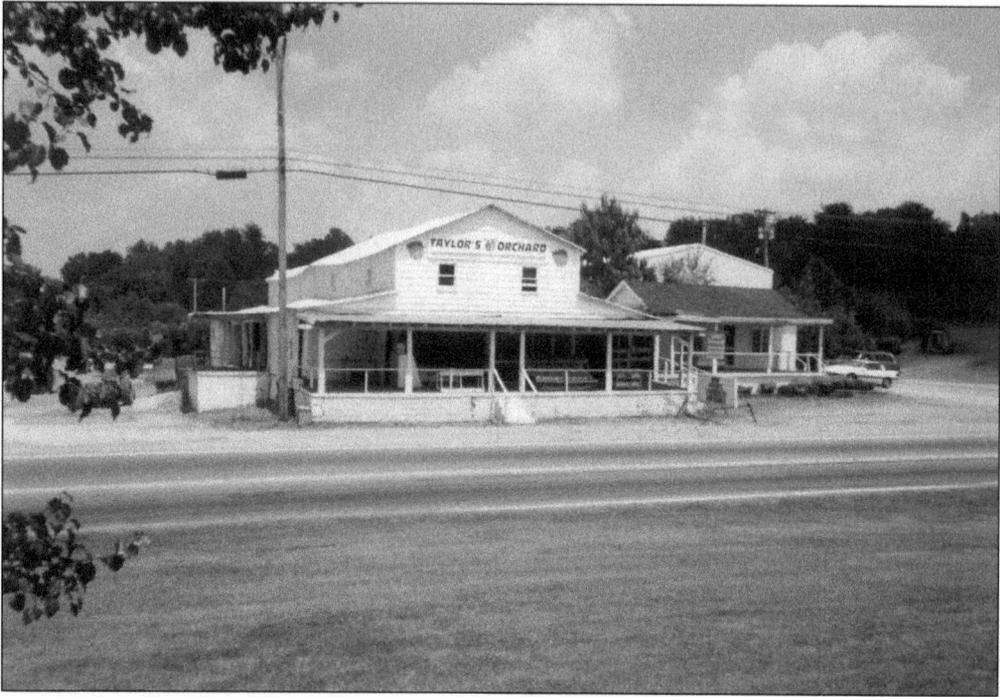

The Taylors' peach shed is a familiar sight at the divide of Highway 290 North and 101. Land all around the shed comprised the Taylors' farm, where trees produced bumper peach crops to be bought locally and shipped out of state. (Courtesy of Karolyn Taylor.)

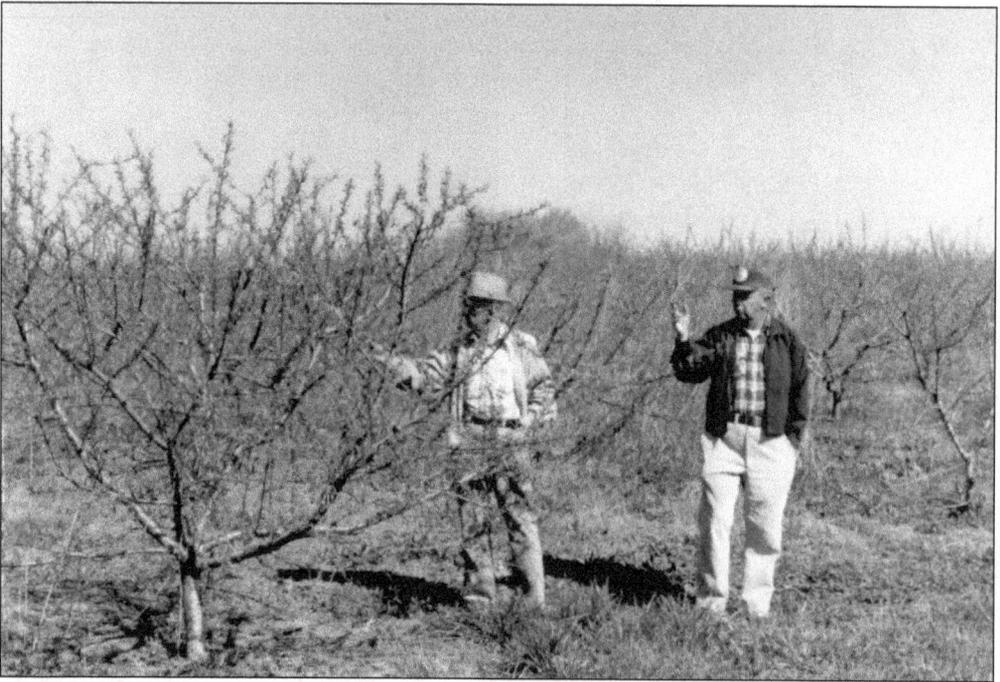

Earle Taylor and son Richard inspect the peach blossoms. (Courtesy of Karolyn Taylor.)

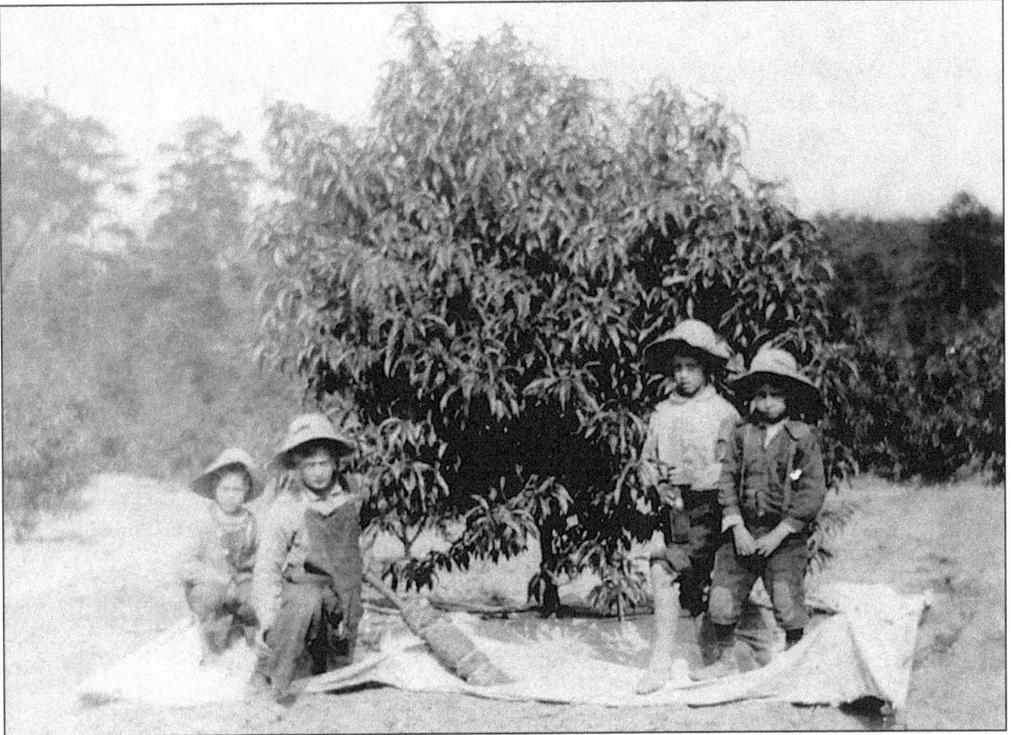

Pictured in the Mt. Vernon Orchard are Earle Taylor, Beco Taylor, Spartan Taylor, and an unidentified child. In 1924 the orchard hit a record of shipping 3,780 crates of peaches. (Courtesy of Sen. J. Verne Smith.)

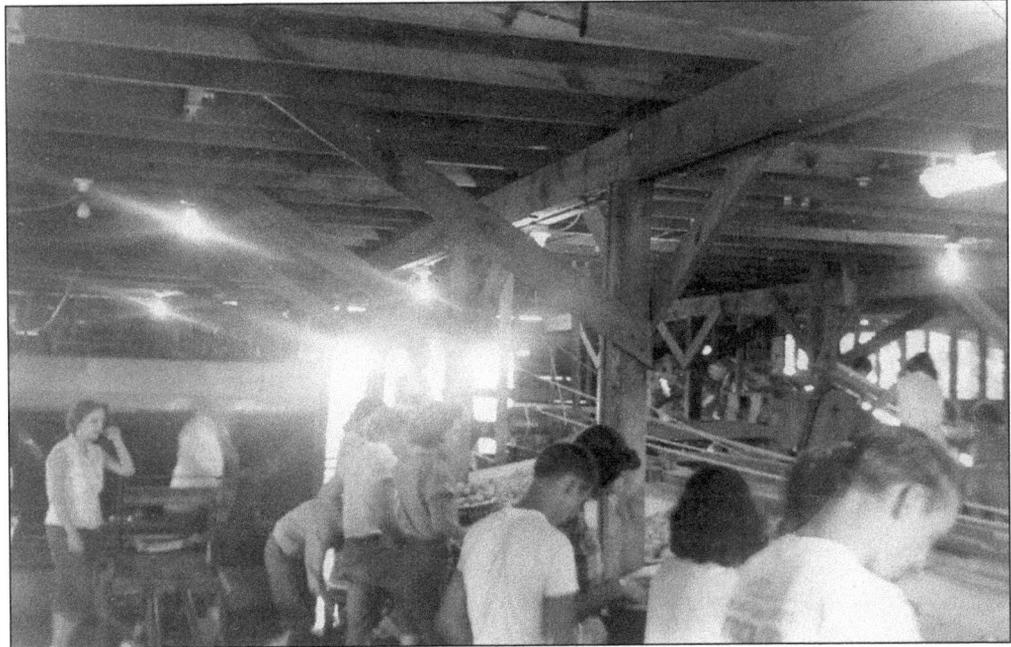

Teenagers are seen working at the Palmer Dillard orchards in 1958. (Courtesy of Ann Withrow.)

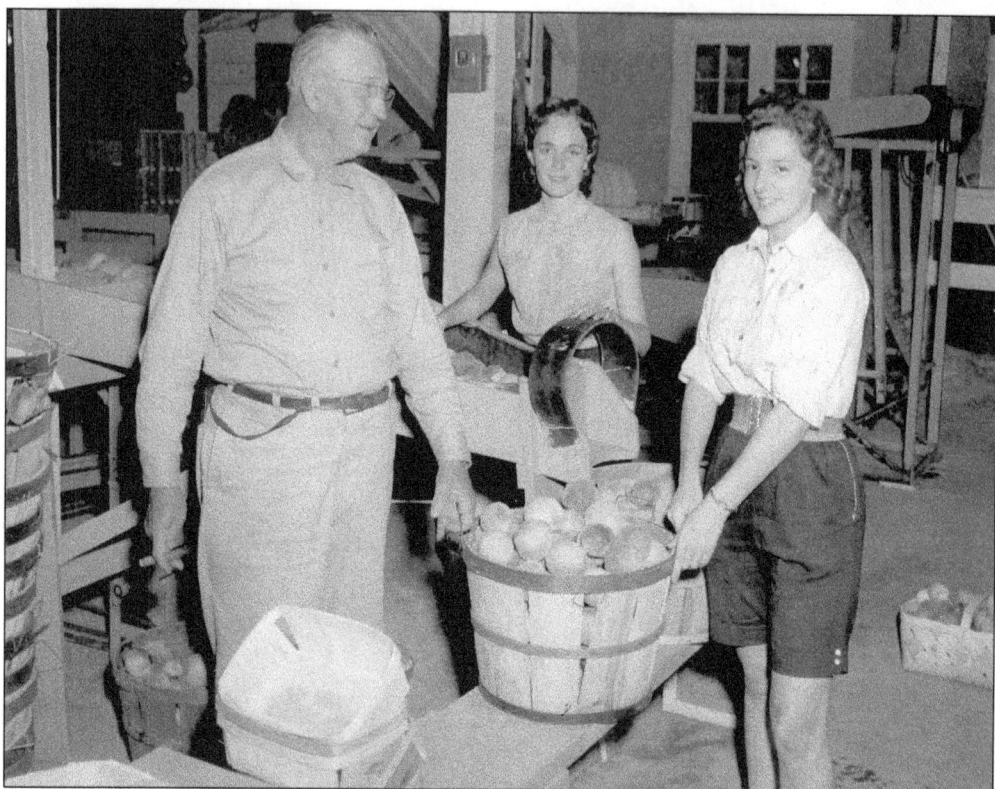

Working at Taylors Orchard in 1957, from left to right, are foreman Jess Bramlett, Susan Jackson, and Dixie Bradshaw. (Courtesy of Karolyn Taylor.)

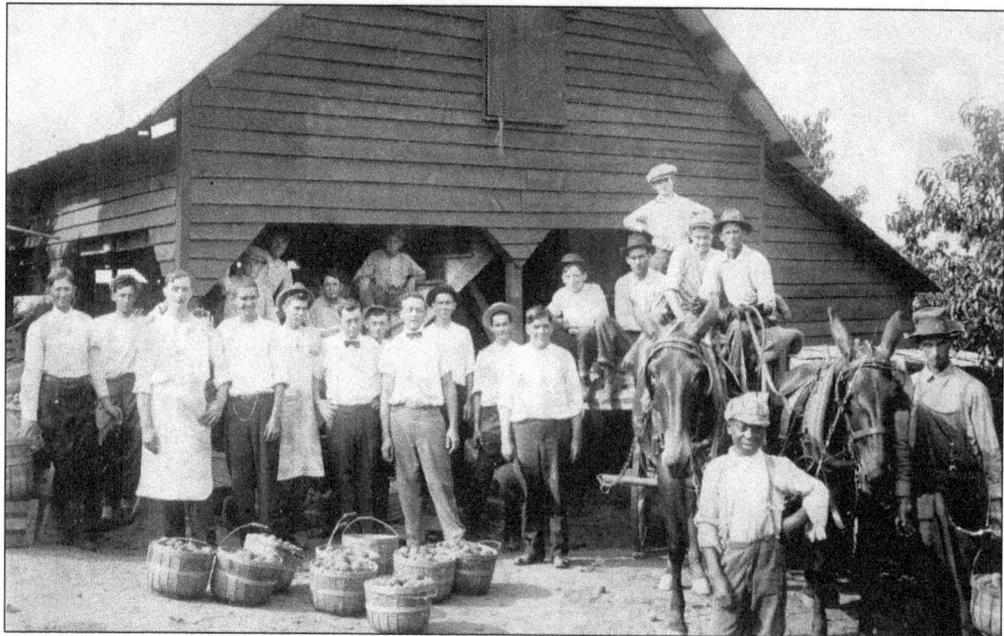

This 1914 scene is from the Mt. Vernon Orchards, owned by J. Verne Smith Sr. (Courtesy of Sen. J. Verne Smith.)

Eight

TEXTILES

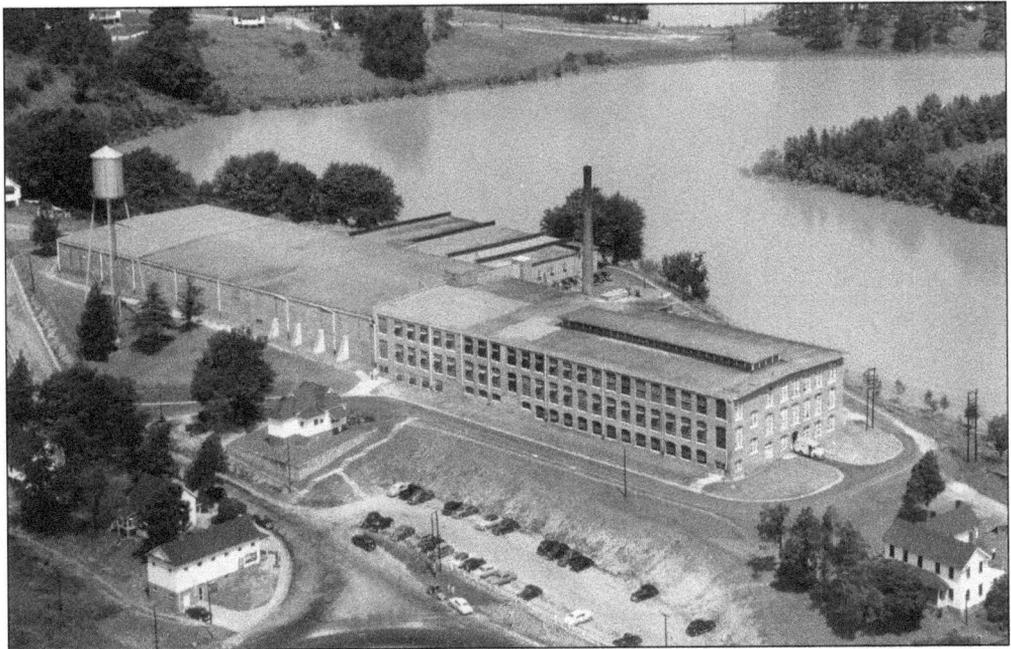

Apalache Mill, pictured here about 1948, sits on the site of Cedar Hill Factory (also called Wallace Factory), which was started in 1820 by Rev. Thomas Hutchings from Rhode Island. In 1888, it became Arlington Cotton Mill. In 1900, it was renamed Apalache Mill when this building was built. The white building in the lower left is the mill store and post office (postmark "Arlington Rural Station"), which was later destroyed in a gas explosion and fire. (Courtesy of Bus Belue.)

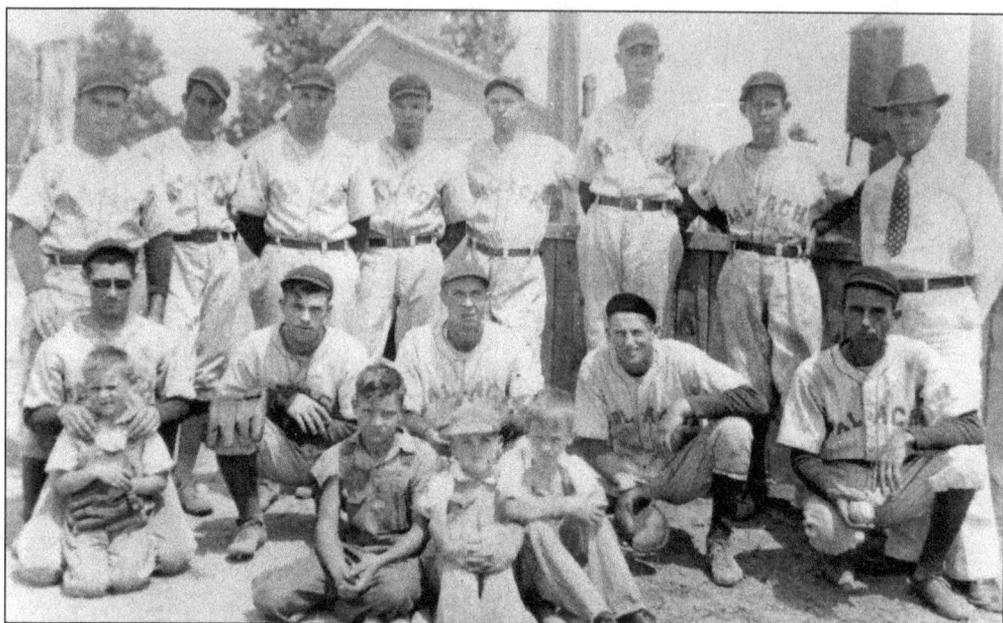

The Apalache Baseball Team is pictured in the 1930s. From left to right are (front row) Lamar Leopard, Wallace Leopard, Bus Belue, and Welton Tapp; (middle row) Bob Leopard, Claude Belue, Gurley Bishop, Peck Ballenger, and Ammon Leopard; (back row) Woodrow Blackwell, Dood Lunny, Earl Belue, Ennis McCarter, Clyde Tapp, Brodus Tapp, Roy Blackwell, and Walt Belue. (Courtesy of Bus Belue.)

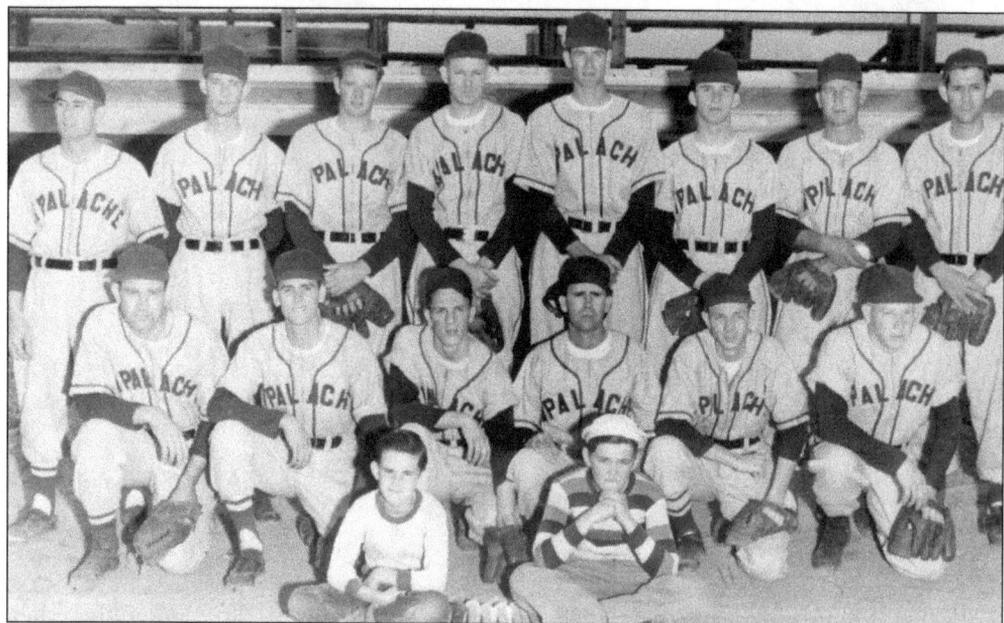

The Apalache Baseball Team is pictured in the 1950s. From left to right are (front row) Ronnie Edge and Mickey Lunny; (middle row) Ralph Bogan, Bus Belue, Eddie Leopard, Gus Watson, Rudolph Ashmore, and Arthur Belue; (back row) Woodrow Blackwell, Romaine Mitchell, Owen Dean Seay, Joyce Pruitt, Carl Ray Tillotson, Floyd Edge, Ernie Vaughn, and Ed Blackwell. (Courtesy of Bus Belue.)

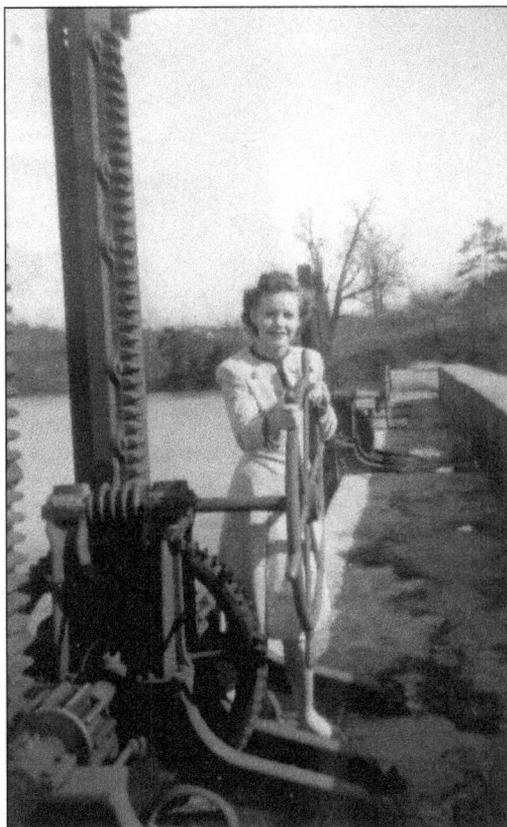

Bobbie (Moss) Tweed stands on the flood gates at Apalache Mill Dam in 1943. (Courtesy of Bus Belue.)

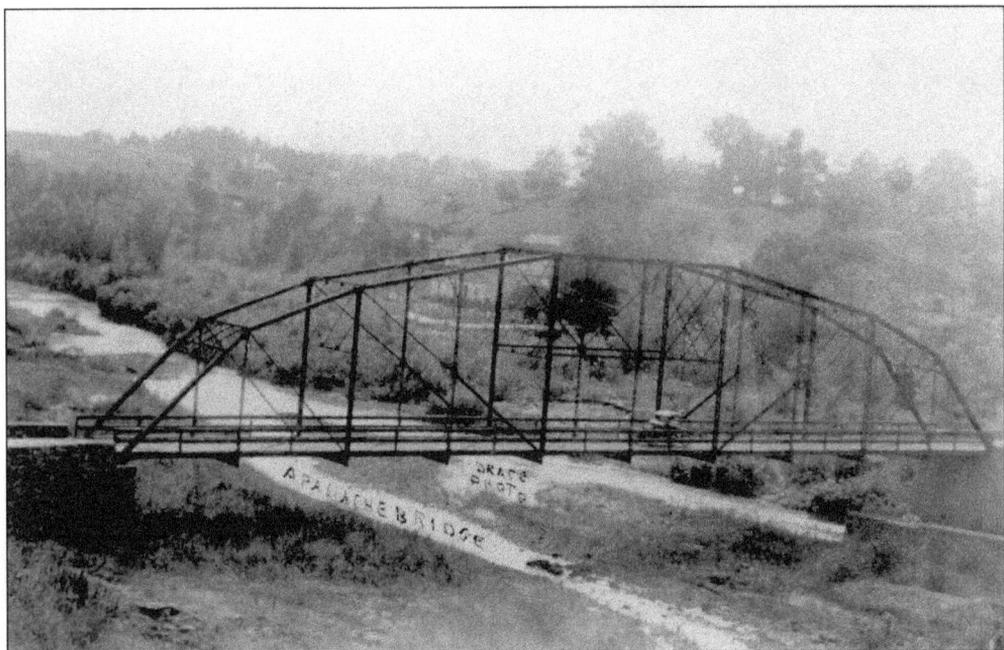

The Apalache Bridge, no longer standing, crossed the South Tyger River near the mill. (Courtesy of South Caroliniana Library, University of South Carolina, Columbia.)

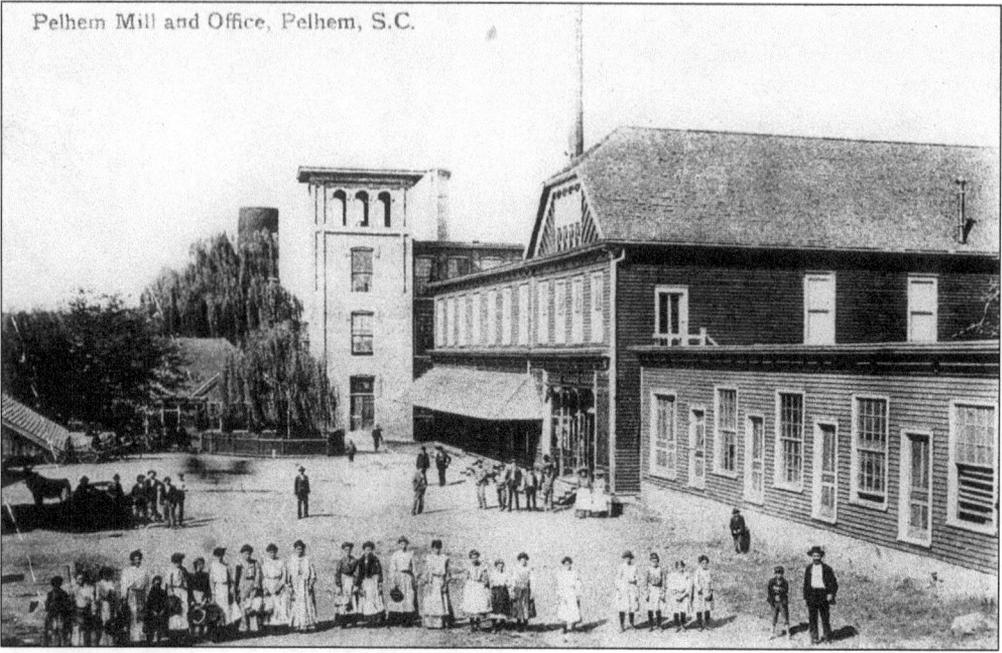

The Pelham Mill and office is pictured in the 1900s. The original mill was built in 1820 in the area known as Buena Vista. It was not known as Pelham until 1880, when Arthur Barnwell bought the mill and changed the name to Pelham because he had been living in Pelham, New York. The mill closed in 1935. (Courtesy of Francis Merritt and Evelyn George.)

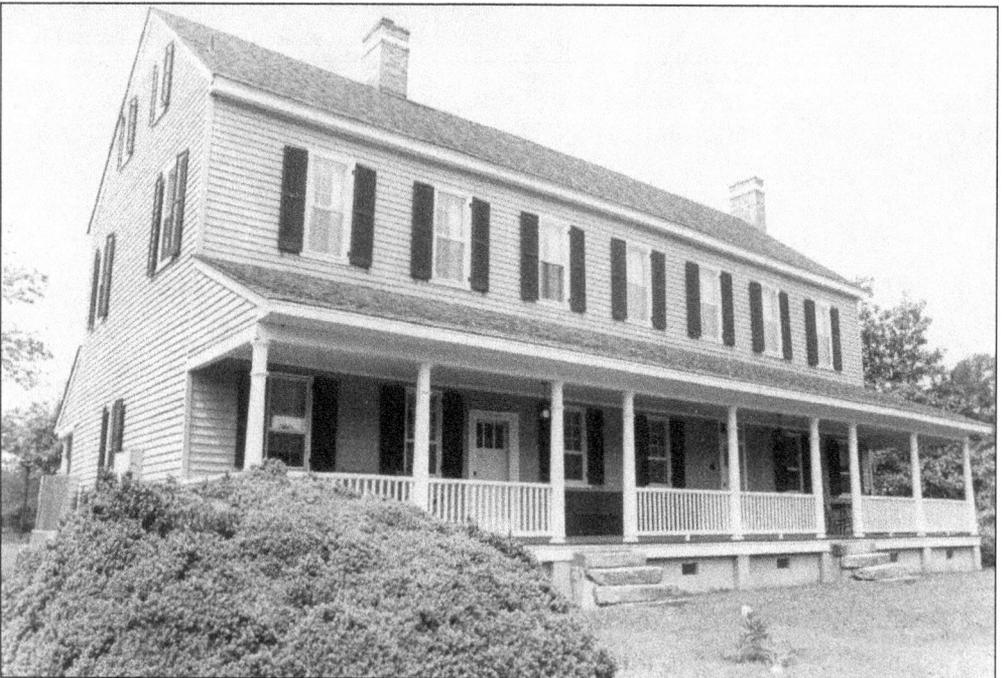

The Bates House, a post and beam constructed house, was built by textile mill owner William Bates, c. 1835. It sits on the hill above the site of Batesville Mill on Highway 14 South and has been listed on the National Register of Historic Places. (Courtesy of Jean M. Smith Library.)

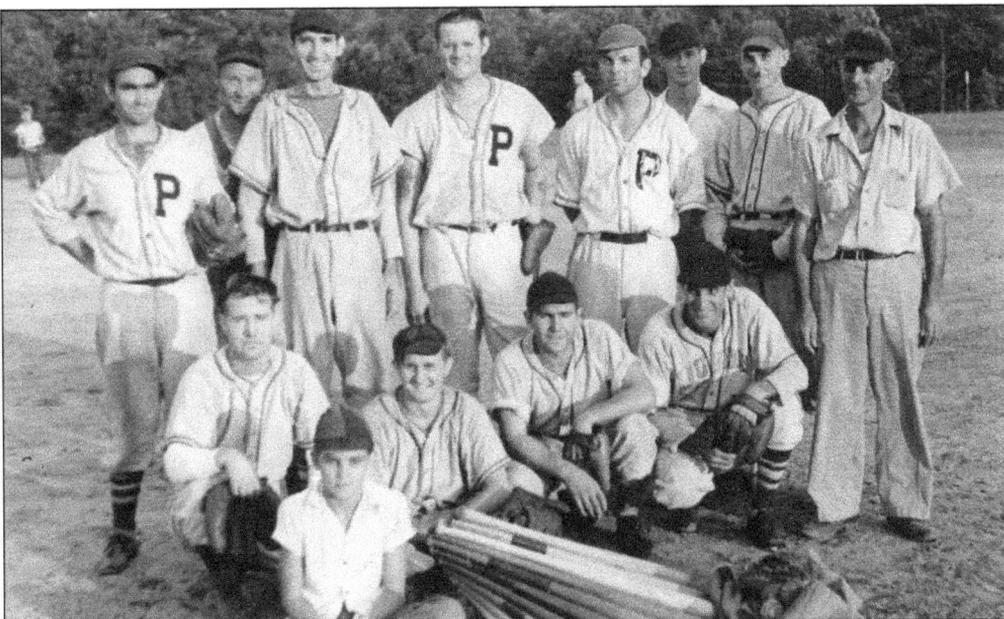

The members of the 1948 Pelham textile league baseball team are, from left to right, (front row) J.T. Pitman (bat boy); (middle row) Willie Moore, Leland Leonard, Mitchel Smith, and Jim Lancaster; (back row) Carl Pitman, Frank Hembree, Marvin Pitman, Mac Seay, Bozo Byers, Graham Poole, Claude Pitman, and Bub Ashmore (coach). (Courtesy of Francis Merritt and Evelyn George.)

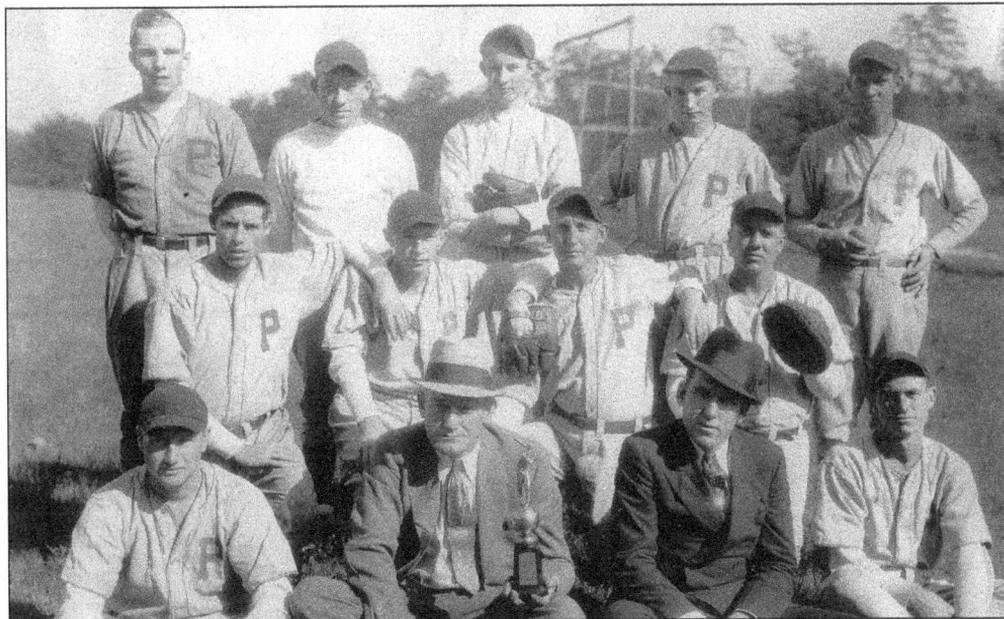

This Pelham Mill team were the champions of the Dixie Textile League in 1934. Pictured here are (front row) Cliff Cox, Frank Pitman (coach), Grover Foster, and John Cox; (middle row) Earl Poole, Dan Greer, Ed Vaughn, and Harold Satterfield; (back row) George Blackwell, Parrott Arnold, Fred Steadings, Claude Pitman, and Gene Bridwell. (Courtesy of Francis Merritt and Evelyn George.)

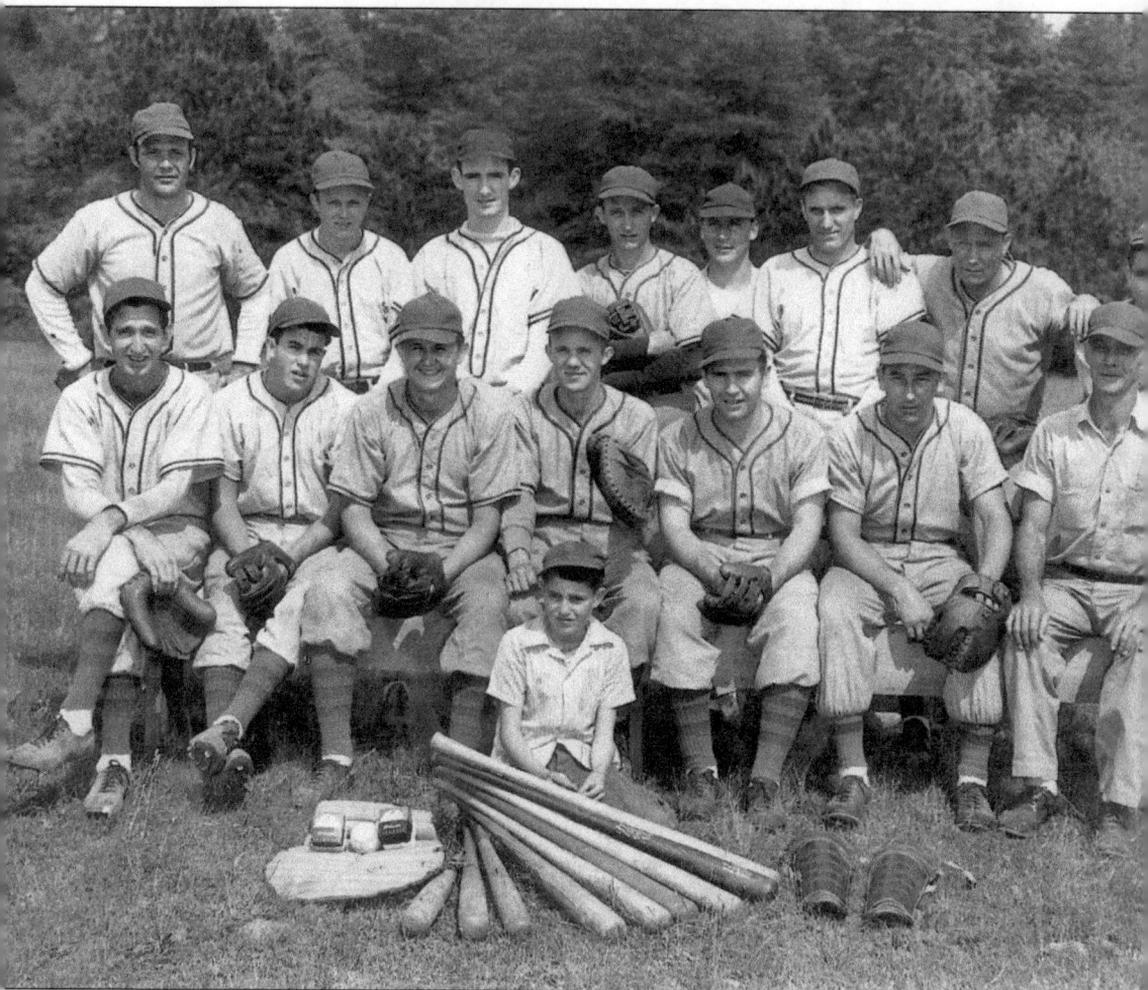

The Pelham Mill team is seen in the late 1940s. Pictured here are (front row) Alvin Pitman (bat boy); (middle row) Marvin Pitman, Wilbur Satterfield, Leland Leonard, Chub Satterfield, Mitchel Smith, Fred Smith, and Bub Ashmore (coach); (back row) Carroll Leonard, Bruce Leonard, James Jones, Claude Pittman, Dennis Adams, Jim Lancaster, Frank Hembree, and Carl Pitman. (Courtesy of Francis Merritt and Evelyn George.)

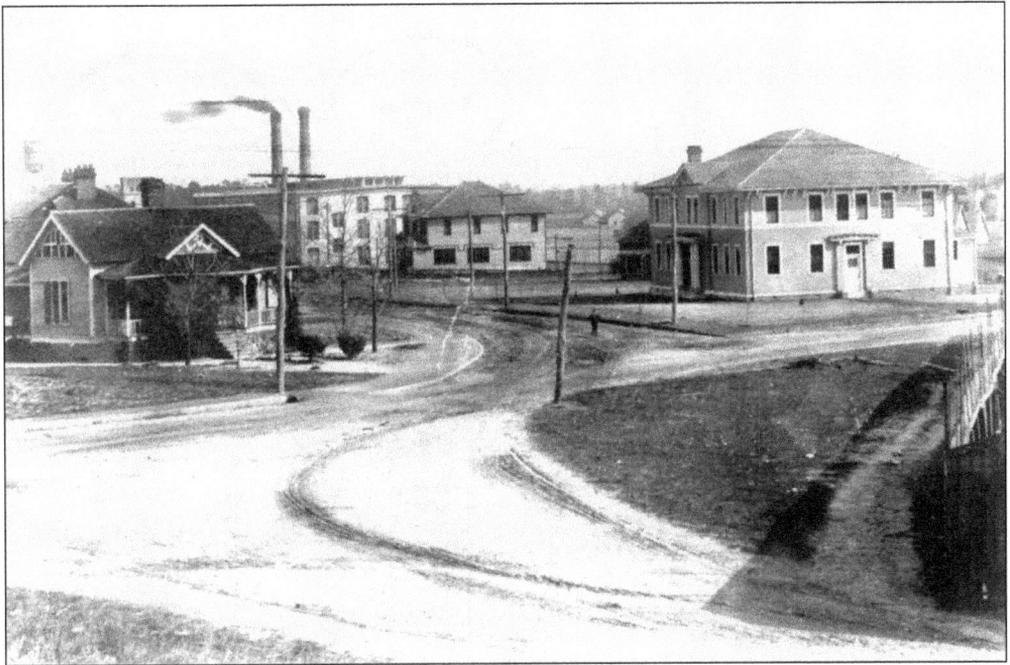

This early photograph of Victor Manufacturing Company shows the mill with its tall smokestacks in the background. It was the center of the mill village, part of which can be seen here. Line Street is to the right, and Victor Avenue Extension is the street leading to the mill. (Courtesy of Joe Bearden.)

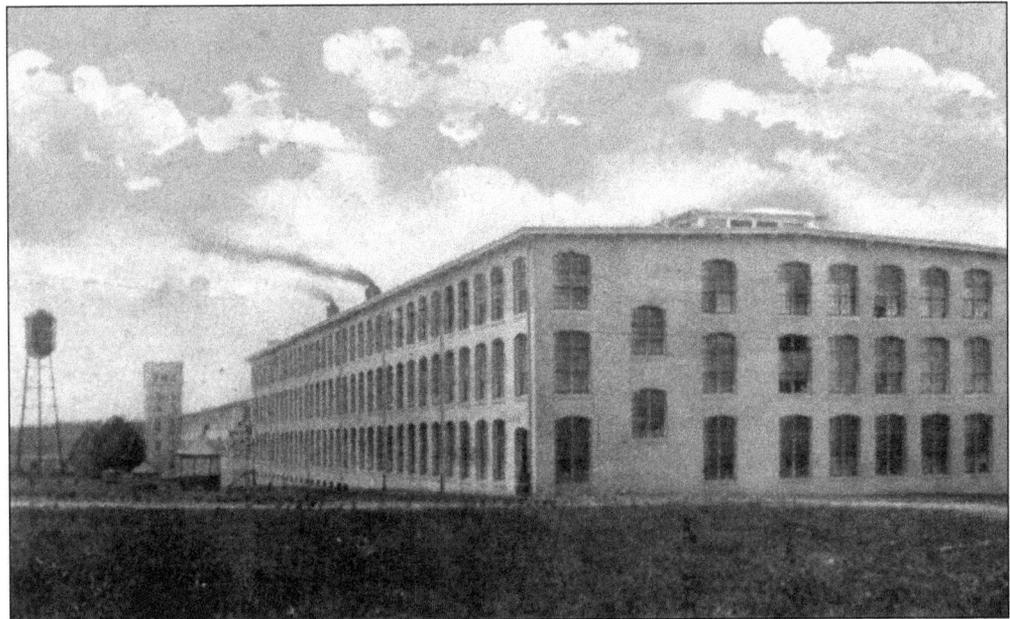

Victor Mill, an electric-powered textile mill, was built in 1895 and began operation in 1896. The mill had 59,136 spindles operating under President W.W. Burgiss. (Courtesy of Joe Bearden.)

Seen here is an 1898 survey of Victor Mill. (Courtesy of Thomas McAbee.)

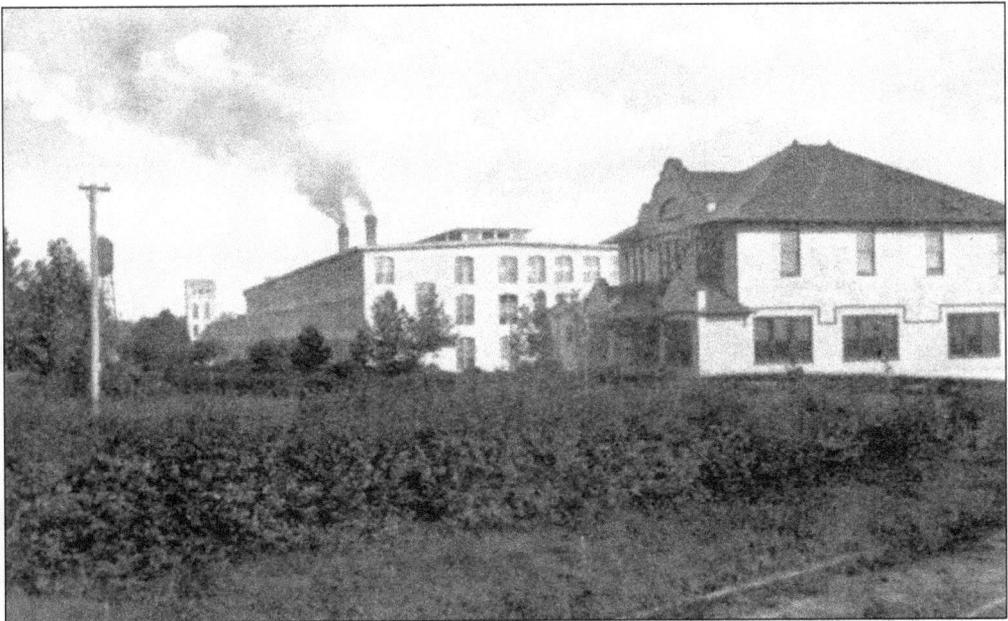

Mill owners built villages for the workers complete with homes, schools, churches, stores, and recreation halls. The Victor Mill village had its own YMCA, shown here in front of the mill in a 1910 postcard. (Courtesy of Joe Bearden.)

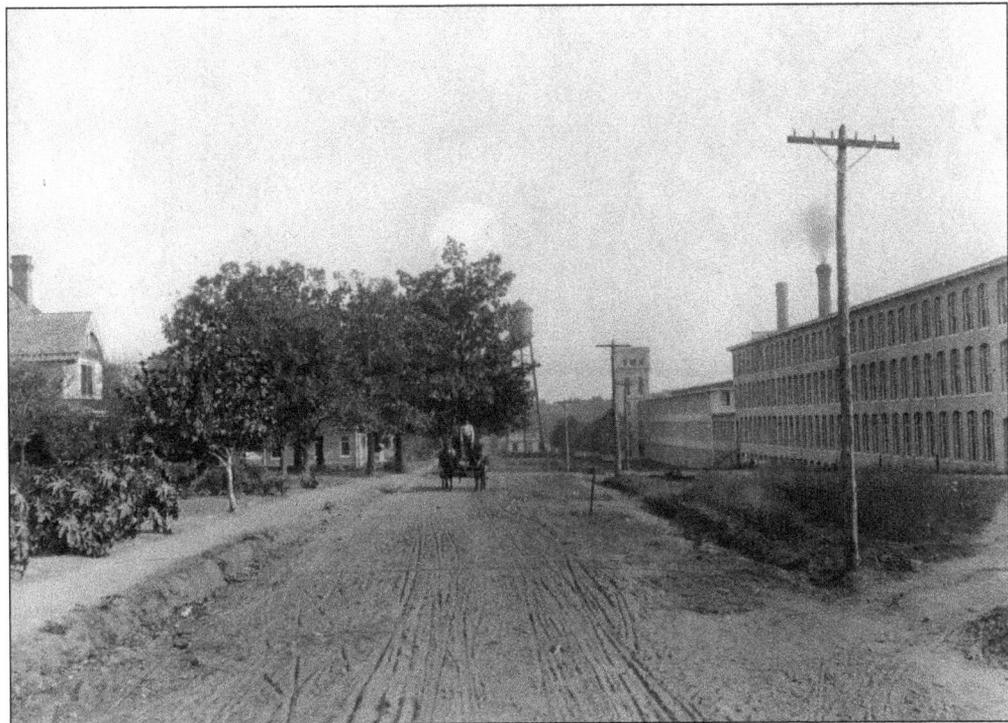

A 1900 photograph shows Victor Manufacturing Company on Victor Avenue Extension. (Courtesy of the estate of Robert S. Hughes.)

The Victor Mill basketball team included, from left to right, Coach Humpy Campell, Linder Duncan, Leon Dill, Boweevil Huthinson, Jesse Pearson, George Beason, "Greasy" Lowe, Virgil Tipton, Elford Campbell, and J.L. Gurley. (Courtesy of George Beason.)

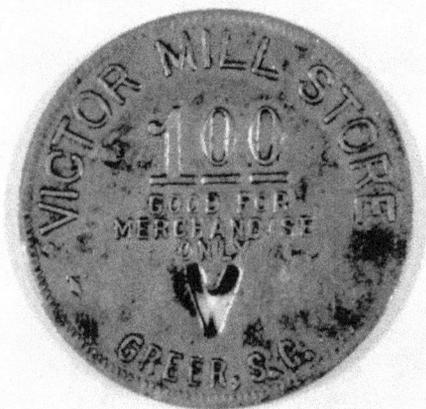

During some years, employees of Victor Mill were paid in whole or in part in tokens that could be used like money at the company store. (Courtesy of Thomas McAbee.)

Taken at Victor Mill Village in 1920, this photo shows Ruby Bridwell Leonard (left) and Leora Bridwell McKinney. They are the daughters of Elisha Velisha Riley and Nanny Paunee Bridwell. (Courtesy of Sarah Watson).

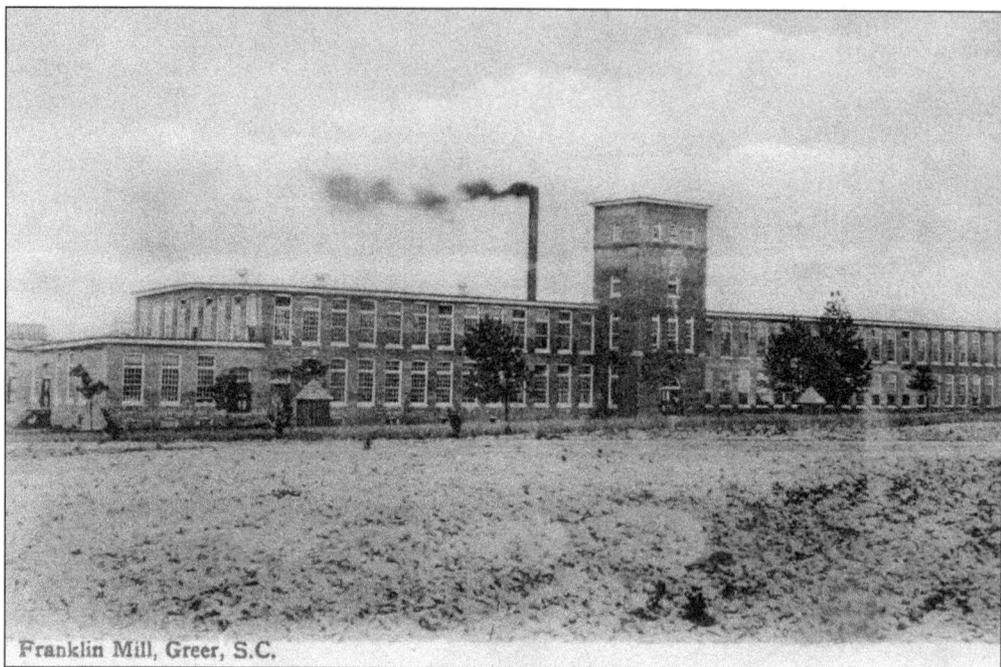

Franklin Mill, Greer, S.C.

Franklin Mill was built in 1900 by W.W. Burgess (also spelled "Burgiss" in early listings) on the site of the present Commission of Public Works property. (Courtesy of Joe Bearden.)

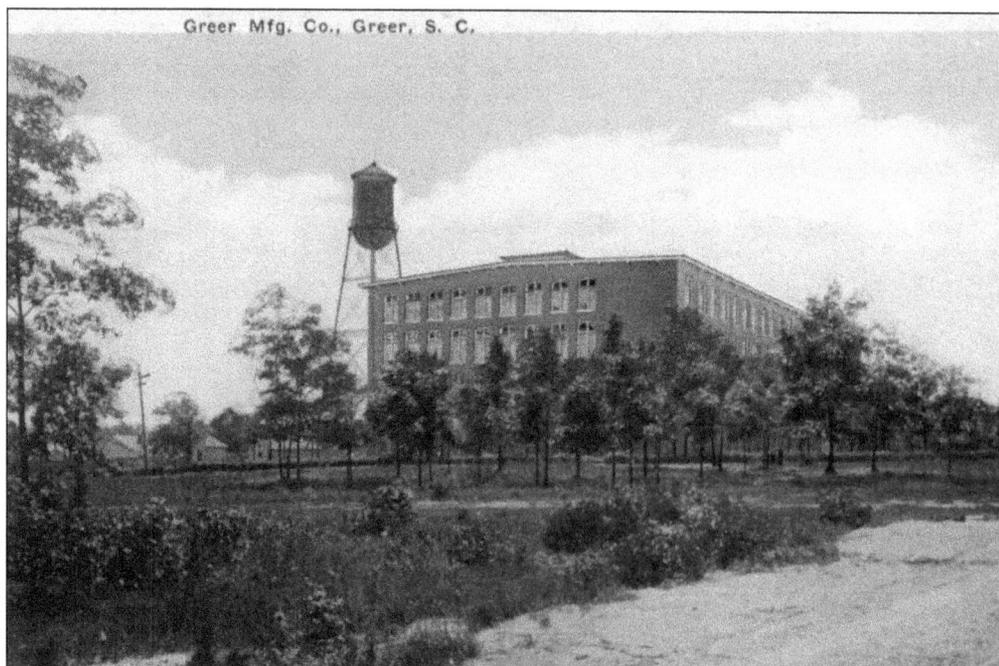

Greer Mfg. Co., Greer, S. C.

Greer Manufacturing Company, known as the Greer Mill until it closed in 1996, was built in 1908 by John A. Robinson Sr. In 1912 it merged with the Parker Mills. Late J.P. Stevens bought the mill and operated it many years. (Courtesy of Thomas McAbee.)

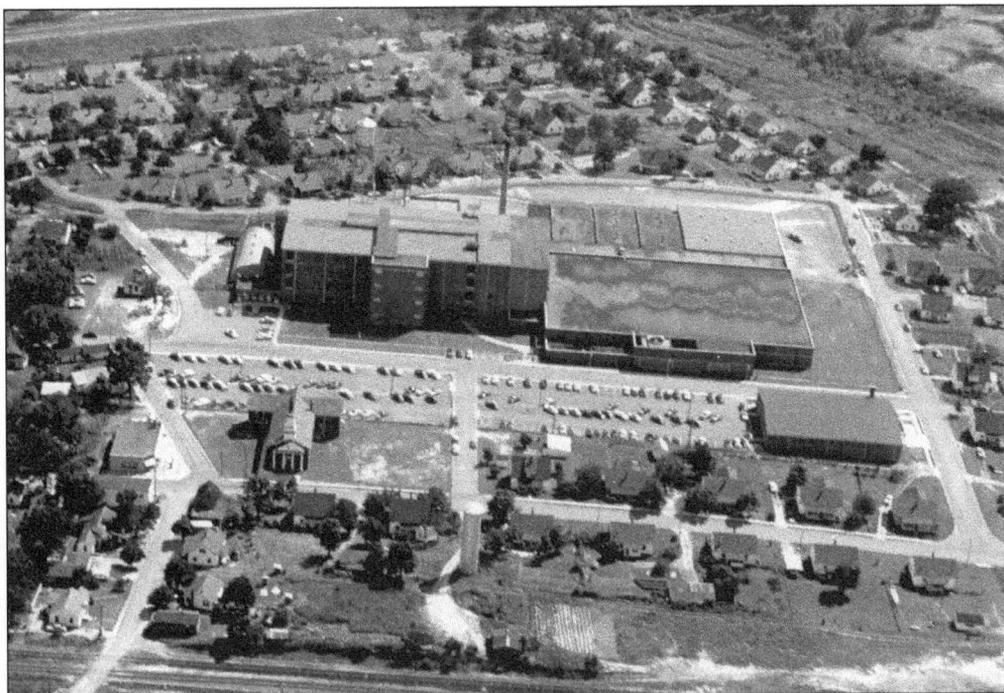

An aerial view shows Greer Mill, also known as Stevens Mill. (Courtesy of Harold James.)

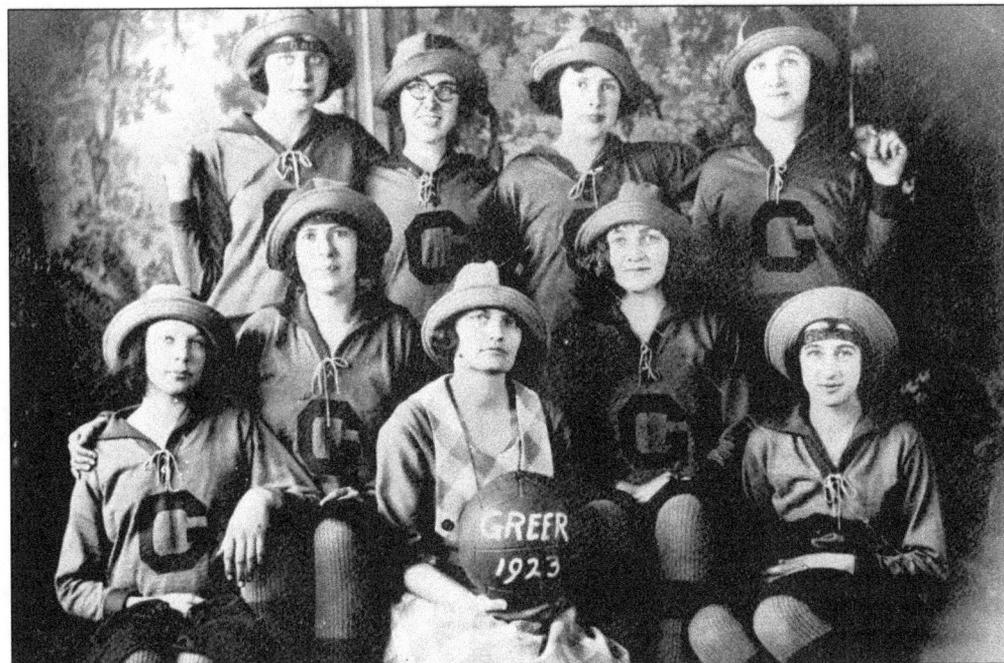

The Greer Mill girls basketball team is pictured in 1923. On the front row are, from left to right, Mae Lillie Mode Berryhill, Lydena Brown Pruitt, Coach Carrabell Carman Belcher, Ellen Richardson, and Ruth Bragg Holland. On the back row are, from left to right, Lucelle Reeves Saylor, Mary Hemphill Flynn, Bernice Seay Heath, and Earline Blanton Campbell. (Courtesy of Ann Withrow.)

Vickie Russell is pictured in the backyard, c. 1950. The houses in the background are on Robinson Street, now Connecticut Avenue, part of the Greer Mill village. (Courtesy of Joe Knighton.)

Claude and Annie Hemphill are pictured with their son Lewis. Claude was the superintendent of Greer Mill. (Courtesy of Ann Withrow.)

Nine

LIFESTYLES

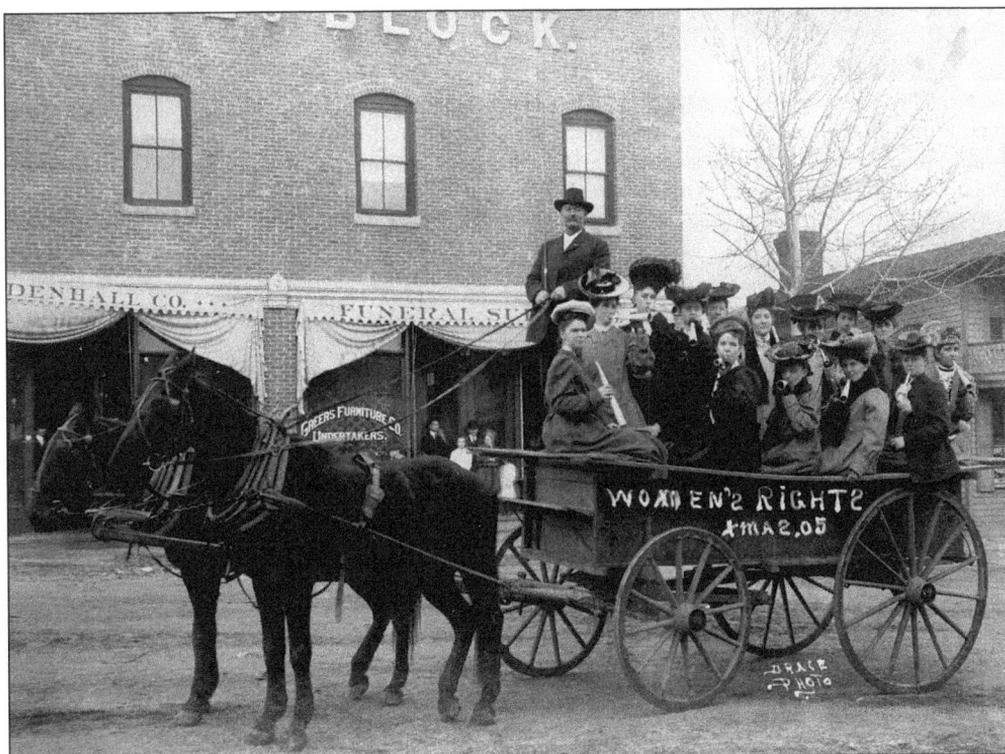

In 1905 the ladies of Greer chose the Christmas parade as a way to demonstrate for the vote, and Sim Burnett was their chauffeur. This photograph was taken in front of Wood and Mendenhall's funeral and furniture business that stood on the corner of Main and East Poinsett Streets. There was some logic to combining the sale of beds for the living with the sale of coffins for the deceased. (Courtesy of the estate of Robert S. Hughes.)

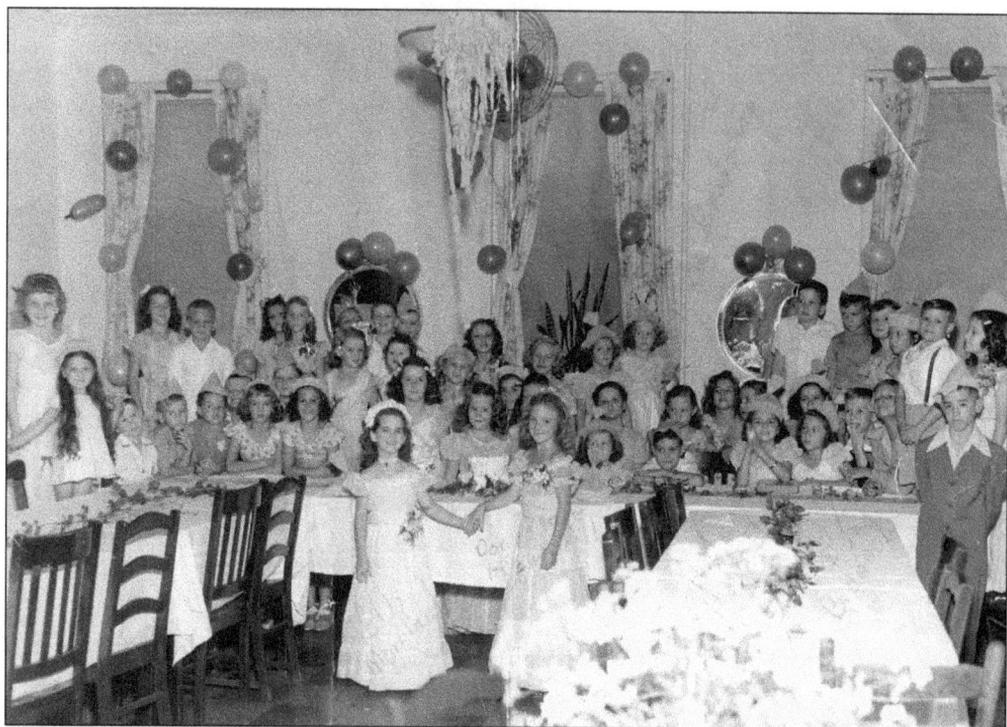

A birthday party for Polly Moreland (left front) and Donna Rea Hemphill (right front) is pictured in 1946 at the Wayside Inn, which was located on the northwest corner of Poinsett and Main Streets. Note that the boy in front of the righthand mirror is *Greer Citizen* co-publisher Leland Burch. (Courtesy of Ann Withrow.)

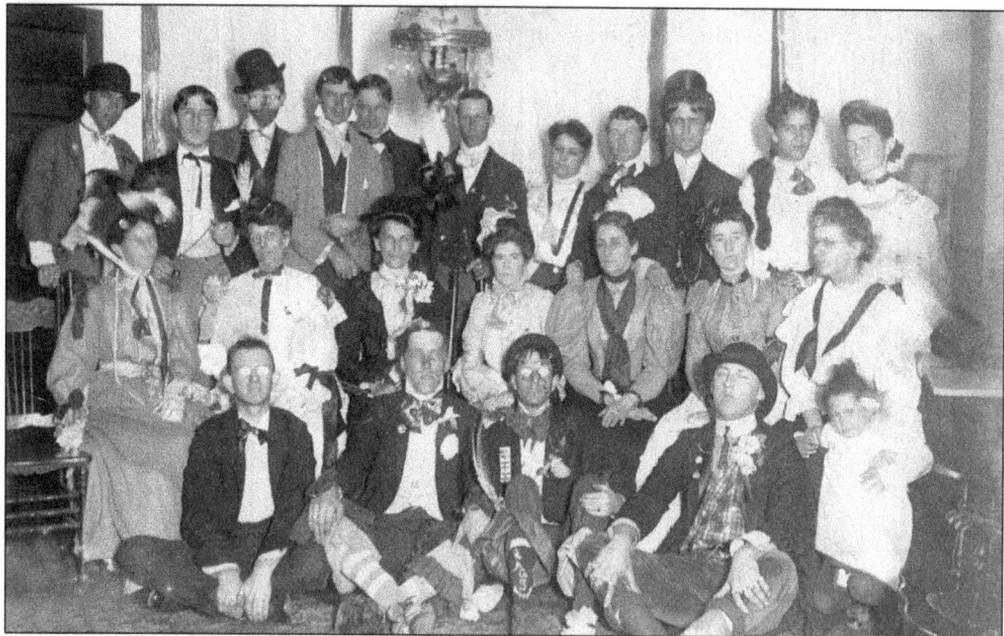

Life in Greer at the turn of the century had its lighter moments. Here, an unidentified group of young people put on costumes for a party. (Courtesy of the estate of Robert S. Hughes.)

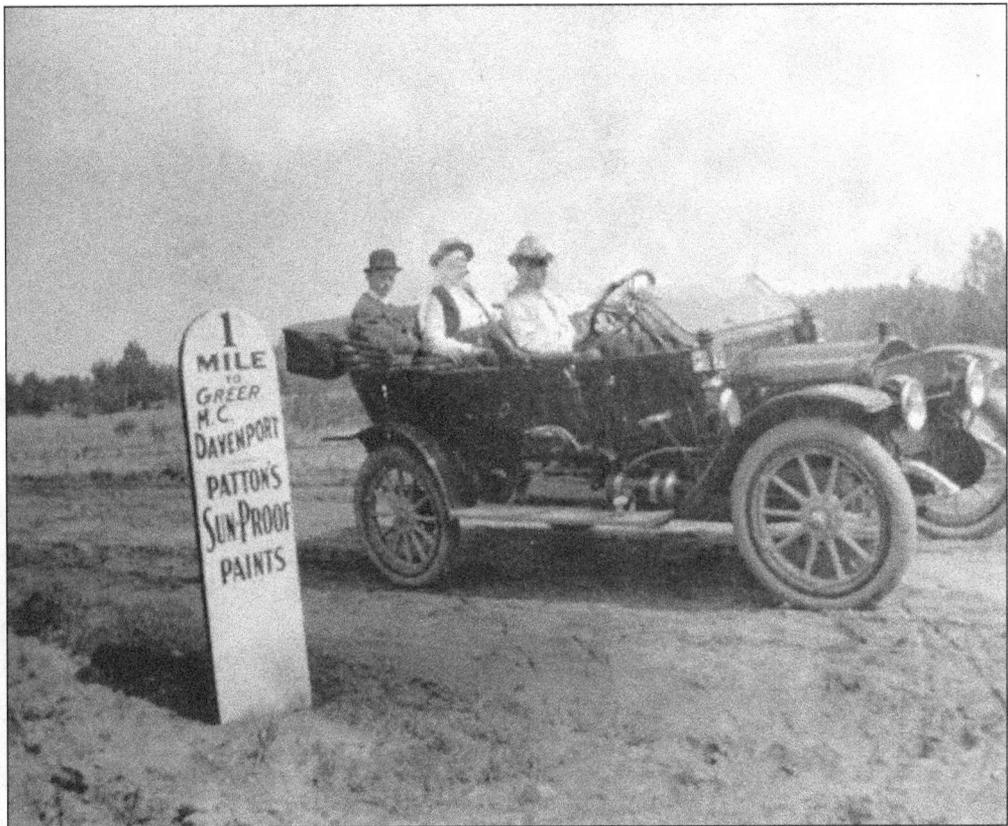

This direction sign is located just outside of Greer. (Courtesy of Norma Clement Bruce.)

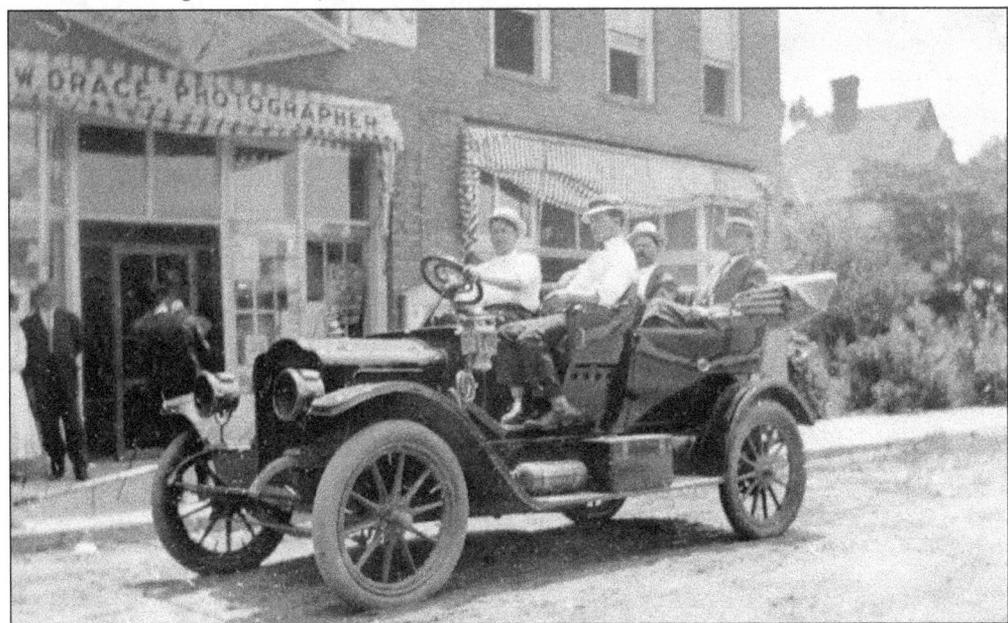

M.C. Davenport is pictured at the wheel of this car, which is in front of Drace Photography store on the left side of the 100 block of Trade. (Courtesy of George Davenport.)

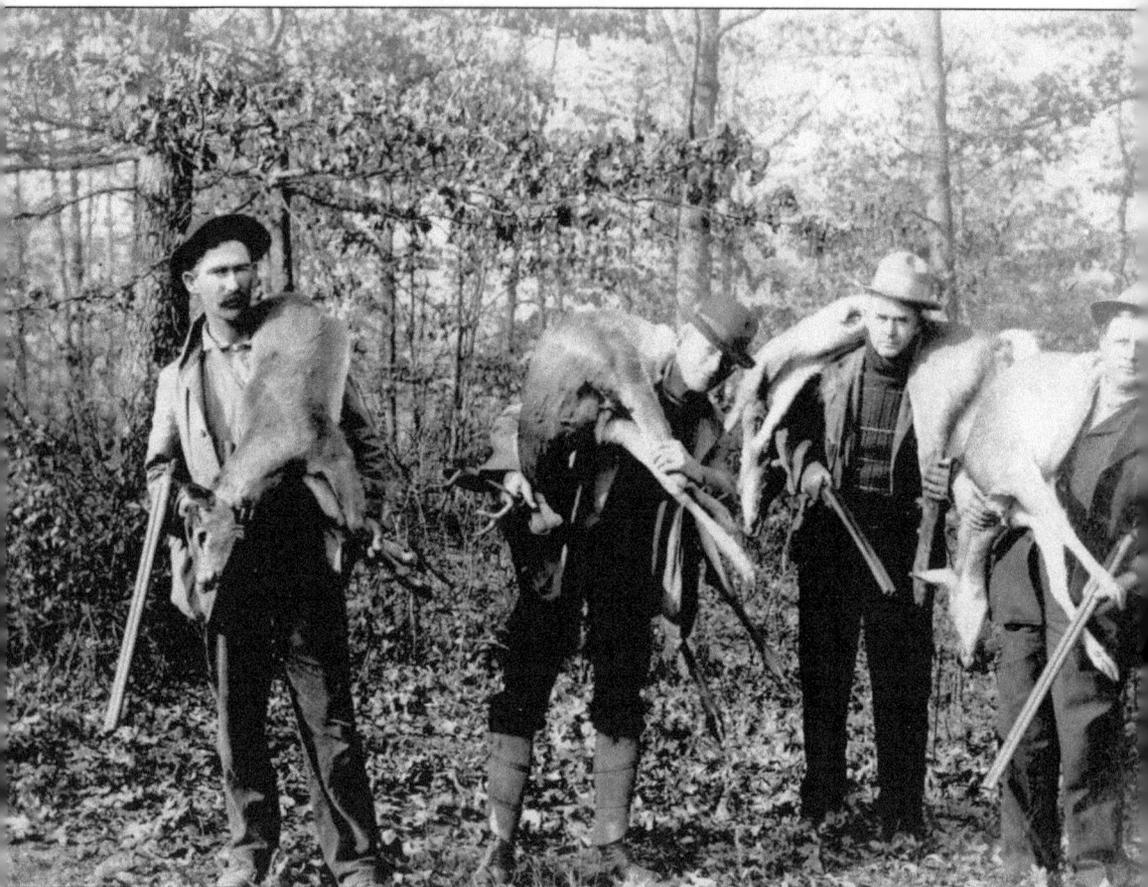

Hunters returning from a successful outing, from left to right, are Will Marchant, J. Verne Smith Sr., Luther Marchant, and Cliff Davenport. (Courtesy of Sen. J. Verne Smith.)

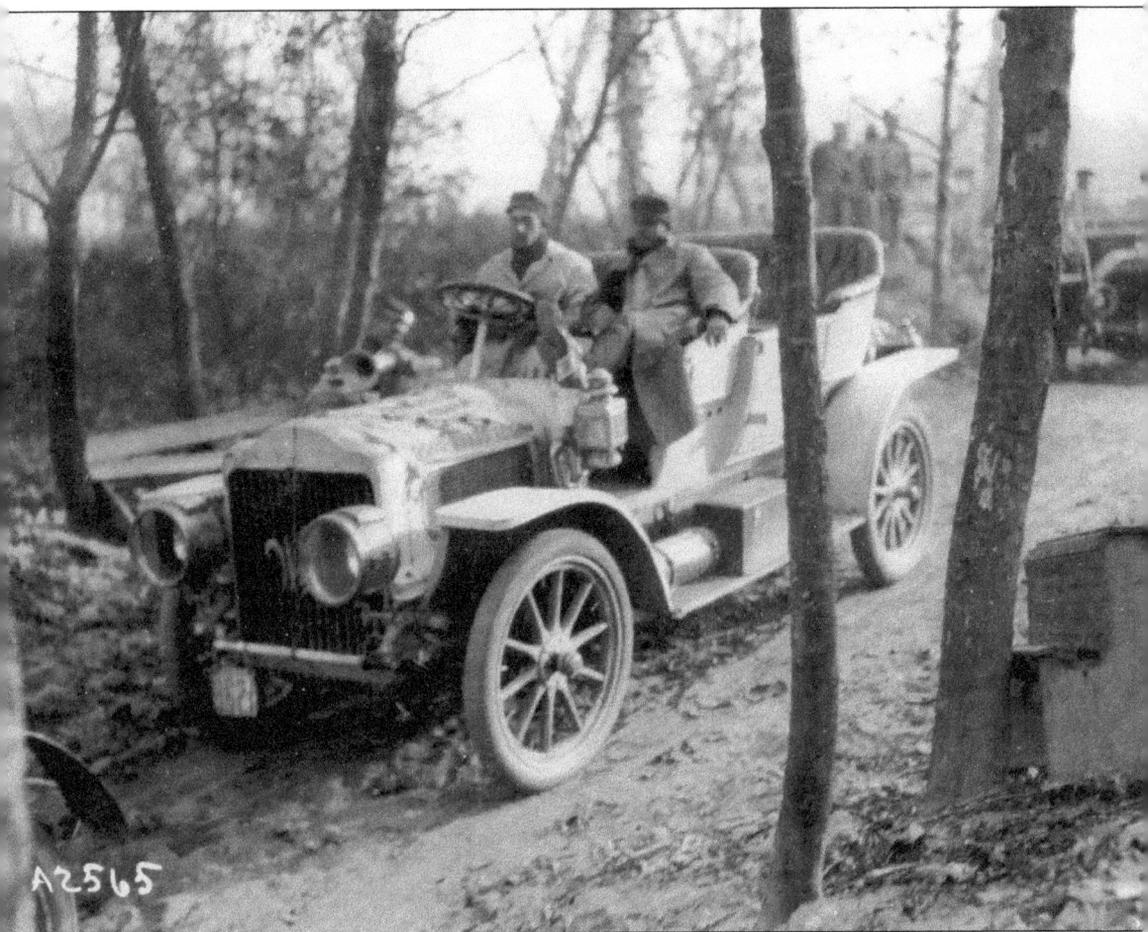

Stanley Steamer is in the race to promote good roads. M.C. Davenport is pictured in the rear seat. (Courtesy of George Davenport.)

This Cannon Street postcard, c. 1950, shows City Park (known to some as "Baptist Hollow" since it was the site of the First Baptist Church's first building). It was built by the WPA and maintained for many years by the Greer Garden Club. (Courtesy of Thomas McAbee.)

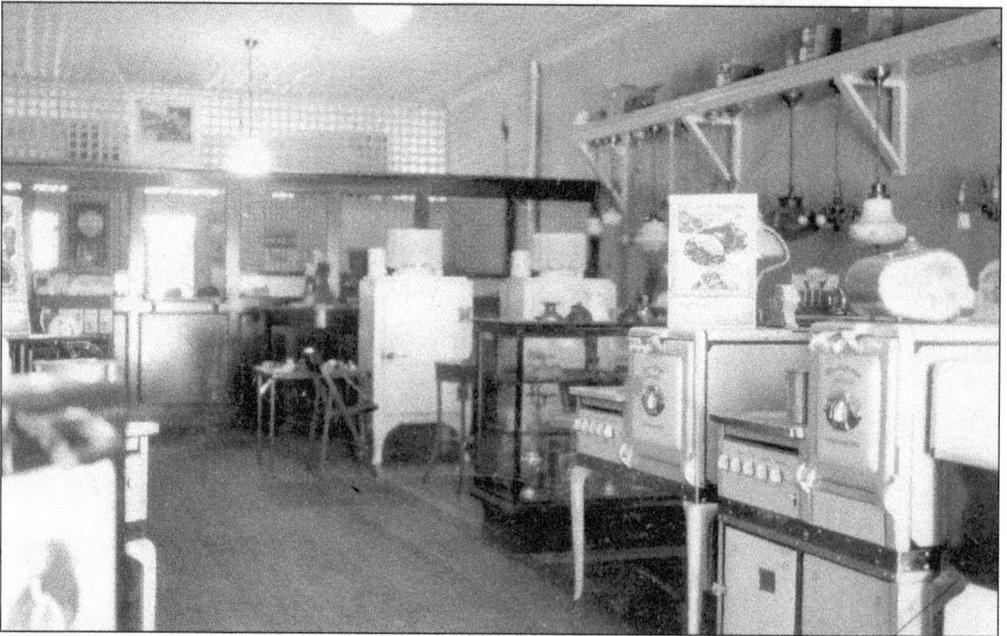

Erected c. 1915 by R.L. Marchant, the building that currently houses the Greater Greer Chamber of Commerce on Trade Street was once a furniture store owned by Samuel B. Hutchings. In 1931 the Commission of Public Works purchased the building and used it until 1960, when it was used as city hall. Shown is the CPW Appliance Sales Room. (Courtesy of Greer Chamber of Commerce.)

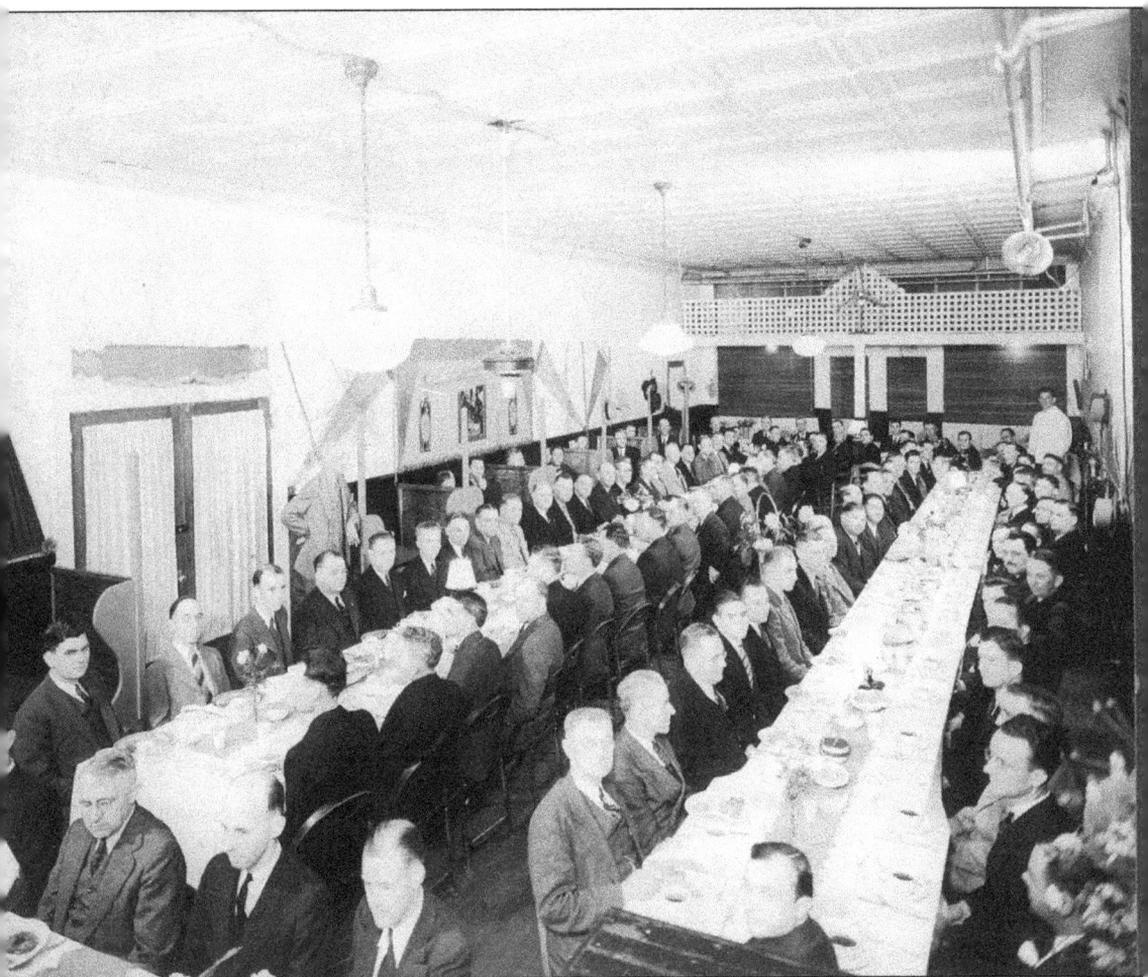

This photo of the Civitan Club was taken in late 1930s in the Wayside Inn, located at the corner of Main and Poinsett Streets. (Courtesy of Harold James.)

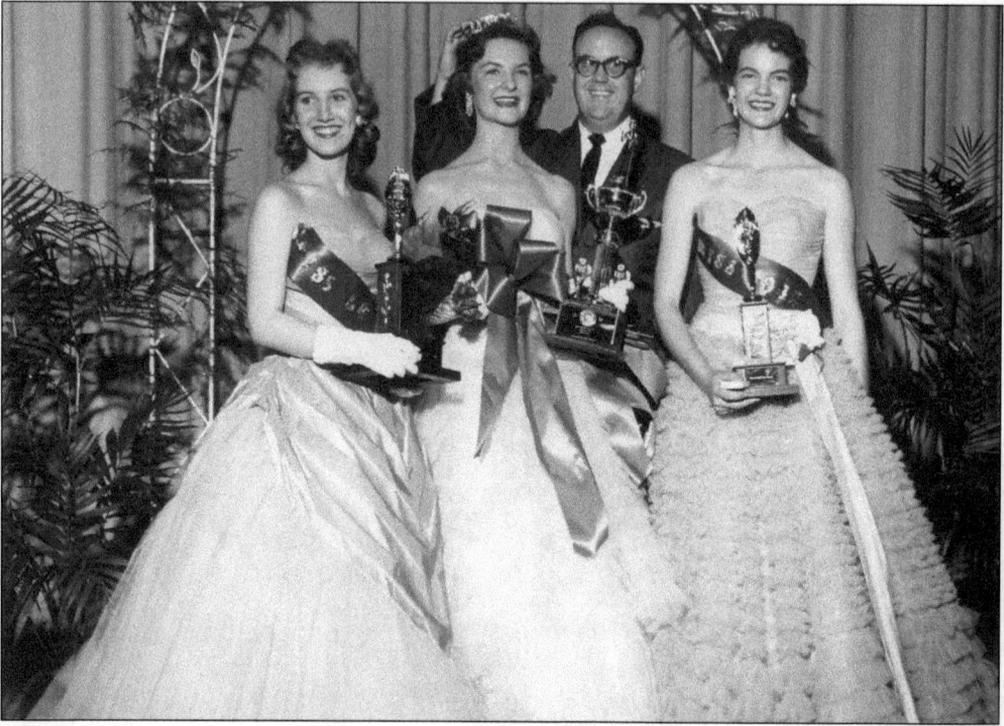

The winner of the very first Miss Greer pageant, sponsored by the Greer Jaycees (Greer Junior Chamber of Commerce), was Sylvia Sue Bishop. She was crowned by Hubert Adair, general chairman of the pageant in 1958. The pageant was held at Greer High School Auditorium. Runners up were Konda Gail Brookshire and Martha Cerne. (Courtesy of Sylvia Pitts.)

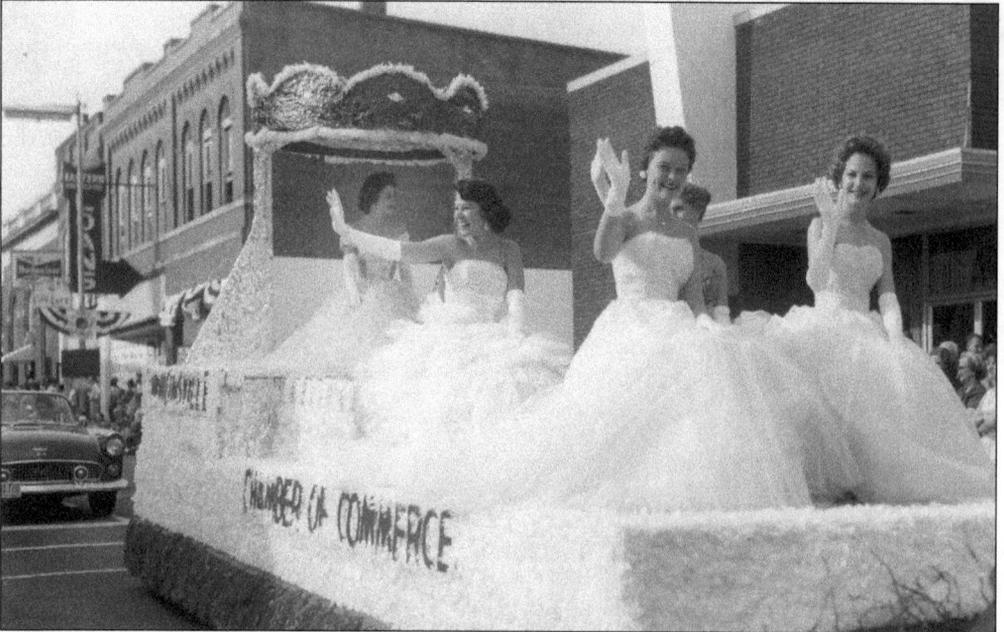

The Peach Festival Float is pictured on Trade Street. Note the current Chamber of Commerce building and First National Bank in the background. (Courtesy of Marsha Strong.)

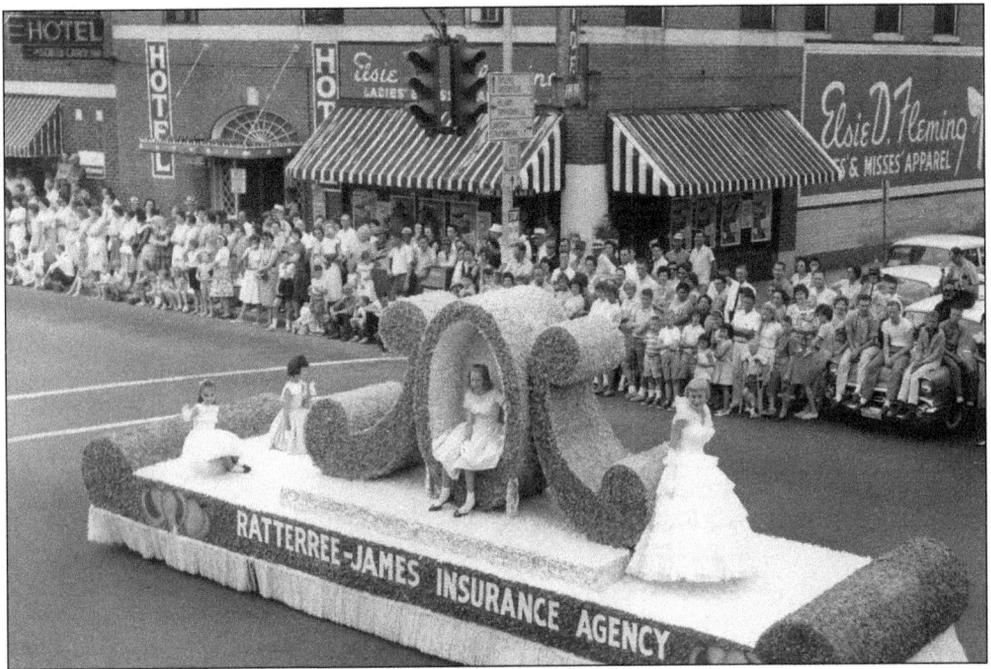

The Peach Festival Parade is seen at the intersection of Main and Poinsett. The Wayside Inn is in the background, c. 1957. (Courtesy of Harold James.)

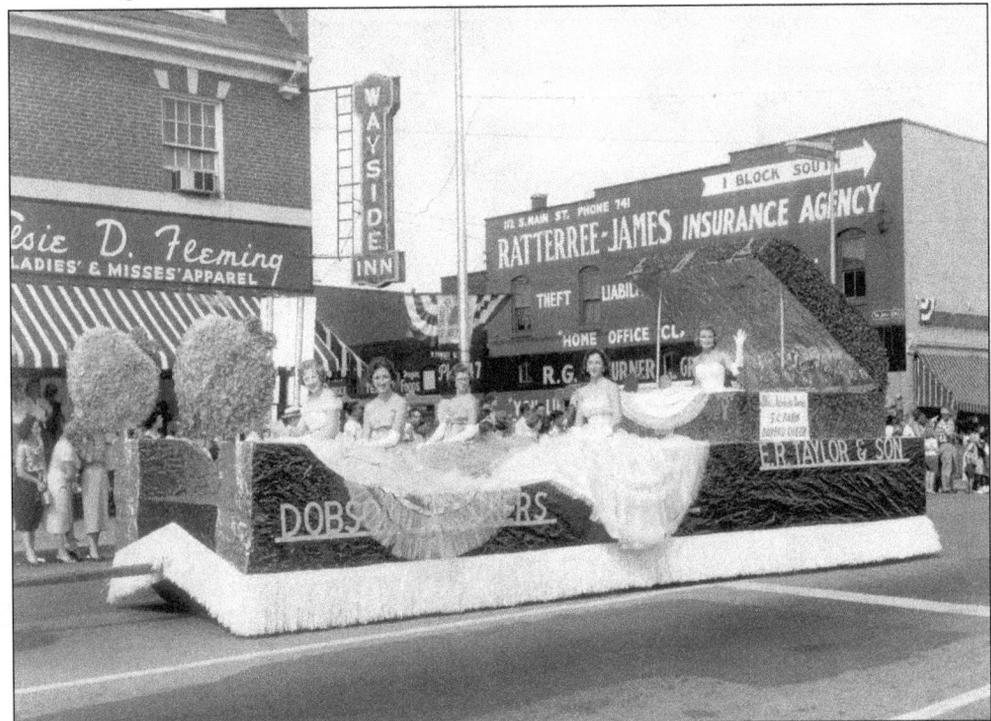

Miss Adelaide "Tootsie" Dennis, a South Carolina Farm Bureau Queen, is pictured in the Peach Festival Parade on East Poinsett Street, just east of the Main and Poinsett intersection. (Courtesy of Karolyn Taylor.)

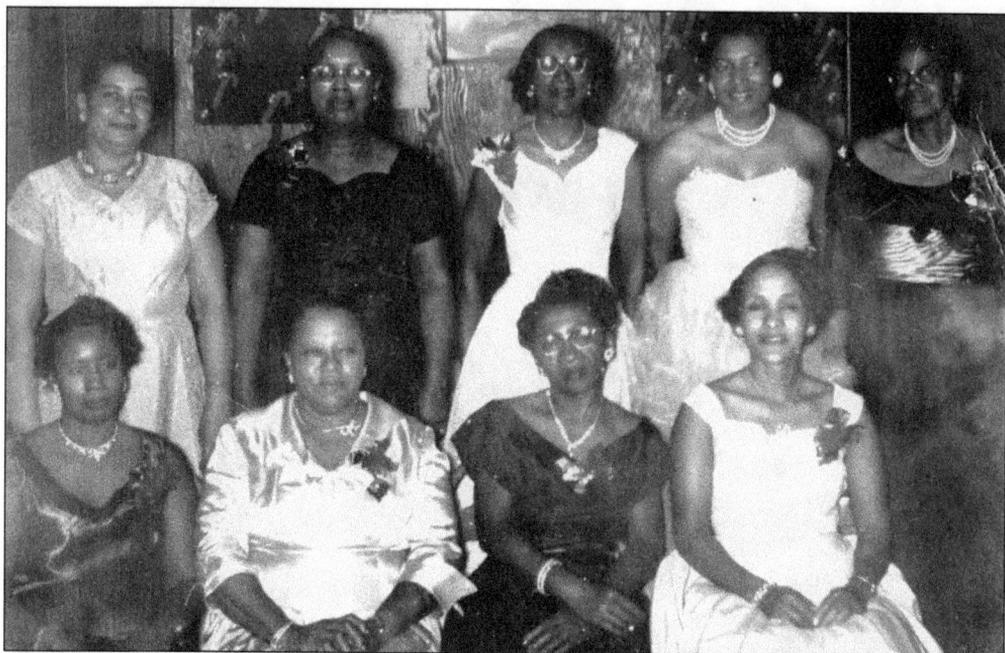

This is the Torchbearers Social Club. From left to right are (front row) Elease Cox, Ruth Nesbitt, Bessie Goodlett, and Annie Sullivan; (back row) Grace Gregory, unidentified, Minnie Foster, Patricia Scott, and Eva Clinkscale. (Courtesy of Margarett Turner.)

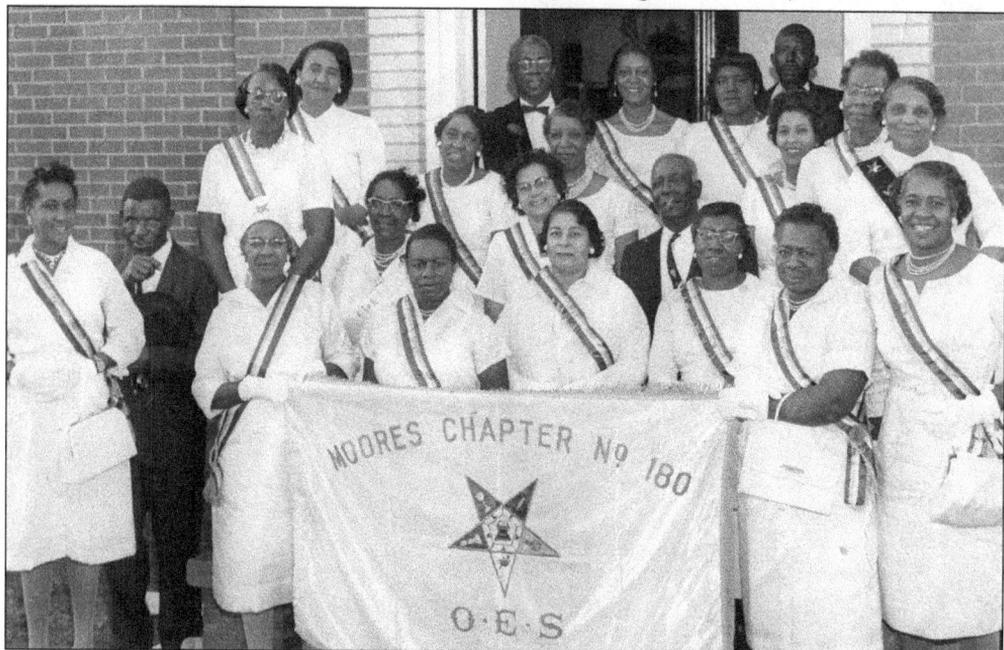

The Moores Chapter No. 180 of Eastern Star is pictured here in 1926. Included in this group portrait are Irene Locke, Grace Gregory, Rosas Williams, Etolia Duckett, Johnnie Harris, Hubert Mayfield, Jane Morris, Viola Brooks, Mrs. ? Wood, Hattie Mayfield, Enna Pea, W. Foster, J.C. Mayfield, Maselena Monroe, Mrs. ? Thompson, and Roy Thompson. (Courtesy of Margarett Turner.)

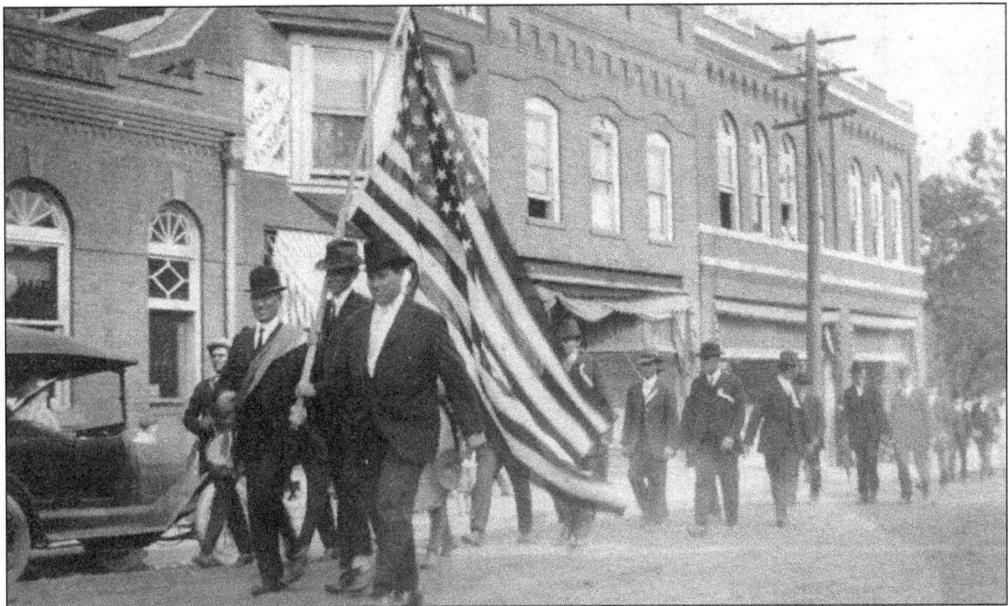

A damaged picture shows a veterans of World War I parade in the early 1920s on Trade Street. The building at the far right is the present Chamber of Commerce. (Courtesy of Harold James.)

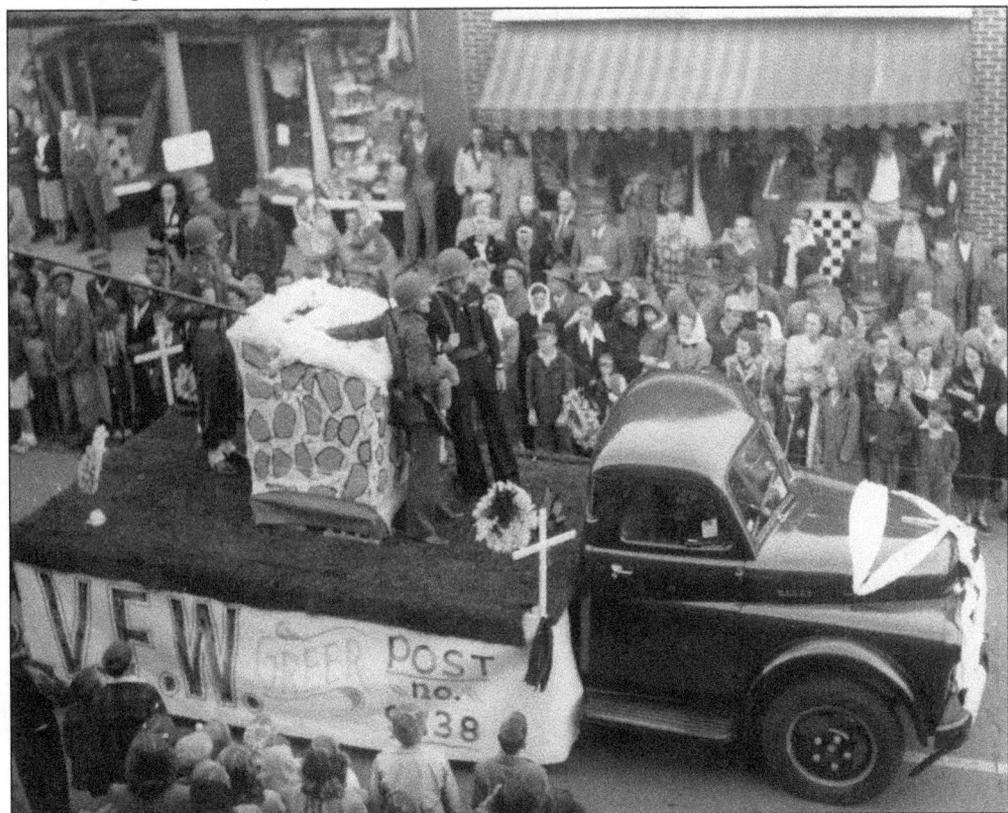

A late 1940s Veterans of Foreign Wars Christmas Parade is pictured along Trade Street. (Courtesy of Jo Ann Greene McAbee.)

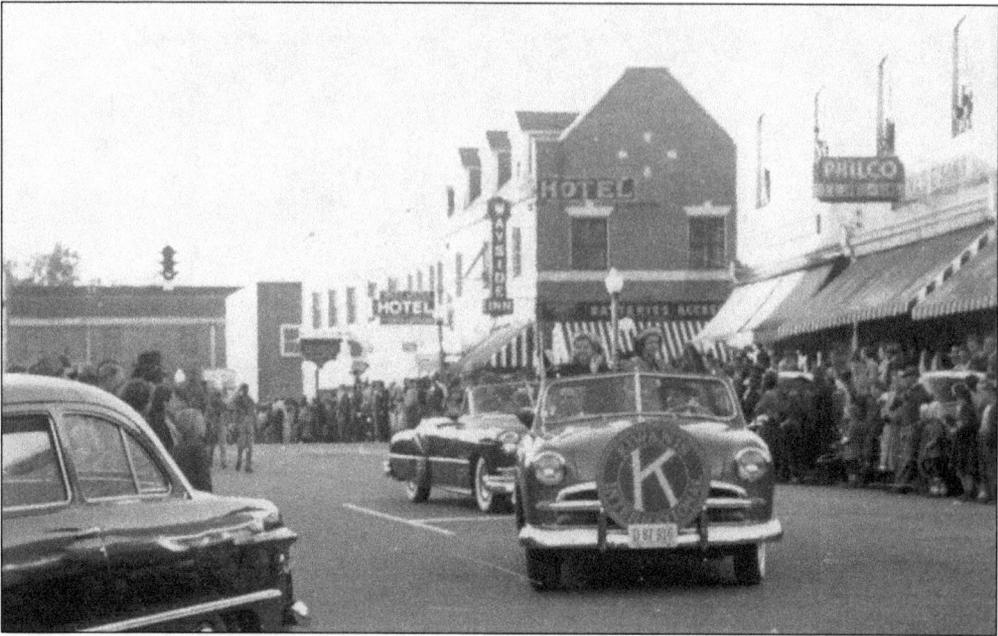

The downtown Greer Christmas Parade has been an area favorite for many years as the pictures on this page indicate. In this scene on West Poinsett Street, the cars are turning onto Trade Street to continue the parade through town. The Wayside Inn, which also had the bus station, is seen in the center of the picture. (Courtesy of the Jean M. Smith Library.)

The Gulf service station was located on the lot where First National Bank, now Duke Power, is located. The current Chamber of Commerce building is to the left of the bank building.

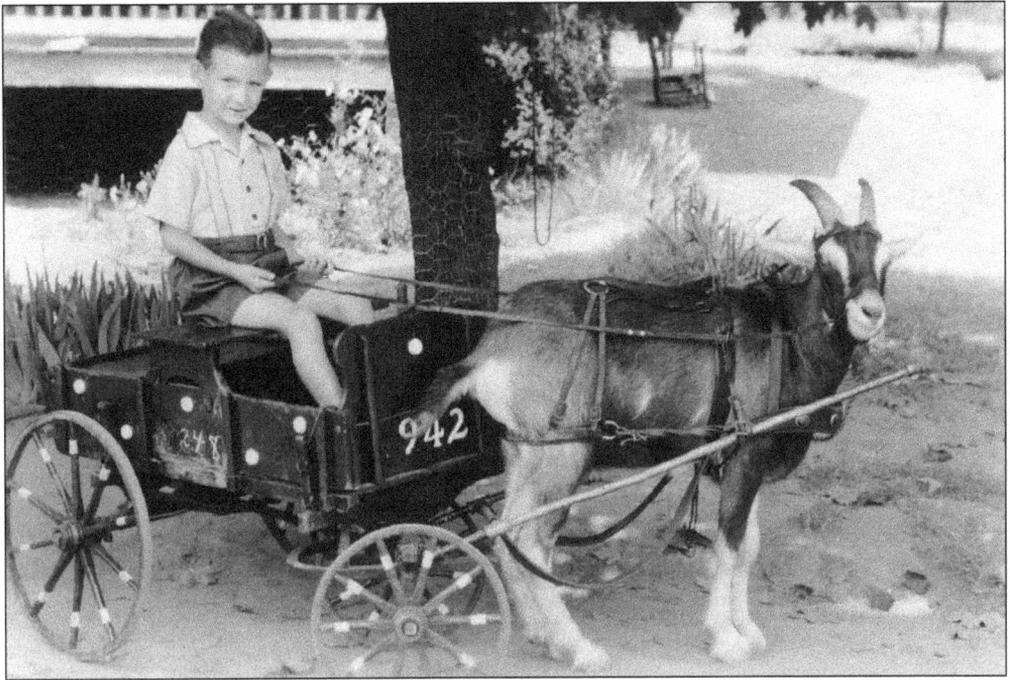

Joe Knighton (pictured at five-and-a-half years old) remembers the summer of 1941 on Robinson Street (now Connecticut Avenue), when a photographer went from house to house with a goat and cart offering to have a picture taken after a short ride in the cart. The number on the side of the cart in chalk was used by the photographer to identify which photo went with which family. (Courtesy of Joe Knighton.)

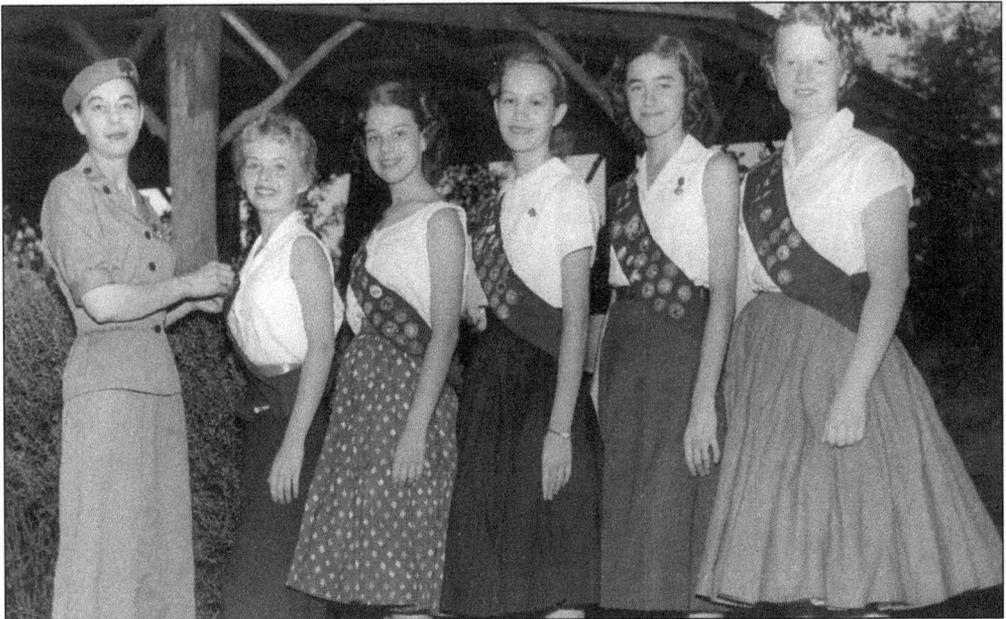

This Girl Scout troop in 1956 included, from left to right, Eulalia Waker, Betty Gail Baughcome, Marsha Lurey, Jane McClimon, Judy Barton, and Brenda Carole Taylor. (Courtesy of Marsha Strong.)

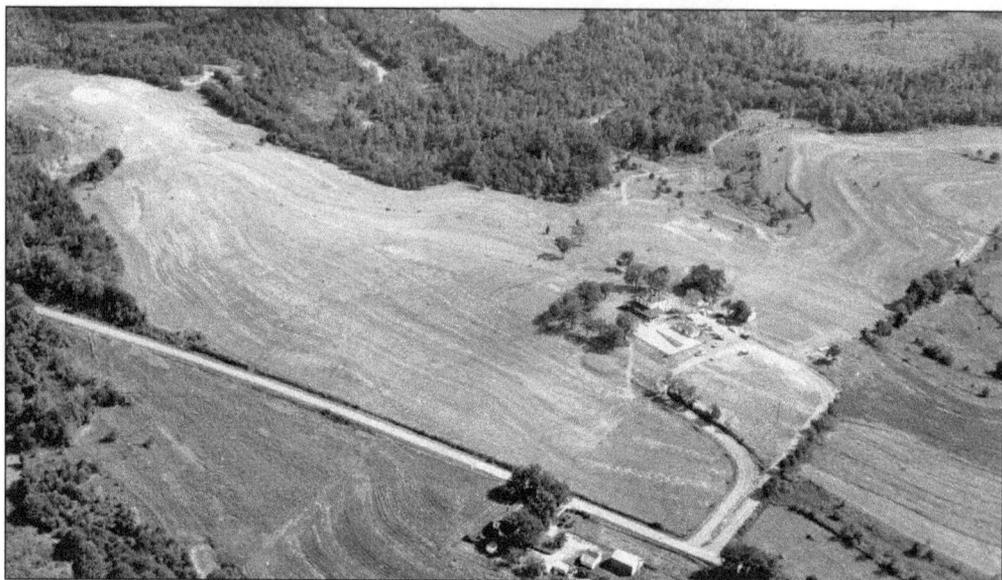

The Greer County Club is seen during construction of the golf course. (Courtesy of Harold James.)

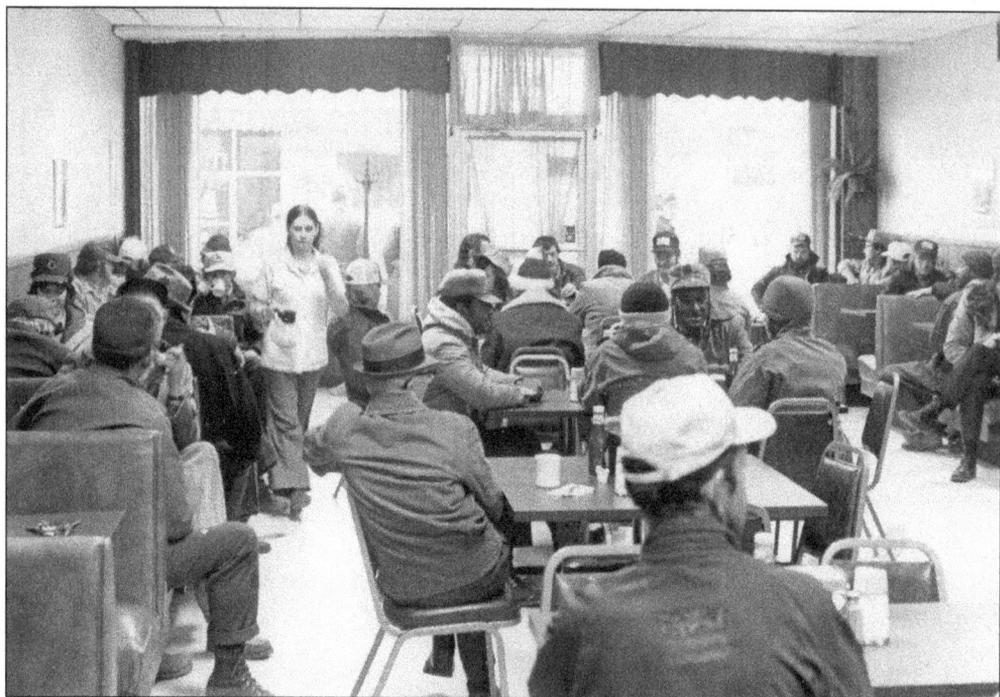

In 1977, a farmers' protest of federal farm policies started in the South and Midwest, called "Tractorcade." Tractors, being driven to Washington, D.C., stopped in towns along the way. This group stopped in Greer on December 14th and are pictured in Louise's New Dixie Restaurant on Trade Street. (Courtesy of Ann Withrow.)

Ten

GREATER GREER

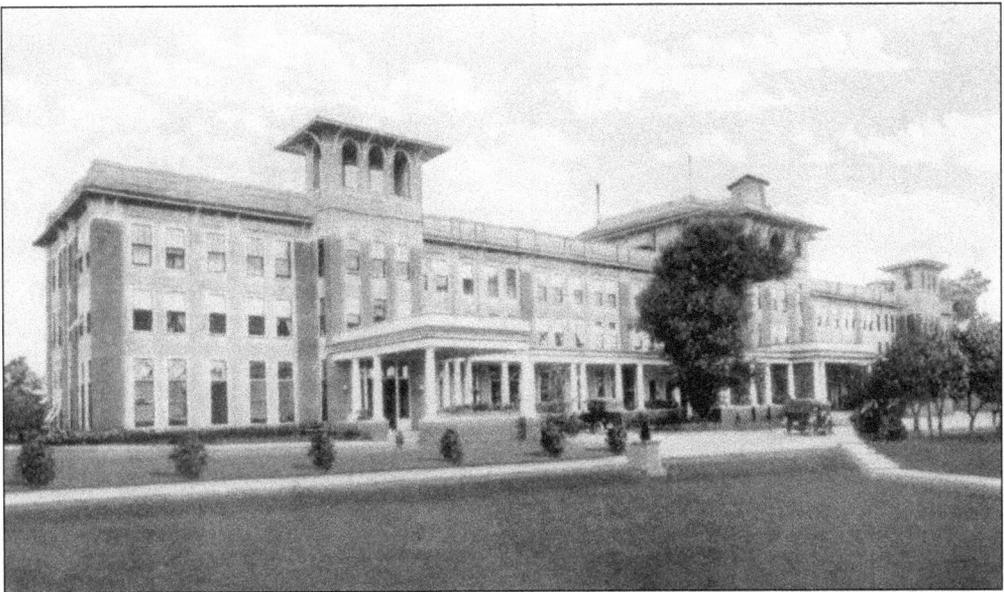

The Chick Springs Hotel was built in 1840 by Dr. Burwell Chick. After a fire, it was rebuilt in 1885. Additions were completed in the early 1900s and can be seen in this view of the popular resort not very far from downtown Taylors. (Courtesy of South Caroliniana Library, University of South Carolina, Columbia.)

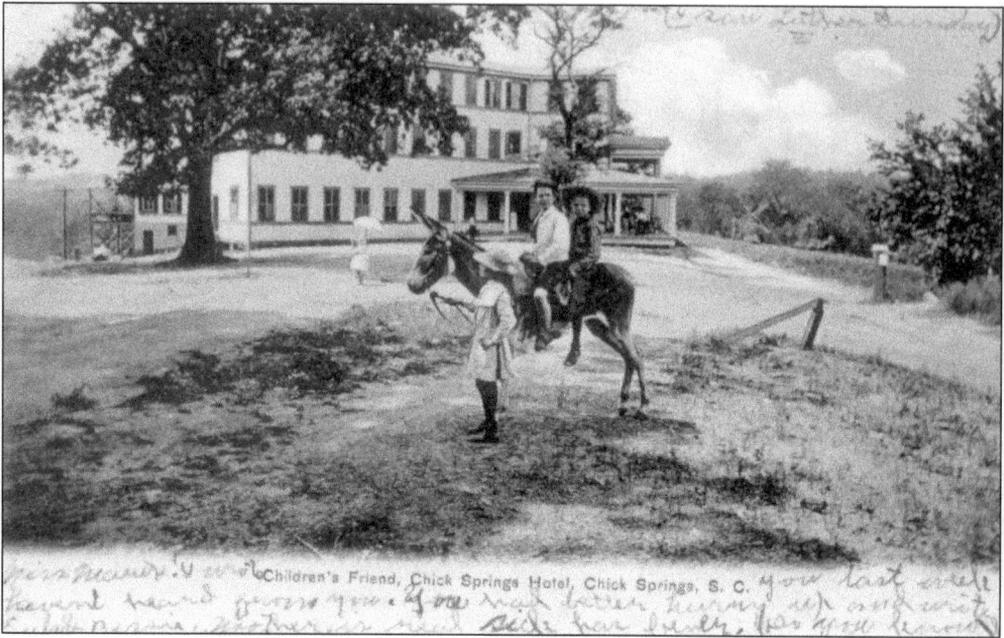

Children's Friend, Chick Springs Hotel, Chick Springs, S. C.

Lazy summer days were fun for children who stayed at the Chick Springs Hotel. They enjoyed donkey rides and swimming in the resort's two lakes. (Courtesy of South Caroliniana Library, University of South Carolina, Columbia.)

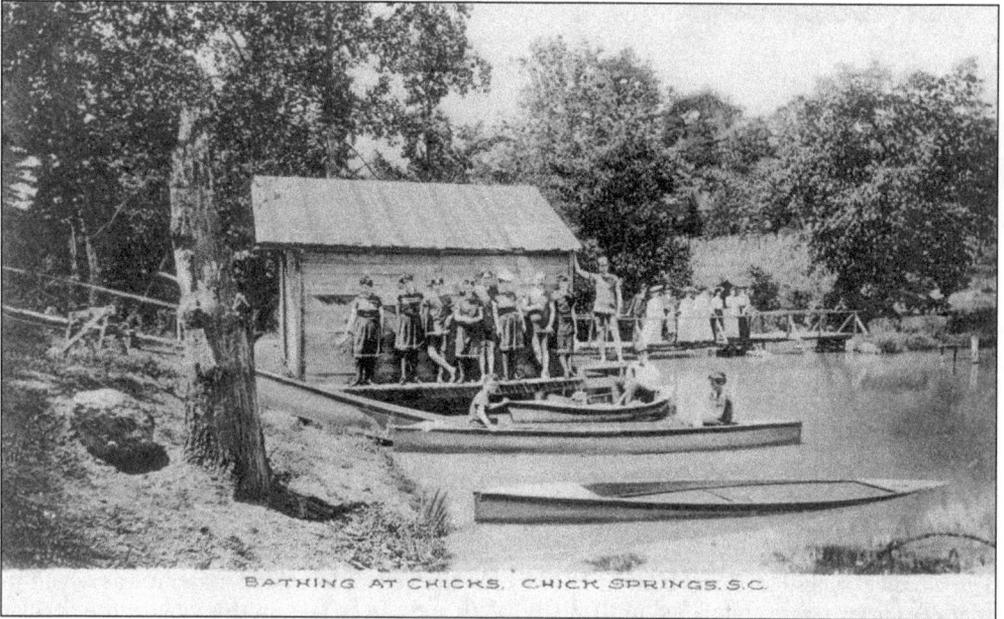

BATHING AT CHICKS, CHICK SPRINGS. S.C.

Swimming and boating were popular at one of the lakes at Chick Springs Hotel. (Courtesy of South Caroliniana Library, University of South Carolina, Columbia.)

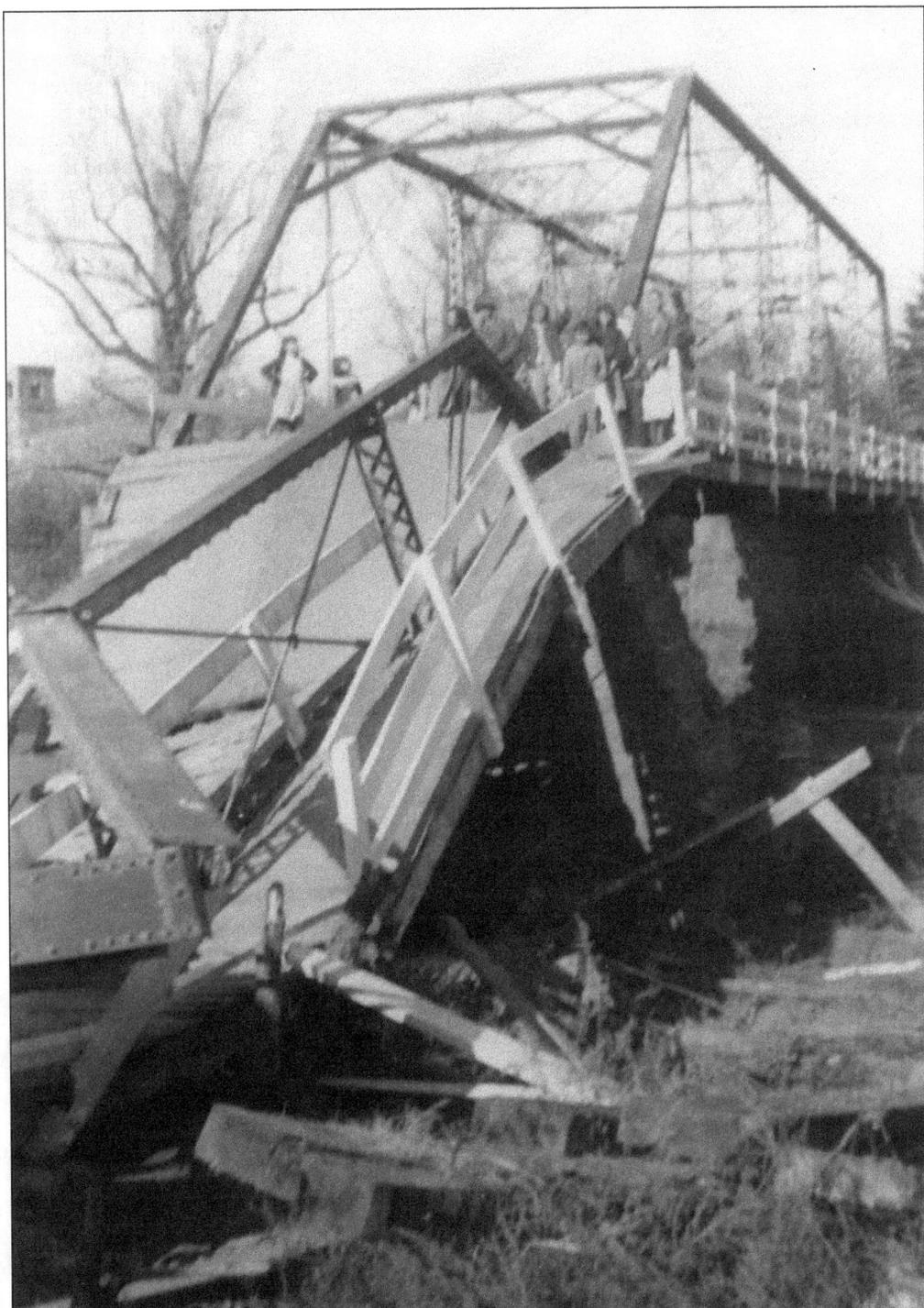

The Pelham Bridge spans the Enoree River on Highway 14. In the 1950s, it collapsed as a large truck passed over. The truck ended up half-on and half-off the bridge and was pulled off the next day. A new bridge was begun almost immediately since it was the major link from Greer to Simpsonville. (Courtesy of Francis Merritt and Evelyn George.)

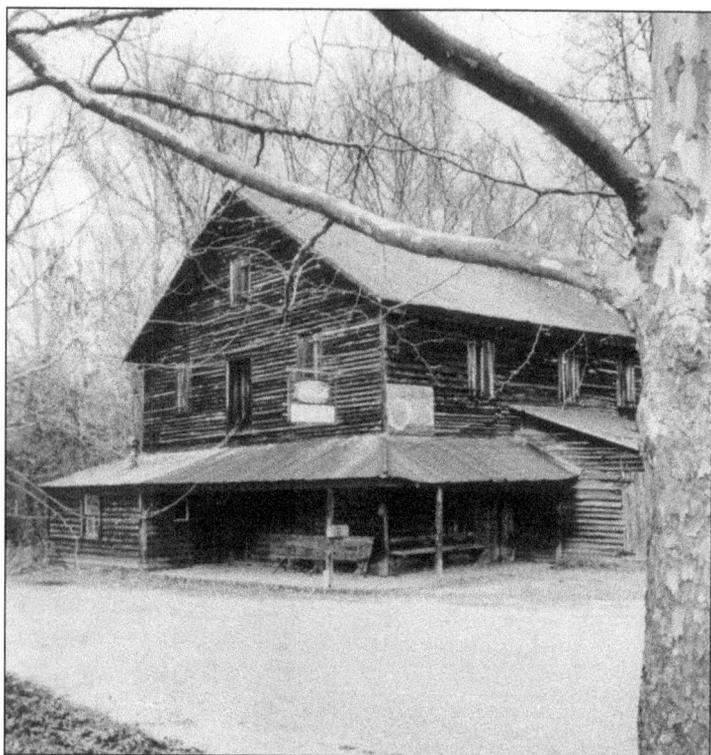

Mosteller Mill was built in 1814 on Highway 14 North (on the current site of Lake View Steak house). Phillip Mosteller planned to build the mill but died before he could begin the work. His wife, Eliza Bruce, and his son David built and operated the mill. David Mosteller later built a cotton mill and gin to operate with the grist mill. The Ansel Post Office was also located here. (Courtesy of Mary Alice Waddell.)

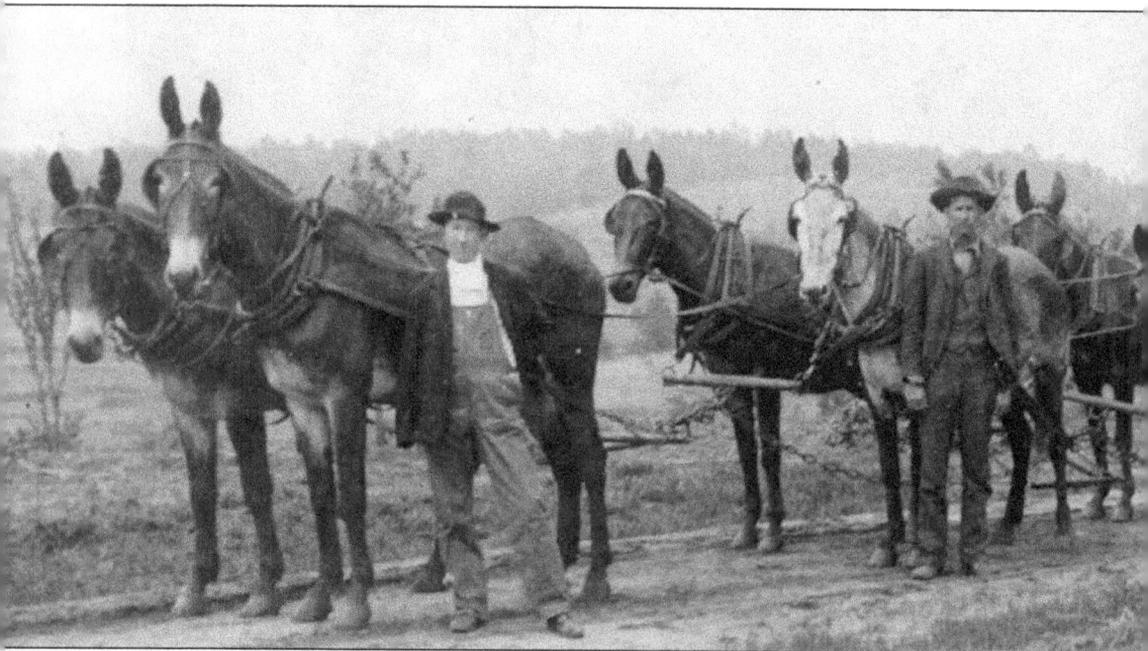

This 1907 picture shows a team of mules pulling the steam boiler purchased by the Mosteller family to power the cotton gin, saw mill, and grist mill. After the boiler blew up, it was replaced with a water wheel. Standing, from left to right, are Allen Green, R. Furman Howell, Jim Howell Jr., unidentified, Homer Howell, and Henry Howell. On the boiler, from left to right, are the

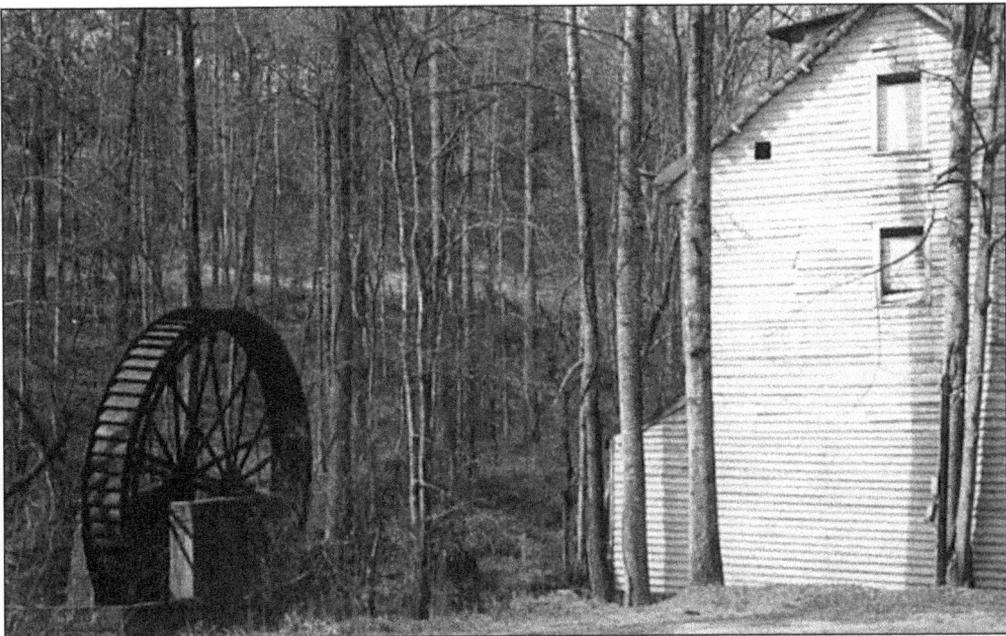

Gilreath Mill, pictured here on Highway 101 North, was originally built in 1812 by a Mr. Alewine for the owner Joel Bruce. This grist mill, which ground both corn and wheat, was later bought in 1890 by its most famous owner, Perry Duncan Gilreath, known as P.D., who was the high sheriff of Greenville County. (Courtesy E. Duke.)

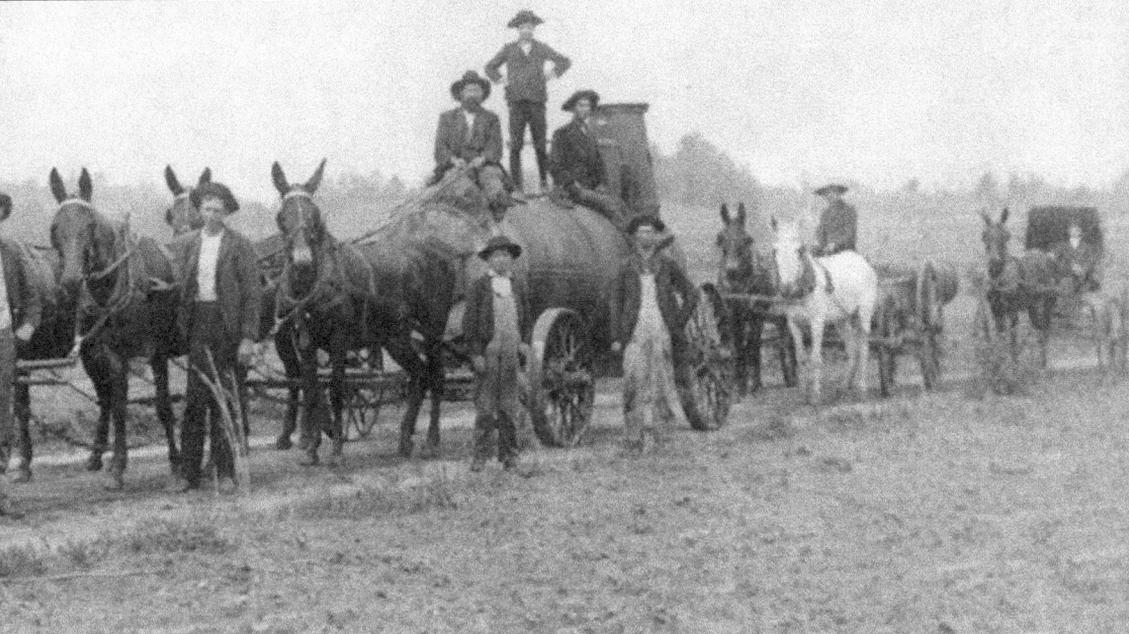

driver Jim Green (seated), Egbert Mosteller (standing), and Stonewall Mosteller (seated). The wagon driver is Oscar Thurmond, and the buggy driver is Rev. J. Tupper Henry. (Courtesy of Mary Alice Waddell.)

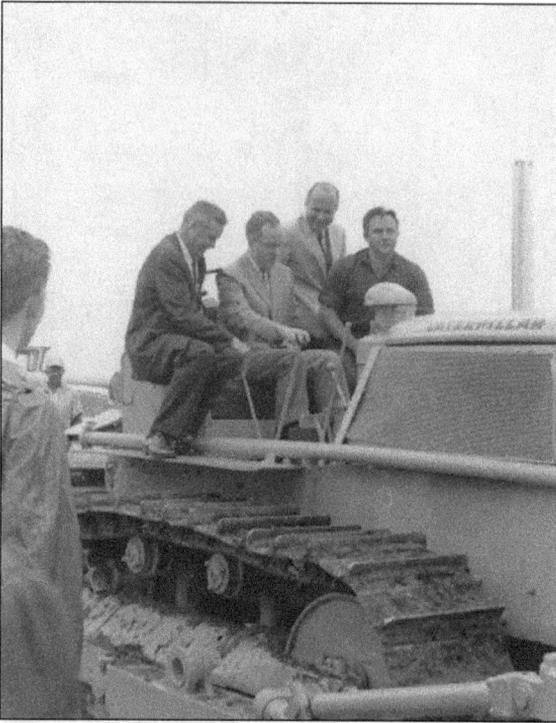

This 1961 Jetport groundbreaking photo shows John Ratterree, local Greer businessman (left, on the bulldozer) and Roger Milliken at the controls. (Courtesy of Kathy Danesi.)

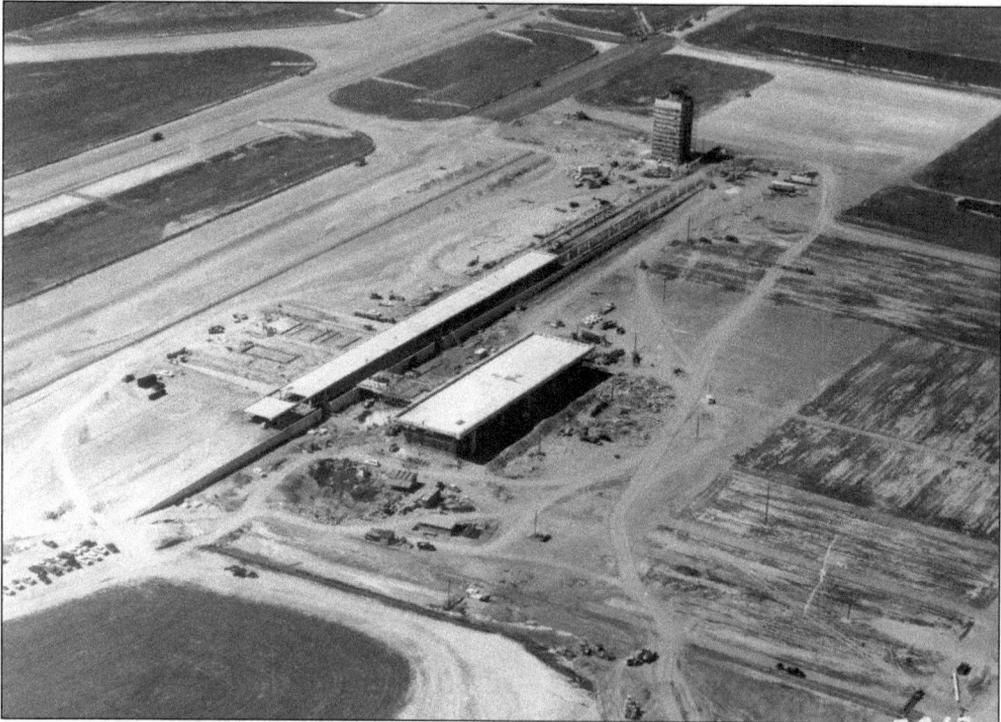

The Greenville-Spartanburg Airport, Greer, South Carolina, terminal is seen under construction in 1961. Known to locals as the Jetport, the $10-million development opened October 15, 1962, along Interstate 85. (Courtesy of GSP Airport Commission.)

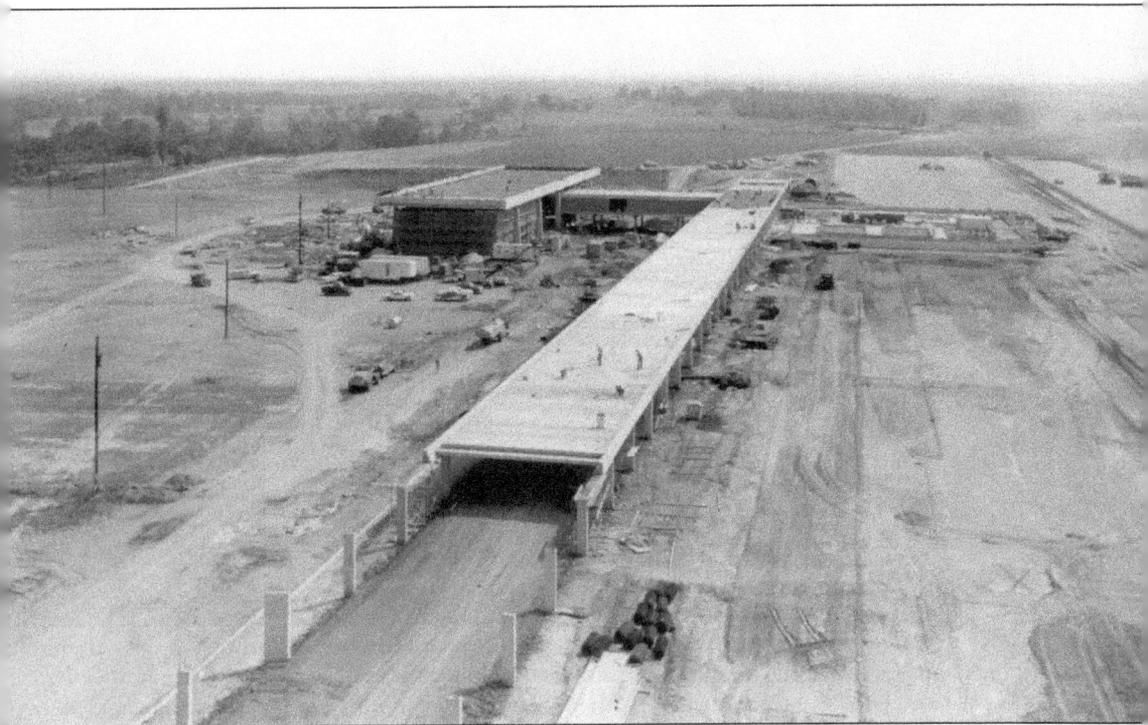

An aerial view shows Jetport construction in 1961. (Courtesy of GSP Airport Commission.)

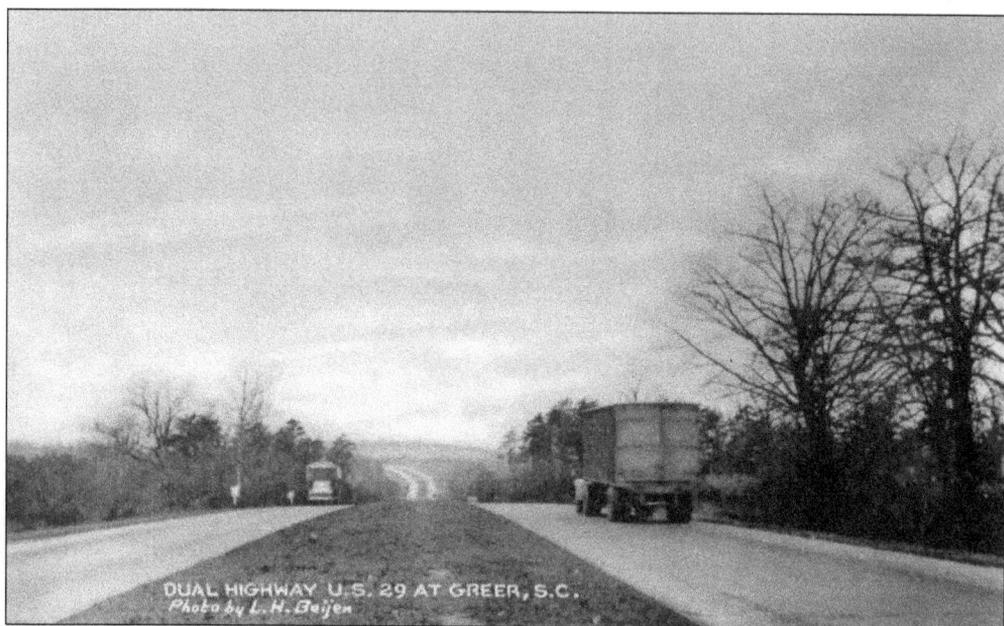

Wade Hampton Boulevard (US 29), known as the Super Highway, was one of the first divided landscaped highways in the state. It was named to honor Wade Hampton, governor from 1876 to 1879 and U.S. senator from 1879 to 1900. The first Hampton family farm was located along the South Tyger River near Tab's Flea Market. (Courtesy of Jean M. Smith Library.)

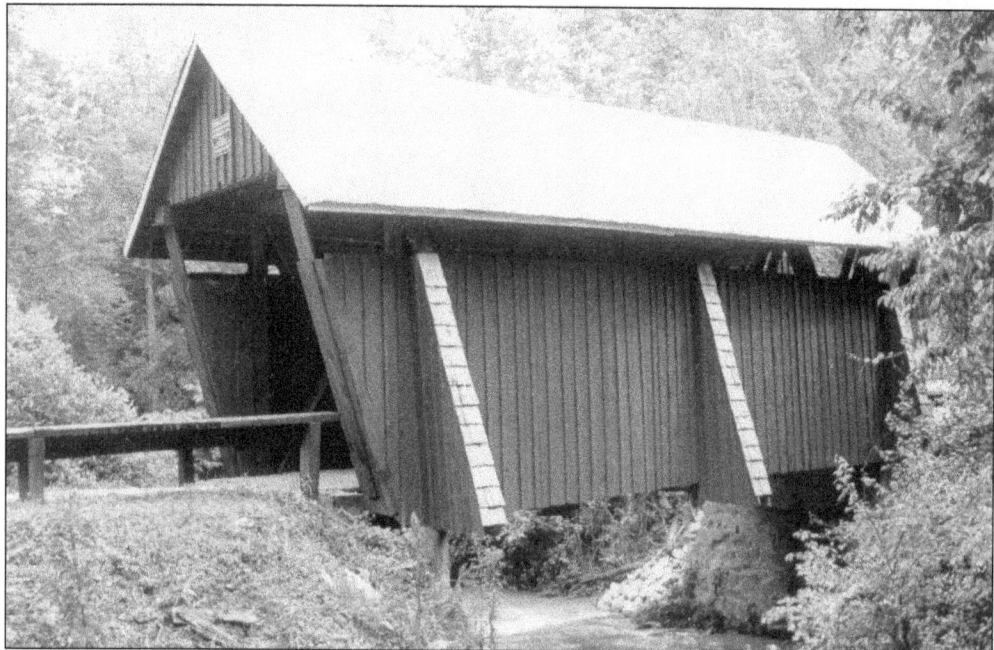

Campbell Covered Bridge, the last remaining covered bridge in upper South Carolina, was built around 1909 over the Beaverdam Creek. The 35-foot-long, 12-foot-wide bridge was built by Charles Irwin Willis on Pleasant Hill Road, off Highway 414, 12 miles north of Greer. "Brice Sudduth cut the rafters," remembers Houston Campbell in the 1975 edition of Clingstone. (Courtesy of Jean M. Smith Library.)

INDEX

www.ingramcontent.com/pod-product-compliance
Lightning Source LLC
Chambersburg PA
CBHW050629110426
42813CB00007B/1754